"During his distinguished career in the West Riding of Yorkshire, Sir Alec Clegg championed the vital role of music, drama, and dance in children's lives. In this major reassessment of his progressive legacy, *Education through the Arts for Well-Being and Community* reaffirms the centrality of the arts in any humane system of education."

William J. Reese, Vilas Research Professor, University of Wisconsin–Madison

"This is a very welcome and necessary book that not only draws together and secures the work of Sir Alec Clegg in British history of education in the UK, but also demonstrates its continued international relevance and usefulness at this crucial point in the history of our planet."

Helen Pheby PhD, Head of Curatorial Programme, Yorkshire Sculpture Park

"Alec Clegg was a gifted, charismatic, innovative teacher and public administrator. This collection of reflections on his personal and philosophical legacy returns us to a boldness of earlier times that is at risk of being forgotten – or worse, distorted – by current rigid dogmas on teaching and learning. English public education has a long history of arts-rich practice, imaginative teaching in the humanities and honouring children's broader well-being. Alec Clegg is a vital part of that history. Any student, teacher, leader or parent who wants to learn from, and draw on, such understandings needs to read this book."

Melissa Benn is a writer, journalist and campaigner

Education through the Arts for Well-Being and Community

Education through the Arts for Well-Being and Community examines Sir Alec Clegg's distinctive contribution to education reform. Revisiting the significance of Clegg's principles for education in the 21st century, the book investigates the impact of his innovative approach to education and his advocacy of an arts-based curriculum to promote physical and mental health.

The book explores a variety of perspectives on Clegg's working relationships, career and achievements. Sir David Attenborough's foreword remembers his uncle Alec as a lively young teacher, and Sir Tim Brighouse considers Clegg as a model for his own leadership in educational reform. Eight authors in all bring a range of academic and professional insights to this study of an exceptional educationalist.

Clegg's national influence as Chief Education Officer in Yorkshire and his impact on schools, teacher education and wider communities through an integrated approach to the arts are richly illustrated in text and pictures. Two aspects of his work have particular topical relevance: Clegg's emphatic concern for 'children in distress'; and his encouragement of creativity through teacher education.

This book will be of great interest for academics, scholars and students in the field of the history of education, educational policy and reform, and all concerned with the role of schools in young people's development.

Catherine Burke is Professor Emerita of the History of Education at the Faculty of Education, University of Cambridge, UK.

Peter Cunningham is an Emeritus Fellow of Homerton College, University of Cambridge, UK.

Lottie Hoare is a Teaching Associate at the Faculty of Education, University of Cambridge, UK.

Progressive Education: Policy, Politics and Practice
Series Editors:
Catherine Burke, University of Cambridge, UK
Jane Martin, University of Birmingham, UK

This series produces authored and edited collections addressing the meaning and expanding understanding of progressive education, past and present. It includes case studies and explorations of schools, individuals, and networks of influence, considering the meaning of progressivism in education from a variety of standpoints. The series focuses upon experience, aspiration, hope and struggle in this consistently contested area of educational ideology, with a purpose to foreground examples of practice, debate and policy in a global context, drawing from the past to inform the future.

Educational Progressivism, Cultural Encounters and Reform in Japan
Yoko Yamasaki and Kuno Hiroyuki

Education and Democratic Participation: The Making of Learning Communities
Stewart Ranson

Educational Reform and Environmental Concern: A History of School Nature Study in Australia
Dorothy Kass

British Froebelian Women from the Mid-Nineteenth to the Twenty-First Century
A Community of Progressive Educators
Edited by Amy Palmer and Jane Read

Education through the Arts for Well-Being and Community
The Vision and Legacy of Sir Alec Clegg
Edited by Catherine Burke, Peter Cunningham and Lottie Hoare

Education through the Arts for Well-Being and Community

The Vision and Legacy of Sir Alec Clegg

Edited by Catherine Burke, Peter Cunningham and Lottie Hoare

LONDON AND NEW YORK

First published 2021
by Routledge
2 Park Square, Milton Park, Abingdon, Oxon OX14 4RN

and by Routledge
52 Vanderbilt Avenue, New York, NY 10017

Routledge is an imprint of the Taylor & Francis Group, an informa business

© 2021 selection and editorial matter, Catherine Burke, Peter Cunningham and Lottie Hoare; individual chapters, the contributors

The right of Catherine Burke, Peter Cunningham and Lottie Hoare to be identified as the authors of the editorial material, and of the authors for their individual chapters, has been asserted in accordance with sections 77 and 78 of the Copyright, Designs and Patents Act 1988.

All rights reserved. No part of this book may be reprinted or reproduced or utilised in any form or by any electronic, mechanical, or other means, now known or hereafter invented, including photocopying and recording, or in any information storage or retrieval system, without permission in writing from the publishers.

Trademark notice: Product or corporate names may be trademarks or registered trademarks, and are used only for identification and explanation without intent to infringe.

British Library Cataloguing-in-Publication Data
A catalogue record for this book is available from the British Library

Library of Congress Cataloging-in-Publication Data
A catalog record has been requested for this book

ISBN: 978-0-367-33136-8 (hbk)
ISBN: 978-0-429-31811-5 (ebk)

Typeset in Bembo
by Newgen Publishing UK

Dedicated to those teachers around the world who share Sir Alec Clegg's conviction and courage by sustaining public advocacy of schools that are centred first and foremost on the needs and interests of children, students and their communities.

Contents

List of figures	xi
List of contributors	xiii
Series Editor introduction	xv
Foreword by Sir David Attenborough	xviii
Acknowledgements	xxi
List of abbreviations	xxiii

	National Arts Education Archive	1
	Introduction: The vision of Alec Clegg, educational leadership and dissemination CATHERINE BURKE, PETER CUNNINGHAM AND LOTTIE HOARE	5
1	Alec Clegg: A model of educational leadership in practice? SIR TIM BRIGHOUSE	11
2	Creativity and redemption: The work of Alec Clegg in post-war England MARTIN LAWN	27
3	Reporting in images: Portraying progress in West Riding education PETER CUNNINGHAM	50
4	Progressivism and art in the West Riding: The role of its Chief Education Officer PETER CUNNINGHAM	73
5	Arts education and oracy with Muriel Pyrah in the West Riding, 1967–1972 LOTTIE HOARE	83

Interlude: Art in the West Riding classroom 99

6 Movement and dance in schools 105
CATHERINE BURKE

7 Bretton Hall: Teacher training through the arts 121
ALLIE MILLS

8 Global travel and exchange in promoting 'a change of heart towards children' 134
CATHERINE BURKE

9 Children in distress and their need for creativity: A psychotherapeutic perspective 147
ALISON ROY

10 The timeliness of Alec Clegg 160
KEN JONES

Conclusion: The legacy of Alec Clegg 174
CATHERINE BURKE, PETER CUNNINGHAM AND LOTTIE HOARE

Index 182

Figures

1	Alec Clegg with pupils	xx

National Arts Education Archive

Archive building 1989 by Building Design Partnership	2
Inscription on façade of the Alec Clegg library building	2
Inscription 'Art of painting speech', NAEA collection	3
Decorated cupboard by Marion Richardson's pupils, NAEA collection	3

1.1	*Story of a School*, Ministry of Education pamphlet, 1949	14
1.2	Alec Clegg building at Bretton Hall College, 1995	17
2.1	Denaby Main in the early 1970s, and rural landscape	32
2.2	West Riding Education Report 1964, Comparison of education costs	42
2.3	West Riding Education Report 1954, School population	44
2.4	West Riding Education Report 1954, Grants paid to students	44
2.5	West Riding Education Report 1964, School population	45
2.6	West Riding Education Report 1964, Awards and aid to students and pupils	45
2.7	West Riding Education Report 1964, Students receiving assistance	45
2.8	West Riding Education Report 1974, Expenditure on education 1954–1973	44
2.9	West Riding Education Report 1974, Increase in costs 1954–1973	45
3.1	Contrasting state of neighbouring schools in 1953	55
3.2	Design of temporary classrooms, 1945–1954	57
3.3	Refurbished school interior, 1954	58
3.4	Cloakroom conditions in an old and a new school, 1954	60
3.5	Lady Mabel College and Bretton Hall College	61
3.6	West Riding Education Report 1964, cover photograph	63
3.7	West Riding Education Report 1964, frontispiece and title page	64
3.8	Remodelling of a school hall, 1964	65
3.9	Dining arrangements: Formal and informal, 1964	67

3.10	West Riding Education Report 1974, cover photograph	68
3.11	Caretakers' training centre, 1974	69
5.1	Muriel Pyrah in her classroom, 1968	85

Interlude: Art in the West Riding Classroom

Art activities at Balby Street Junior, Denaby Main, 1974	99
'A Weasel' collage by an Airedale pupil c.1968-1972	100
Collage of a West Riding home, by a primary school pupil	101
Artwork by a child at Whitwood Mere Infants, 1970s	101
Topic Book covers by pupils at Airedale School, Castleford	102
Self-portrait by Doncaster schoolboy Michael Biggins	104

6.1	Jessie Clegg dancing	108
6.2	Jessie Clegg teaching	109
6.3	Children dancing: Leaping and twisting, 1953	111
6.4	Movement class, Horbury Bridge CE Primary School, 1960–1961	113
6.5	Movement class, Horbury Bridge CE Primary School, 1960–1961	114
6.6	Movement class, Balby Street Junior School, Denaby Main, 1975	118
7.1	Bretton Hall and Gymnasium	122
7.2	Plan of Bretton Hall and Park	125
7.3	Bretton Hall Gymnasium in use	125
7.4	Bretton Hall Gymnasium, 2017	129
9.1	The covers of *Children in Distress* by Alec Clegg and Barbara Megson (1968, 1973)	151
10.1	Lesson planning template, c. 2019	165
11.1	*Recipe for Failure* by Alec Clegg, NCH Convocation Lecture, 1972	176
11.2	Blue Plaque in memory of Alec Clegg	178
11.3	West Riding Education Offices, 1962	179

Contributors

Tim Brighouse, after teaching in grammar and secondary modern schools, followed a career in educational administration. He was, for ten years each, Chief Education Officer in Oxfordshire and Birmingham, sandwiching four years as Professor of Education at Keele University before ending his career as Commissioner for London Schools leading the London Challenge.

Catherine Burke is Professor Emerita of the History of Education at the Faculty of Education, University of Cambridge, UK. Her research focuses on 20th and 21st century progressive education with a particular interest in material contexts. She has published widely on the history of relationships between architects and educators in 20th century school design and collaborates with architects designing schools today who are interested in drawing on useful knowledge from past efforts to design schools to fit the child.

Peter Cunningham is Emeritus Fellow at Homerton College, Cambridge. He lectured formerly on social and cultural histories of education, school systems, curriculum and teachers' professional identities. Teaching in primary schools for two progressive Local Education Authorities, his research interests came to focus on children's learning and development in social and cultural settings, and on the dynamics of curriculum change in differing political and economic contexts.

Lottie Hoare is a Teaching Associate at the Faculty of Education, University of Cambridge and has worked as a lecturer in Education and Early Childhood Studies at Middlesex University. Her research interests focus on the history of arts education, the broadcast representation of education in non-fiction film and radio from 1940s onwards and the actual experiences of pupils and teachers in Local Education Authority schools in England and Wales during the same period.

Ken Jones is a Senior Policy Adviser for the National Education Union, working on curriculum and assessment. He is also Emeritus Professor of Education at Goldsmiths, University of London. He writes about education, culture and policy, in books which include *Education in Britain* (2015). He

co-edited, with Catherine Burke, *Education, Childhood and Anarchism: Talking Colin Ward* (2014) and, with Anna Traianou, *Austerity and the Remaking of European Education* (2019).

Martin Lawn is a Research Fellow, University of Edinburgh. His research interests include European education policy and the history of European educational sciences. Recent books include *The Rise of Data in Education Systems: Collection, Visualisation and Use* (2014); with Romuald Normand, *Shaping of European Education: Interdisciplinary Approaches* (2015); and with Cristina Alarcon, *Assessment Cultures: Historical Perspectives* (2018).

Allie Mills is a doctoral researcher whose PhD study explores the influence and legacies of Sir Alec Clegg's leadership at Bretton Hall, Teacher Training College for the Arts between 1949 and 1974. Her sources include the narratives of Bretton Hall College students and staff, employees of the wider West Riding Education Authority and Sir Alec Clegg's family members. Allie's PhD was supported by the University of Huddersfield and the National Arts Education Archive at the Bretton Hall site within the Yorkshire Sculpture Park.

Alison Roy is a consultant child and adolescent psychotherapist and the professional lead for child and adolescent psychotherapy in East Sussex Child and Adolescent Mental Health Services (CAMHS). She is also the clinical lead and co-founder of a specialist adoption service called AdCAMHS. Within these roles, she provides direct therapy, group work, training, consultation and supervision for professionals including those in educational settings and across children's services.

Series Editor introduction

The Progressive Education: Policy, Politics and Practice series produces authored and edited collections addressing the meaning and expanding understanding of progressive education, past and present. It includes case studies and explorations of schools, individuals and networks of influence, considering the meaning of progressivism in education from a variety of standpoints. The series focuses upon experience, aspiration, hope and struggle in this consistently contested area of educational ideology, with a purpose to foreground examples of practice, debate and policy in a global context, drawing from the past to inform the future.

'The past is a foreign country', sighs old Leo as he looks backs on his childhood with nostalgia in L.P. Hartley's influential novel *The Go-Between* adapted as film in 2015: 'they do things differently there'. We may share Leo's sentiment but this collection of papers are testimony to the relevance of the vision of Sir Alec Clegg to the present day, showing how the problems of English education, including conceptions of meritocracy and sorting by ability, are embedded in its history, as are the means of addressing them. Clegg was Chief Education Officer for the West Riding of Yorkshire, England, between 1945 and 1974.

Contemporaries called him the conscience of the education service. However, this book recalls a time when a Chief Education Officer's vision, working alongside local government infrastructure, could be realised across a region of a fractured Britain.

At the time of writing, a global pandemic makes a fundamental reappraisal of the purpose of education and of the needs of society and individuals central questions of our time. This volume combines a biographical study of a (nowadays) virtually unknown man with an original exploration of these themes through a critical assessment of the achievements and vision of an educator and community leader who stressed the need for supportive relationships to enable schools to thrive. Authors chart the ways in which Clegg sought a change in relationships to support teaching and learning, redesigning the material conditions of schooling, bringing the arts, creativity and appreciation of beauty to the heart of pedagogy and the curriculum. None of this was to be at the

expense of the development of basic skills such as reading, writing and mathematics. Some rethinking of the culture of teaching and the cognitive diet of the conventional curriculum would, he contended, enhance those skills.

Oral testimony, documentary texts and visual sources help reconstruct what being a West Riding pupil or teacher meant when Clegg was Chief Education Officer. These were decades that spanned an age when offering secondary education to all children provided the base for a slow but steady raising of standards with growing rejection of deterministic theories of intelligence and advocacy of the comprehensive principle that a democratic society should educate all its young people rather than selected elites. The discussions that inspired this book helped reinvigorate a timely reassessment of an educator who sought to develop ways to increase the humanity of the classroom. Paying special attention to the place of the arts, school architecture and environment, teacher training and development, mental health and well-being in the organisation of schooling and the teaching profession, this book provides new conceptualisations of modern education systems and the nature of the society for which young people are allegedly being prepared.

Clegg's utility as a historical subject is to show a critique of traditional pedagogies (local and global) that failed (then and now) to acknowledge the limitless capacities of young children given an educational environment appropriately designed to release them. He shared the concern with the wholeness of self that was for 20th century progressive educators an essential purpose of education. He understood the illusion and cultural power of the idea of meritocratic selection in the sense that whilst it promises opportunity, it in fact creates new forms of social division. In his words, 'every time we select, we discard or under-estimate those left behind'.

This collection demonstrates the importance of regional historical geographies and a view of education from the classroom that help shift the gaze from core to periphery, away from the metropole. A gaze that takes in the global, through social networks and the travel of ideas, interwoven with a rich tapestry of institutional and personal histories, of innovation and change. To name but two examples, Bretton Hall teacher training college, which Clegg founded, warrants further attention for its contribution to the arts, as does the use of fantastic places like Woolley Hall for continuing professional development, which offered scope for creative and reflective thinking in schools. There is no claim made for representativeness but the reader enters a landscape populated by (nowadays) virtually unknown figures from past classrooms that contribute to new ways of seeing education, policy and society.

Above all else, editors Catherine Burke, Peter Cunningham and Lottie Hoare collate a hopeful message from the past to the present for the future. A message that draws attention to the impossibility of measuring all that is valuable in education. A message that provides a powerful counter to a dominant political and cultural narrative that suggests there is no alternative to the status quo. In his day, Clegg showed an alternative approach was possible, growing educational

opportunities for the mass of children in post-war Britain and challenging a selective system with its narrow curriculum, which was an inadequate means of initiating pupils into the creative and expressive arts and natural sciences, organised for allocating young people to very different life chances. Historical reconstruction and deepening in the light of documents, oral histories, and a review of contemporary positions, is critical to dispel misconceptions and help us to realise the learning community explicit in the comprehensive ideal. Alternate futures are possible. Revisiting Clegg's life and work, through the lens of the arts, shows the importance of the path not taken. A path that might yet offer the foundations for greater democracy in education in the interests of children, students and their communities.

Jane Martin, University of Birmingham

Foreword

Sir David Attenborough

I may well have been Sir Alec Clegg's first pupil. He was my mother's brother, the youngest of five children of Samuel Clegg, himself a teacher and the headmaster of a school in Long Eaton in Derbyshire. My mother was his oldest sister and Alec himself was only a dozen years older than my elder brother Richard. My two brothers and I therefore regarded him as belonging rather more to our generation than that of our parents. Looking back, I suspect he rather enjoyed that. He certainly loved being with children. For several years he regularly joined us for our summer holidays in Anglesey and he entered into our games with great enthusiasm, even inventing some specially for us. He took us for rides in his battered second-hand car, whizzing at speed through the narrow country lanes. Whenever we neared a hump-backed bridge, he would accelerate so that as we crossed it our stomachs shot up into our mouths. Such a bridge, he told us solemnly, was technically termed an 'oo-er'. But as we approached one, could we predict whether it was a genuine oo-er or merely one that allowed our stomachs to remain between our ribs? What made the difference? Was it the bridge's steepness or the speed at which we drove at it? Experimentation was called for. And when we were able to predict the result correctly, he was just as delighted as we were. Finding things out was fun.

The thrill of helping children to do that never left him. Nor did his pleasure in sharing it with those he taught, which is why, I suppose, he was such an inspirational teacher. Teaching, for him, was not pouring facts into children like filling bottles with milk.

Alec's father certainly held this view. Under his guidance, his school placed great emphasis on the visual arts. Its centre was an Arts Room on the walls of which hung reproductions of Italian Renaissance paintings. Each had a frame copied from that of the original by boys in the school's carpentry shop. Pupils studying drawing and design analysed the pattern of the lace made locally by their parents. The effect of this emphasis was such that former pupils returning to the town and walking down the main street were able to deduce, from the curtains and the objects sitting on the window-sill, which were the homes of children who had been educated at the County School.

Alec's own bent was not particularly for design but for modern languages. In the early 1930s, he was sent by his parents to live with a family in Germany to learn the language properly, and from there he brought back splendidly designed wooden animals for his three nephews. Then he too became a teacher and for some time we lost sight of him.

After the war, he left direct teaching and became an educational administrator in Yorkshire. Eventually he became so senior and so effective that he was regularly summoned for consultations by the Department of Education in London and once again we saw a little of him as he stayed overnight with me and my new family in Chelsea. And whenever he did, he always brought with him writings and drawings produced by children from schools in his charge. He would show them to us, beaming with pleasure at the originality and freshness of children's perceptions. His sympathy for and admiration of the gifted teacher was paramount. He would talk at length about those whose pupils had produced the most bold and vivid images. And again and again he would explain how he saw his job as Chief Education Officer to be the protector of the teachers whose pupils produced such things, shielding them from the deadening effects of routine administration and the dogma of educational theory.

Perhaps there is a teaching gene that causes those who have it to find a special delight in leading others to new insights and understandings. If there is, then my mother's family, the Cleggs, certainly had it and over several generations. Not only was Alec's father a remarkable headmaster, but his grandfather ran a small village school in Derbyshire. And I can count at least nine of his close relatives who have taught or are still teaching in establishments ranging from infant schools to universities.

But the gene also works in less obvious ways. I suspect it may explain why my brother Richard became first an actor and then a film director, and why I have spent my life making documentaries about the natural world. Alec himself, of course, left direct teaching quite early in his career and became an administrator. But as the following pages will make clear, he was such a gifted and charismatic educationalist that he has probably had a greater influence on more impressionable minds in this country than any of us.

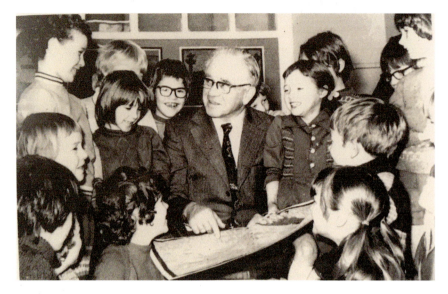

Figure 1 Alec Clegg with pupils
Bramley Occasional Papers, vol. 4, 1990

Acknowledgements

The research project 'Sir Alec Clegg Revisited' was funded by the University of Cambridge Arts and Humanities research fund to which we owe thanks. Alec Clegg's sons, Peter, John and Andrew, have provided much support and shared with us family photographs, books belonging to their father and copies of speeches and other materials. Peter Clegg of the architects' studio FCB has provided financial support to enable the book to be well illustrated. Peter Newsam, who worked closely with Clegg, contributed his intimate professional knowledge and Michael Fielding has been an advocate of the project throughout. Anna Bowman and Leonard Bartle at the National Arts Education Archive have been particularly helpful in sourcing material for the book.

We are grateful to Sir David Attenborough for providing such a splendid and appropriate foreword.

Many individuals contributed their personal knowledge of the time and place of interest to this study, including the late Alison Drake MBE, whose knowledge of Castleford was so helpful. Many past pupils and teachers provided testimonies and memories, including pupils of Whitworth Mere primary school, Castleford, and pupils and teachers at Girnhill Infants School, Featherstone: Ian Clayton, Sheila Mackie, Paul Rhodes, Nora Carlisle, Ruth Nettleton, Margaret Brooke, Mel Dyke, Audrey Thompson, Dot Else, Pamela Marley, David Wilders and Rosemary Devonald.

Thanks are due to all who participated in the seminar series. In particular, we would like to thank Jay and Helen Featherstone for crossing the Atlantic to speak at the seminar recognising 50 years since the publication of the Plowden report. Also thanks to Caroline Peet and to Scott Hartley, a newly qualified primary school teacher, who spoke of the relevance of Clegg's philosophy for the teaching profession today.

We were delighted to have Barbara Megson, who co-authored *Children in Distress* with Clegg, participate in the project. Thanks to the National Education Union for providing premises for the Plowden seminar.

Finally, we want to acknowledge the valuable work of Derek Gillard for making accessible key texts of Clegg speeches, and especially a rare and valuable audio recording of his Centenary of Public Education speech at Central Hall

Westminster, London, referenced by Ken Jones in Chapter 10: audiolink available at Derek Gillard's Education in England: www.educationengland.org.uk/documents/speeches/1970clegg.m4a

Staff of the National Arts Education Archive have given much practical support to our research as we acknowledge elsewhere. Here we make formal recognition of their permissions granted for reproduction of items in their care: works of art by children and especially those from West Riding schools, documents, photographs and objects held in the archive, identified individually in the chapters that follow. The West Yorkshire Archive Service (WYAS) has also assisted by generously providing permission for publication of images under copyright, as follows: WREC Report 1954, *Ten Years of Change*, ref: WRDS/1/2/34 (Chapters 2, 3); WREC Report 1964, *Education 1954-64*, ref: WRDS/1/2/35 (Chapters 2, 3, 6, 7); WREC Report 1974, *The Final Ten Years*, ref: WRDS/1/2/36 (Chapters 2, 3); WRCC Education Department, *Bretton Hall College of Education* (Prospectus 1963-69), pp. 6–7, Plan of Bretton Hall and Park (Chapter 7). Details of these sources are given in the relevant chapters. Thanks also to: Times Newspapers News Licensing for Figure 5.1; Penguin Random House UK for Figure 9.1; and Action for Children for Figure 11.1. Every effort has been made to trace the copyright holders and to obtain permission for the use of material.

Finally, we thank our editorial team at Routledge, Emilie Coin, Swapnil Joshi, Katie Finnegan and Helen Strain, for the impressive expertise, care and attention to detail they have shown in preparing this book for publication.

Abbreviations

CEO	Chief Education Officer
DES	Department for Education and Science (1964–92 – formerly MOE)
EPA	Educational Priority Area
HMI	Her Majesty's Inspector (of schools in UK)
LAP	Low Attainment Project
LEA	Local Education Authority
MOE	Ministry of Education (1945–64 – later DES)
NAEA	National Arts Education Archive
NATE	National Association for the Teaching of English
SPA	Social Priority Area
TALIS	Teaching and Learning International Survey (OECD)
UCL IOE	University College London, Institute of Education
UNESCO	United Nations Educational, Scientific and Cultural Organization
WRCC	County Council of the West Riding of Yorkshire
WREC	West Riding Education Committee
WYAS	West Yorkshire Archive Service
YSP	Yorkshire Sculpture Park

National Arts Education Archive, Yorkshire Sculpture Park

The National Arts Education Archive (NAEA) at Yorkshire Sculpture Park might be seen as a significant continuation of Clegg's work in recognising and promoting a central role for the arts in the school curriculum and in young people's education. 'Alec Clegg Revisited', the research project that generated this book, benefited greatly from its resources, and from the interest and support of its dedicated and long-serving staff. From 1985, material was gathered at Bretton Hall College and in 1989 a purpose-built archive building, The Lawrence Batley Centre, became the home of the NAEA, an independent charitable trust, and its collections, supported by Bretton Hall College (see Chapter 7). 1985 was just a year before Sir Alec's death, and the archive continues to work with an enthusiastic and knowledgeable team of volunteers who curate an extensive collection of art by children and students, their teachers and lecturers, including many of the most influential figures in art and design education from the early 20th century to current times. Internships, placements, personal research support, lectures and seminars are provided for student teachers and art students, and regular exhibitions attract an audience of visitors to the Yorkshire Sculpture Park.

A research facility with over a hundred catalogued collections, the NAEA documents the development of art education nationally and internationally from the Child Art Movement of the 1930s and 1940s onwards. Items from its collection are loaned to national and international exhibitions. An active advocate for the future of art education, the NAEA has an important role to play, especially at a time when art education is currently neglected by new educational policies in the UK (Adams et al. 2017: 177). And as Anna Bowman stated: 'We've come at it as educationalists… it's a special collection… and if we think of what our purpose is, it's really we do want to preserve, or conserve, or have at least evidence of how the arts have been taught, how they've developed' (cited in Adams et al. 2017: 178).

Volunteers share varied experience as art educators, in social care and in research and see their work as outreach, advocating engagement with arts both in and beyond mainstream schooling, with wider audiences and diverse communities, fostering creativity to cultivate self-esteem, social interaction and

2 National Arts Education Archive

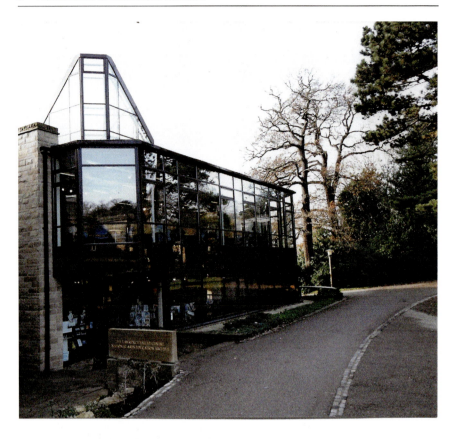

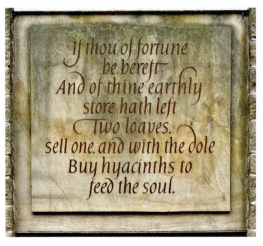

Inscription on façade of Alec Clegg library building (opened 1995) adjoining the NAEA building (see Chapter 1, Figure 1.2). A favourite verse cited often by Clegg to illustrate an 'ever more dangerously materialistic world' and an education that cares 'more for the mind rather than the spirit' (Clegg 1980: 17).

All images reproduced by permission of NAEA @ Yorkshire Sculpture Park. Archive building photo by Jill Thompson.

National Arts Education Archive 3

Archive building 1989 by Building Design Partnership. BDP founder Prof Sir George Grenfell Baines, Hon Fellow Bretton Hall College and lifetime supporter of the arts. Leading sponsor was Yorkshire businessman Lawrence Batley, after whom the Centre was named.

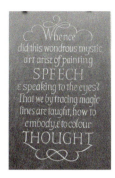

Inscription on black slate in the NAEA collection. The quotation is from celebrated Canadian philosopher Marshall McLuhan's best-selling book, *The Medium is the Massage* (1967). (McLuhan studied at Cambridge just a few years after Clegg.) From the NAEA Walter Cowan collection.

A celebrated item in its large collection of children's art, NAEA contains two decorated cupboards and screens painted by Marion Richardson's pupils at Dudley Girls' High School between 1917 and 1930. Richardson was highly influential as a pioneer art teacher and lecturer from the 1920s to 1940s.

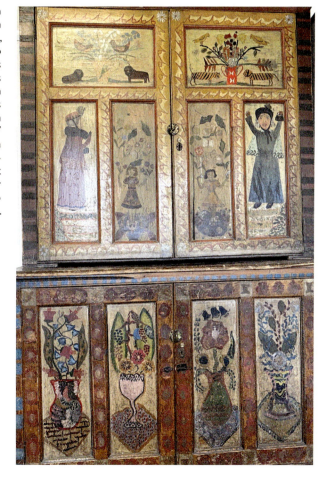

mental health. The archive's programme has included interactive performance and installation events by leading artists such as Bob and Roberta Smith, Oreet Ashery, Hester Reeve and Ruth Ewan.

One experienced teacher of art and design in state comprehensive schools described the archive as a repository of collective memory embodying the history of thinking and practice, teaching and learning, over the last century and a half, an essential foundation for continuing development. This attitude echoes conceptions expressed by Alec Clegg to be found in the chapters that follow. As Ken Jones elaborates in Chapter 10, the dynamic of West Riding policies and practice under Clegg's leadership was never aimed at a final goal, but at a continuing process of adaptation and change embodied by the NAEA.

Reference

Adams, J., R. Bailey and N. Walton. (2017). 'The UK National Arts Education Archive: Ideas and imaginings'. *International Journal of Art Education and Design* 36(2): 176–187.

Introduction

The vision of Alec Clegg, educational leadership and dissemination

Catherine Burke, Peter Cunningham and Lottie Hoare

Sir Alec Clegg, unduly overlooked by educationalists and policy-makers today, was one of the most significant and widely admired 20th-century educational administrators. Chief Education Officer (CEO) for the West Riding of Yorkshire[1] from 1945 to 1974, at that time the second largest Local Educational Authority (LEA) outside London, Clegg prioritised the arts as essential both for excellence in attainment throughout the curriculum, and for ensuring the humanity of education in schools for children and students of all ages. His educational vision and his leadership skills provided the impulse and direction for teachers to fully support young people's emotional development, to meet their sensory needs, through the arts. For several decades in the mid-20th century, West Riding schools were on the itinerary of any progressive school administrator across the English-speaking world, and his achievement may be seen as a model for schools' potential contribution to the well-being of their communities today.

The book in your hands grows out of a project initiated by Catherine Burke, generously supported by the University of Cambridge Arts and Humanities Research fund in 2016. A proposal to 'revisit' Sir Alec Clegg had several elements. It brought together scholars from the history of education and wider disciplines in universities with teachers and practitioners in schools, health and social services, to reassess the value of his contribution to theory, practice and debates around the meanings and intentions of progressive education. Three invited seminars were designed to engage in responding to research reports, drawing on archival investigations that illuminated Clegg's particular significance for 20th-century educational development in the following areas: educational leadership and dissemination; education through the arts including school buildings and environments; schools' responsibilities towards children 'in distress'; children and young people's well-being and mental health; teacher training and professional development; and international exchange of ideas and practice.

Specific seminars focused on classroom experiences in the West Riding; school welfare and counselling for children suffering from poverty and neglect; and a fiftieth-anniversary reflection on the Plowden Report of 1967, *Children*

and Their Primary Schools, for which West Riding practice was so influential (DES 1967).

The project recognised a need to 'revisit', in changed times, the cultural, technological and political transformations that schools and children's lives have undergone in the decades following Clegg's retirement, and indeed the half-century since Plowden. A project requiring historical study, its outcomes are highly relevant as governments across the world today struggle with the multiple challenges of how to shape a school curriculum suited to information technologies, individual mental health and communal well-being in 21st-century conditions.

Compiling a new collection of essays on Clegg, we view our subject as historians, as teachers and as educationists. We acknowledge a debt to previous authors, recognising how a fresh view in revisiting his work is determined not only by cultural and political change, but also by the histories that have accumulated since his time. Clegg and West Riding education within living memory invite an element of 'auto/biographical' study. Sociologist C. Wright Mills observed 50 years ago: 'No social study that does not come back to the problems of biography, of history and of their intersections within our society, has completed its intellectual journey' (Wright Mills 1970: 6). More recently, Jane Martin identified auto/biography as drawing on individual memory, biographical and autobiographical, accepting the researcher's own background as factors in selecting and interpreting data (Martin 2003). Our book is a tapestry woven by several hands from a research project drawing on authors' experience in various ways. It weaves auto/biographical threads into our accounts of Clegg, assembling a contemporary history based on individuals' perspectives on the past but also, we hope, speaking to those who concern themselves with education in the present, whether as policy-makers, administrators, teachers, parents or students.

Clegg's public addresses and extensive writing are coloured with reflections on his own development as teacher and educational administrator. His managerial style entailed listening carefully to the viewpoints of teachers and advisers, and close observation of their work in schools fed his philosophical approach to policy-making. Enquiry and dialogue characterised his teamwork and those qualities are reflected in a key starting point for our research, his four substantial articles commissioned by the *Times Educational Supplement*, the leading national newspaper for teachers, following his retirement in 1974 (Clegg 1974). These articles focused on the value of collaboration; the importance of aesthetics in the school environment; a 'transformation' in primary schools; and his memories of working with political personalities in local government, ending with a characteristically down-to-earth prognosis of both good and ill in education. His writing is frank in identifying problems past and future, but also humorous and humane. Six years later, he again drew on his own career with a critical overview of public education in *About Our Schools* (Clegg 1980). A memorial volume in 1990 also presents a classic auto/biographical text, where many of

its 60 pages are taken up with Clegg's own words, coupled with descriptions by those who knew him (Thistlewood 1990). The ideas, and ways of thinking, that he shared included his own family traditions, steeped for generations in school teaching. His wide reading in history and philosophy was a way of understanding fundamental and enduring principles; he cited frequently the Yorkshire schoolmaster Charles Hoole (1610–67), and the advocate of physical education, headteacher Edward Thring (1821–87).

This auto/biographical mode is evident too in a critical awareness of his own professional formation. He considered 'perhaps the luckiest thing that ever happened to me' was attending the London Day Training College where he heard 'probably the most distinguished trio of educationalists lecturing together at any one time – Cyril Burt, John Dover Wilson and Percy Nunn in the early 1930s' (*TES* 20 Sept. 1974: 29). Burt had recently introduced child guidance as a professional specialism, while Dover Wilson promoted literature in schools and championed adult education; both thereby informed key priorities for Clegg in his later career. And with hindsight we see that Nunn anticipates Clegg in both intellectual range as educationist, and personality as teacher; his 'authority and pre-eminence were unquestioned', his 'force of character and width of interest and knowledge', 'charm and whimsical humour' were widely acknowledged (Aldrich 2004).

Clegg's first biographers crossed boundaries in the way that 'narrative and auto/biographical social science research and writing' implies (Sikes 2012: 124). Peter Newsam, who worked closely with him as Deputy Education Officer in the West Riding and carried forward Clegg's influence in his own career as a leading CEO and Director of an Institute of Education, articulated an appreciation through a critical analysis of Clegg's principles, and later wrote Clegg's entry for the *Oxford Dictionary of National Biography* (Newsam 1990).

Two book-length accounts appeared at the turn of the millennium, both by authors who knew and worked with Clegg. Peter Darvill and Nora George both draw in detail on Clegg's own papers, an extensive collection of personal and professional correspondence as well as official documents, deposited in a local government and two institutional archives. Peter Darvill taught and led in West Riding flagship comprehensives before spending his retirement researching these archives; recall of his own experience, combined with documentary sources, inform a detailed and sensitive evaluation of Clegg's work (Darvill 2000). Darvill's acquaintance with people and relationships in the education department, with recorded memories from Clegg's national acquaintances, sustain the auto/biographical quality of his account. Text and notes are packed with information about comings and goings, negotiations and implementation of policy. Strategic management comes to the fore as each educational innovation is painstakingly negotiated towards implementation, and experimental projects in diverse communities scattered throughout this third largest education authority are supported and promoted. In a context of teachers' lives and careers, Darvill's own life course offers important insights,

read against his biography of Clegg. Eleven years younger and from a humbler family background, he shared Clegg's social and educational principles, was dedicated to his students' progress, active in caring for their welfare and for his local community in retirement. His son recalled 'his study room, the rich smell of books he collected and the painstaking hours he spent there' completing the biography.[2]

Nora George had been a teacher and headteacher in the West Riding before moving to Hull as a university lecturer in education, where she published a distillation of Clegg's thought disseminated through his 30 years of public speaking and writing (George 2000). She cites at length his writings to illustrate his depth of philosophical reflection, together with evidence of his strategic skill in persuading politicians and motivating teachers to achieve appropriate ideals. She structures her analysis in terms of 'values' or principles and 'accountability' or commitment: the values embraced children's learning and methods of teaching, the learning environment created by schools, and the curricula and pedagogies he encouraged to maximise educational opportunity for all students; commitment was realised in the preparation and further professional development of a well-motivated and highly skilled teaching force. Working under his leadership, she had clearly internalised Clegg's adherence to intellectual and moral principles coupled with creative and adaptive pragmatism, and their urgent relevance to the circumstances that confronted children and families, students and teachers.

A further auto/biographical thread is woven through the oral history research that launched this revisiting of Alec Clegg. Hoare's research gathered personal testimony of former administrators, teachers and pupils, discussing their memories individually with her and with each other. The first of our three research seminars reported on this work. Our project benefitted from meeting with retired teachers, who discussed their experience of education and shared their memories of working with Clegg as their CEO. We also learned from ex-pupils who recalled their school days under his aegis. Some went on to careers in the arts, such as the writer Ian Clayton and poet Ian McMillan, both men still resident in West Yorkshire. The teachers recalled Clegg's frequent visits to their schools, often unannounced but always welcome. A common theme was weekend or week-long in-service courses of professional development at Woolley Hall with ample time allowed for sharing experiences. Clegg would often plan sessions to ensure that early years teachers were paired with teachers of older children so that they could learn from each other. One challenge at the time was to encourage male teachers specialising in sports and physical education to explore and experience the possibilities of movement and dance. A participant in our research recounted how, reluctant at first, he had come to see how a shift from uniformity of practice towards individual expression could be transferred productively to other areas of learning such as writing. This oral history research elicited some conflicting and controversial first-hand memories and interpretations. Criticism of Clegg as a person or of his philosophy of

practice was rarely articulated, though recent research has challenged the extent of change in some schools (Wood et al. 2020).

Children's well-being, now high on the agenda for education and for health services, in Clegg's time was generally seen as a relatively marginal issue. The Warnock Report, issued four years after his retirement, shifted public consciousness, though even then the language remained of '*Handicapped* Children and Young People'. As educationists and historians, we perceived this important aspect of Clegg's work as relatively neglected in the literature to date. Certainly, it receives little attention in the biographies by Nora George and Peter Darvill.

So, in convening our second research seminar on *Children in Distress*, we were privileged to enjoy the company of Clegg's co-author Barbara Megson, contributing her own auto/biographical perspective to the research. Like him she was a Cambridge graduate, going on to teach history and thus sharing his enthusiasm for the subject. In 1966, however, she had joined the West Riding education office as an administrative assistant, where Clegg asked her to research the plight of troubled children. Their work, first published in 1968, aimed to 'call attention to a problem… which is damaging to our society and… [largely] unrecognised. It may be the nursery of costly disorder' (2nd ed 1973: 7). Reprinted three times in as many years, it indeed roused public attention, a second edition appearing the year before Clegg's retirement. In that seminar we were also assisted by Alison Roy, a child psychotherapist able to enlighten our historical understanding from a contemporary perspective. Her chapter therefore brings a novel and valuable dimension to our book.

A third seminar held at the then National Union of Teachers (NUT) – now National Education Union (NEU) – in London, revisited the Plowden Report. It drew key participants from the United States who recalled their visits to progressive LEAs at the time of Plowden, and testified to their collaboration with West Riding teachers amongst others in drawing on and sharing child-centred approaches to teaching in primary/elementary schools.

Authors in this book bring a variety of backgrounds to representing West Riding education and the work of its leader. One or two met Clegg in person, and most encountered his educational philosophy or practice in the course of their careers. Lawn visited him in the 1970s, when researching and filming a school at Denaby Main. Brighouse recalls meeting him in 1980; he also networked with progressive LEA leaders in Clegg's time and beyond, their practices steadily challenged by trends in national policy as the century progressed. All have shared inspiration from his principles and an aspiration to practise those principles in a variety of settings, motivated especially by the potential of art for individual and communal well-being.

Notes

1 The 'Ridings' of Yorkshire: Local government in Yorkshire has a unique and complex history. Founded in antiquity as the Kingdom of Jorvik, it was divided in the

ninth century by invading Danes into thirds ('thriddings'), North, East and West. This arrangement began to dissolve into smaller units with local government reorganisation in 1974, and again in the 1990s. In 1971, the population of West Riding was 1.8m (in the administrative county) and 2.7m in the County Boroughs, total 4.5m. Greater London was 7.4m (Inner London) and 9m in the Outer Boroughs. The population of Lancashire was 5.1m including its County Boroughs, making it the most populous county in UK outside London at that time.

2 Private communication with Lottie Hoare, November 2019.

References

Aldrich, R. (2004). 'Nunn, Sir (Thomas) Percy', in *Oxford Dictionary of National Biography*.

Clegg, A. (1974). *Times Educational Supplement (TES)*, 20 September 1974: 29–30, 27 September 1974: 24–25, 4 October 1974: 19–20, 10 October 1974: 24–25.

Clegg, A. (1980). *About Our Schools*. Oxford: Basil Blackwell.

Darvill, P. (2000). *Sir Alec Clegg: A Biographical Study*. Knebworth: Able Publishing.

Department of Education and Science (DES). (1967). *Children and their Primary Schools: A Report of the Central Advisory Council for Education (England)*. London: HMSO. www.educationengland.org.uk/documents/plowden/plowden1967-1.html

George, N. (2000). *Sir Alec Clegg, Practical Idealist 1909–1986*. Barnsley: Wharncliffe Books.

Martin, J. (2003). 'The hope of biography'. *History of Education* 32(2): 219–232.

Newsam, P. (1990). '"What price hyacinths?" An appreciation of the work of Sir Alec Clegg', in *Bramley Occasional Papers* 4 (NAEA); partially reprinted in *Education 3–13* (2008), 36(2): 109–116.

Sikes, P. (2012) 'Truths, truths and treating people properly: Ethical considerations for researchers who use narrative and auto/biographical approaches', in *Explorations in Narrative Research* (Studies in Professional Life and Work, vol. 6). ed. Goodson, I., A. Loveless and D. Stephens. Amsterdam: Sense Publishers (Brill), 123–139.

Thistlewood, D. ed. (1990). *The Sir Alec Clegg Memorial Volume*. Bramley Occasional Papers 4, Bretton, Yorks.: NAEA.

Wood, M., A. Pennington and F. Su (2020). '"The past no longer casts light upon the future; our minds advance in darkness" 1: The impact and legacy of Sir Alec Clegg's educational ideas and practices in the West Riding of Yorkshire (1945-1974)'. *British Journal of Educational Studies*, doi:10.1080/00071005.2020.1799935

Wright Mills, C. 1970. *The Sociological Imagination*. Harmondsworth: Penguin.

Chapter 1

Alec Clegg
A model of educational leadership in practice?

Sir Tim Brighouse

To talk of Clegg as a leader in education is in part anachronistic. 'Leader' was not a word used much in the post-war years, especially in educational circles. It would have conjured up uncomfortable echoes of *Mein Führer* and the unnerving consequences of the cult of leadership in Spain, Italy and especially Germany in the dangerous between-wars years pregnant with the disasters that fatally unfolded, and in which so many Europeans perished. Certainly, Clegg would not have admitted to being a leader, preferring modestly to label himself an 'administrator' – albeit with the flicker of an eyelid perhaps, adding the adjective 'creative'.

To an extent therefore it is necessary, in considering him as a leader, to remind ourselves that he had retired 25 years before the National College for School Leadership had been founded, before many – indeed in education, *any* – books had been written about 'leadership' and before the first research had been carried out on school effectiveness (Rutter et al. 1979), or the burgeoning literature on school improvement had begun. Schools of Management in higher education were in their infancy only at the end of his career. And it was after the reorganisation of local government in 1974 that the word 'leader' was first used to describe the most influential person in a political party in the County Council.[1] The modern observer, however, would have no difficulty in 'back-mapping', as it were, on Clegg's practice the essential characteristics and subtleties of successful modern leadership and management of large organisations. Later in this chapter an attempt will be made to sketch such a 'back-mapping', but first a brief explanation of the context in which he worked.

During the 29 years from 1945 to 1974 that Clegg was in the West Riding, the Local Education Authority (LEA) was in its heyday. Through their role as 'creative administrators', a few great Chief Education Officers in LEAs shaped educational policy and practice across the whole range of educational provision. They influenced and created developments in music, the arts, and sport in and out of school and college, and their writ ran from nursery through infant, junior, secondary, sixth forms and the youth service to further education colleges, adult education, teacher education and higher education outside

the old universities. Many education officers missed that opportunity for want of the elusive quality of 'creativity', but the few great ones laid the foundation of what we now recognise as outstanding provision. There was Newsom in Hertfordshire, Wilson in Shropshire, Mason in Leicestershire, Chorlton in Oxfordshire, Morris in Cambridgeshire, Russell in Birmingham, Sylvester in Bristol and of course their minder Sir William Alexander at the Association of Education Committees. But among all these, Clegg was recognised as preeminent. From the early 1950s and throughout the next decade, such was the reputation of Alec Clegg – and his impact on all the educational provision of the West Riding, one of the largest local education systems in Europe where he was Chief Education Officer – that thinking and committed teachers elsewhere envied their counterparts in Clegg's county. To be a West Riding teacher, head or adviser was to know that you were part of a great enterprise and associated with something generally acknowledged as very special and at the forefront of educational practice.

After his first few years and with his reputation, and that of his authority, established, there was never a shortage of applicants for headships in the county while any ambitious educational administrator wanted to get a job there. Some hoped that simply by sitting at the feet of the master, a little of the magic might rub off on them; others that they would learn and contribute alongside greatness as part of a pioneering educational adventure. Clegg always had an infallible eye for spotting who was in which camp. He was good at making outstanding appointments and in the important early days of his time in the West Riding, like the present-day football manager, he recruited outstanding folk he knew from where he had worked before in Worcestershire, Cheshire and Birmingham. A high proportion of his appointments turned out to be inspired: indeed, they had to be because, as he was fond of maintaining – not altogether truthfully – he was no expert himself in whatever was being discussed or considered and preferred to leave matters to those people working with him who did know about the matter in hand. What he was good at was thinking aloud and asking good questions which, while supportive, extended others' thinking – a trait identified now as indicating very high-quality educational leadership (Fullan 2019).

It was said of Clegg that he didn't go to London to meet policy makers; they came to him. Edward Boyle, who visited and stayed at the Cleggs' house, told his civil servants that whenever they were making decisions or had a tricky issue to consider, they should ask what Mr Clegg would advise as 'the conscience of the education service'.[2]

What made Alec Clegg so great? Other contributors have chosen from the many issues on which his influence proved over time to be significant. My illustration of his impact rests on primary education, particularly in the junior years. His knowledge and insight came from his fascination with schools, teaching and learning, and their eternal task of 'unlocking the mind and opening the

shut chambers of the heart' – to quote Edward Thring, the Victorian educator whose writings inspired Clegg (Newsam 2014: 254–259). He was never happier than when visiting schools where he had the eyes to see and the wit to recognise genuinely good practice. Subsequently he would speak and speculate to others about what he'd seen. Such was his regard for outstanding teaching that nothing pained him more than to observe outstanding teaching which had never been recognised. 'To think', he once remarked on returning to the office, 'that she's been doing that for years and nobody has told her.' Nowadays we would call him an 'appreciative inquirer'[3] and, by being that, he encouraged a sense of collaborative creativeness about curriculum and teaching that was the unique hallmark of the West Riding.

The only time I ever met the man was at a meal after a memorable talk to Oxfordshire primary heads in December 1980, just 15 months after I had taken up my post there as Chief Education Officer. His talk had been spellbinding as he quietly acknowledged what he called the superior expertise of his audience, and prayed in aid by way of recompense the experience of his extended family:

> …which contains every kind of teacher and administrator in the education service including teachers in infant schools, grammar schools, colleges of education, the inspectorate, local authority administration… including such rare tasks as the governor of a school for wayward adolescents, a Cambridge don and many others. My grandfather, my father and I have between us covered the education service of this country since it began over a century ago.

His talk on that occasion illustrated his love of primary education on which his influence had been profound. He referred to Steward Street School in Birmingham where he had started his administrative career at the outbreak of the Second World War. His visit to it had proved seminal. He witnessed there a mixture of a focus on basic skills and a freedom of spirit that expressed itself in some astonishing children's art – he carried with him examples of children's art whenever he gave such talks – and musical and dramatic performance. It is not surprising perhaps that the headteacher of that school, Arthur Stone, was later an influential adviser in the West Riding. Stone also chronicled the work of Steward Street School in Ministry of Education pamphlet no.14, *Story of a School*, published in 1949 (with ministerial exhortation to primary teachers 'to go out and do likewise') and reissued throughout the 1950s. The pamphlet formed a link between the Hadow report in the 1930s and Plowden report of the 1960s by describing the reality of what the former had dreamt as possible and the latter celebrated as best practice. As Clegg wistfully remarked, 'Stone was paid £20 for a document which was printed and reprinted, and sold over 60,000 copies' (Clegg 1980: 5).[4]

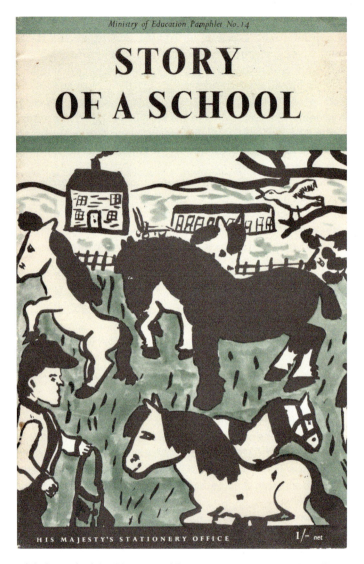

Figure 1.1 Story of a School, Ministry of Education pamphlet no. 14, 1949. London: HMSO

As he illustrated his talk that day with children's artwork, he recounted:

> I will never forget going into the school at South Kirkby where these paintings, the like of which I had never seen before, were on display at child height. I was forced to a conclusion which I had hitherto rejected – that almost all children must be capable of work of this quality. I could have

accepted it more easily if I could have stated that it resulted from expert tuition, but it was not so… it resulted from inspiration, encouragement and recognition rather than technique… I had a similar experience in a movement class in Castleford… within months an adviser sent me a memo about Thurnscoe School: 'The art is the best I've witnessed in a junior school. The awakened imagination and freed expression is beginning to produce a flow of language that cannot be stopped; whereas a child used to take 18 months to fill a composition book, he will now use one-and-a-half books in a term and Mr Jones is approximately £10 overdrawn on his capitation allowance with the spring term still to go'.

Lest it be deduced from the language that Clegg's insights are time-specific with their frequent male imagery,[5] it should be said that he relied heavily on, among others, two female advisers. Diana Jordan, whom he recruited from Worcestershire where Clegg had been deputy, after some time in hugely influential advisory work in schools, established Woolley Hall. This was the first centre for what we would now call professional development, where teachers would exchange ideas and where West Riding inspectors and HMI together ran courses that changed the approach of almost all who attended them. The other female influence, apart from his wife whom he met teaching in a Birmingham infant school, was Rae Milne who as Clegg said, 'was as knowledgeable about these matters [primary education] as anyone I have ever known'. It is an incident in which she was involved that illustrates both the essence of what he thought about primary education and a technique he deployed to make what he believed clearer by describing what he did *not* believe. So he asked her to write about what a bad progressive school looked like (Clegg 1980: 97). 'A wet playtime all day' is how she started before expanding on the detail as 'work that is ill-mounted and badly displayed, too much tissue paper filling in outlines drawn by the teacher, animal slums, noisiness that comes from lack of purpose, writing which is artificially fancy, meaningless displays, groups working side by side on incompatible activities and of course work of a low standard'. Clegg believed that the teachers in such schools too often mistook activity for learning and sentimentality for compassion. They kept inadequate records, organised their work badly, failed to pre-select pupil tasks so that they had too much choice, and failed to understand the difference between effort and achievement by not having the eyes to see or deploy the right questions.

That evening almost 32 years ago, when I met him for the first and only time in Oxford, was particularly pertinent for me because Oxfordshire had recruited Edith Moorhouse from Hertfordshire to produce a parallel transformation of what went on in the primary school. Moorhouse hailed from and had been trained in the West Riding, which she admired enormously. The recipe in both places seemed to involve advisory teachers, who spent all of their time in schools alongside teachers and an inspirational HMI – in the West Riding Christian Schiller, in Oxfordshire the artist Robin Tanner – coming together with teachers

and headteachers of an evening to learn from each other. They always reaffirmed their shared values through their behaviour one to another and in their dealings with others: there was often an unspoken understanding of what underpinned successful teaching and learning. I had already seen enough to recognise both the genuine progressive school and the false impersonator and I had even then in my thirties as a young Education Officer learned much about Clegg from other sources. I was accompanied to my meeting with Clegg in 1980 by John Coe whom Oxfordshire had also recruited from the West Riding as Edith Moorhouse's successor, and who recently on hearing that I was writing this chapter, summarised Clegg's impact on schools: 'He was always welcomed into schools not as the Chief Education Officer but as our friend Mr Clegg'. Earlier in my career, I had worked as deputy in different contexts to Leonard Browne and Peter Newsam who had both themselves at different times worked as deputies to Clegg in the West Riding and talked a good deal about Clegg and his habits, often to illustrate how better to go about things. Peter Newsam in particular has been a source of information and inspiration, and his chapter on the West Riding illustrates the essence of Clegg's qualities as a successful leader and manager in all sorts of contexts, including that of operating within the political control of local government (Newsam 2014). Local government officers work in a very different context from civil servants. Unlike the latter, they are expected to be experts mostly with a background in the profession for which they are responsible – in Clegg's case, education. Inevitably, in those days at any rate, they took the lead, rather than the councillors, on the development of policy and were as much in the public eye as the councillors whom they served.

It as well to remind ourselves that in the post-war years the contexts in which LEAs properly involved themselves were many and varied. I have chosen to focus on primary education but Clegg was responsible for not just more than a thousand primary and secondary schools. He had a dozen or more colleges to worry about, whether of further education, newly established as a result of the 1944 Education Act, or for teacher training (later Colleges of Education). There was the provision of what was called Advanced Further Education (later higher education and the world of the polytechnics) and a Youth Service to establish as well as a network of Youth Employment Officers (later the Careers Service). Clegg managed to persuade his county councillors to purchase and refurbish a set of Country House estates, such as Wentworth Woodhouse and Bretton Hall, to house some of the teacher training establishments as well as a residential centre for adult education, which was the inspiration for Northern College in Wentworth Castle near Barnsley. Woolley Hall, described by Clegg as a 'gem of a building', became the first residential and day centre for the training of teachers in service. His deputy, Jim Hogan, a pioneer of residential 'outdoor educational' experiences for schoolchildren, oversaw the acquisition and maintenance of centres for that purpose as well as ensuring that the management side of the West Riding education service ran efficiently and smoothly.

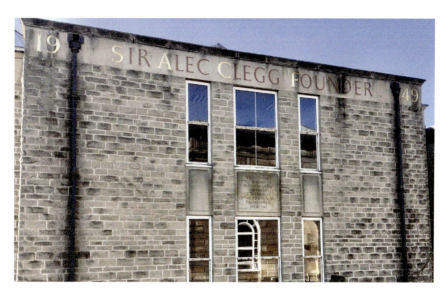

Figure 1.2 Alec Clegg building at Bretton Hall College, 1995
Photo: Peter Cunningham

Besides being innovative and creative himself, Clegg drew out the same qualities in others. More than one witness refers to his ability to appoint good people and then 'allow them to get on with the job' within a culture which one of his sons described to me as a 'moral imperative to live up to his enthusiastic expectation that you would succeed in what you are doing'. According to Peter Newsam, on appointing a new senior colleague he would take them aside and ask them not to hesitate if they ever got really worried about something in their work or private life 'to come and talk to me and I'll help in any way I can because what we are engaged in here is so important that we none of us can allow anything unnecessarily to get in our path' (Ibid.).

It is interesting to attempt a retrospective analysis of Clegg's practice (who, as I have earlier pointed out, had none of the advantages of being able to read the academic studies of leadership and management which have blossomed since the end of his career), against what is now seen as the essentials of successful educational leadership. Michael Fullan (2001) has written most extensively on the subject and is a reliable and perceptive witness on what works in terms of system leadership (Ibid.: 4). In his *Leading in a Culture of Change*, he sets out a schema on some general qualities of leadership, not context bound. He states that these qualities are moral purpose, understanding change, relationship building, knowledge creation and sharing, and coherence making. These should be, in terms commonly used by Fullan, encircled by energy, enthusiasm and

hope, backed by external and internal commitment. Clegg's working life was an illustration of this theory in practice.

So far as '*moral purpose*' is concerned, the educational leader must be seen as authentic with values which show a matching integrity among 'what s/he says, what s/he does and who s/he is' (Brighouse and Woods 2013: 55). Clegg achieved this by his thoughtfulness towards others personally and by a constant and consistent set of messages over his many years in the West Riding. He scripted and kept over 100 speeches[6] and contributed many articles to the *Times Educational Supplement*. He wrote and co-authored books – most revealingly about his priority concerns such as *Children in Distress* with Barbara Megson (1968). These many publications, especially *About Our Schools* (1980) written at the end of his career, leave no doubt about his beliefs: he was in schools at least one day each week in term time: a chapter in his book is titled 'Schools which changed my views'. He was fond of quoting the Victorian headmaster Edward Thring, who also had a powerful influence on his educational thinking. In respect of the impact of poverty on the less fortunate, Clegg quotes Thring approvingly: 'It is an axiom that a system which takes no account of the weak is no part of God's true world. Gather up the fragments that remain, that nothing might be lost' (Newsam 2014: 255).

Everybody could see his commitment to improve the lot of what he called 'those who learned more slowly' or who were held back by poverty. The EPA (Education Priority Area) scheme would never have come to fruition in South Yorkshire without his input to A.H. Halsey's 'research-into-practice' proposals backed by central grants. In the question of *relationships* and *communication* he was naturally authentic and gifted. He used stories which became familiar with repetition, and which conveyed appropriate educational messages to notable effect both through writings and in speeches. As an addendum to this chapter, I have provided Clegg's own educational fable – the 'Fable of Fred' (below) – which speaks to educators in whatever age they live. It reveals Clegg's views vividly. And it should be remembered he did this before local radio stations were established, before there was easy car access to regional meetings for headteachers and before the internet and mobile phones – indeed, one of his first managerial tasks in the West Riding was to ensure every school had its own landline phone. He lived in an age before the electric typewriter, when printers and photocopiers were the stuff of science fiction and where teachers relied on new-fangled Banda machines and Gestetners for duplicating documents and worksheets. Yet he conveyed his feelings and beliefs impressively. Nobody could seriously doubt his commitment to the West Riding: he was CEO for almost 30 years and punctuated the time with proud but modest accounts of what educators in the authority had achieved, in the form of books about *The First Ten Years* and so on (see Chapters 2 and 3).

What Fullan calls '*external and internal commitment*' is testified politically not merely at a national level by Edward Boyle's comments about Clegg being the 'conscience of the education service' and the fact that he was invited to give

the main speech at the centenary celebrations in Central Hall Westminster of Forster's 1870 Education Act (Clegg 1970),[7] but also at a local level by Peter Newsam's moving account of the deathbed scene of Mrs Fitzpatrick, Chair of the Education Committee, when she summons 'her boys' and reminded them, in a letter, of their duty once she had gone to sustain the legacy of the achievements in the West Riding (Newsam 2014: 264). Securing *commitment* depends on, and flows from, making and sustaining relationships with other key stakeholders. Clegg's memoir is revealing in this respect, where chapter headings in the second half of the book devoted to 'people' tacitly imply those whom he sees as vital to the successful completion of his work. 'Children', 'Teachers', 'Parents', 'Inspectors, Advisers and Administrators' and 'Councillors' are predictable, but 'Caretakers' less so to the modern eye. Once again, however, some consideration of context explains exactly why Clegg confesses that while 'pressure of work' occasionally precluded his attendance at teacher conferences, nothing got in the way of his attending those for caretakers. It was not just taking Thring's dictum of 'taking my stand on detail' (Clegg 1980: 121) seriously, important though that was to Clegg as a leader who knew that to neglect management was to undermine leadership – he understood that intuitively without any help from subsequent research and literature – but in his day, school caretakers were employed and run directly by the LEA not the school. The school environment mattered to children and teachers alike and Clegg was determined it should be as good as it could be and that was why 'caretakers' were high on his priority list. In short, at the level of a system as large as an LEA with thousands of educational provisions and staff the leader necessarily becomes a 'remote' leader and that's the last thing any leader wants or ought to be. It therefore requires Herculean efforts in communication coupled with an uncanny knack of knowing when, on what, and how to delegate – all made the more difficult if, like Alec Clegg, you are easily obligated. To sustain that successfully for nearly 30 years is remarkable. That he was successful in doing so is evident still in the classrooms of the former West Riding where his name and achievements are often warmly remembered nearly 50 years after his retirement. Indeed, teachers were so confident in his trust in them when he was in harness that, to use John Coe's words, they referred to him as 'their friend Mr Clegg'.[8] Maggie Farrar, at one time Director of the National College for School Leadership, told me as I was preparing to write this chapter that she recalled, as a child attending school in Keighley, 'my parents talking about him as though he was a family friend – a kind of kindly uncle who they saw from time to time. But I don't think they ever did – he was just a good famous figure'.

As for *'creating knowledge and sharing'*, the evidence is strong on all fronts – not just in the creative arts or the attention to in-service training of teachers at Woolley Hall but in a deep understanding of what helps 'school improvement' even though it was a concept which commanded little or no attention during his lifetime. The creation of middle schools, which required him to argue successfully for changes to the educational legislation, is one example.[9] His

global reach evidenced through visits and described elsewhere in this book (see Chapter 8) ensured that ideas about practice were shared and refined. In terms of educational policy, his concern for children who learned more slowly, which he initiated, has lasted to this day via various initiatives such as SPA (Social Priority Area) allowances incorporated into teachers' pay scales for teaching in such areas in the late 1970s, LAP (Low Attainment Project) in the mid-1980s, Education Action Zones, Excellence in Cities and City Challenge in the late 1990s or the current concern about 'closing the gap' in order to improve social mobility and 'equal opportunity'.

Fullan also refers to *'understanding change'* as crucial to successful leadership. Clegg lived in the period of post-war reconstruction and the development of the welfare state. It represented a change in the role of the state, which hitherto had been regarded as the provider of last resort and therefore required a cultural change which Clegg helped lead and establish. It was of course an age where change seemed to modern eyes to be more gradual and pleasant. His successors operated in arguably less favourable climates when the post-war consensus of 'trust and optimism' gave way to 'markets and managerialism' (Pring and Roberts 2015: 153–167) and wrestled with falling school rolls, diminished resources and the gradual dismantling of the role of local government in educational provision. But leaders can operate in their own time only, and in any case Clegg's memoir showed his capacity to anticipate the future and illustrates the many occasions on which he had to battle against the odds of hostile circumstances.

For his own and subsequent generations, Clegg was both the standard of excellence for the LEA Education Officer and a benchmark against which to measure one's own efforts. How often were you in schools, and when you were there did you recognise both effort and excellence correctly? Did you follow up? Were you being successful in employing people who empowered schools whatever the external climate? Were you supporting those in the office who knew more about a particular matter than you will ever know? How well were you handling the political interface: did you speak up when it was necessary and remain quiet when a word from you was superfluous? Above all, were you telling good stories, speculating about possibilities, and writing in places and in a way that would effect the spread of good practice? In short, was your example of educational living a model that would affect the behaviour of others in just the same way as the good teacher does in the classroom and the headteacher in the school?

Of course, the uncomfortable truth is that often we fell short of the standard Clegg had set us but we would have done so more often if his life and career – and the two were inextricably intertwined; he even took advisers on family holidays – had not provided us with such an inspirational and clear map. In Fullan's prescription for successful leadership, there is the suggestion of a need to surround activities with a climate of *'energy, enthusiasm and hope'*. Nobody reading his speeches, listening to his address in 1970 at Central Hall Westminster,

or taking note of Newsam's chapter quoted earlier, can fail to be impressed by his humanity, humour and generosity of spirit.[10] George Bernard Shaw might have been writing of Clegg in *Man and Superman* when he puts the following words into a character's voice:

> This is the true joy in life – the being used for a purpose recognised by yourself as a mighty one: being a force of nature rather than a selfish little clod of ailments complaining that the world won't devote itself to making you happy. I am of the opinion that my life belongs to the whole community and that for as long as I live, it is my privilege that I must do for it what I can. I want to be thoroughly used up when I die, for the harder I work, the more I live. I rejoice in life for its own sake. Life is no brief candle to me: it's a sort of splendid torch which I've got hold of for the moment and I want to make it burn as brightly as possible before handing it on to future generations.

It is said of leaders that they model behaviour which influences others: great teachers do so too. Clegg was both.

Addendum

Fred: A fable by Sir Alec Clegg[11]

About 100 years ago there was a small boy called Fred and he lived on an island with his father and mother and nearby lived his uncle and aunt. His father kept pigeons and bees and a garden of flowers and vegetables. His uncle was a forester and planted acre after acre of trees in rows. The boy did not go to school; there wasn't a school on the island, but his mother taught him to read and write and encouraged him to draw and paint pictures; she also recited poetry to him and sang to him when he was little. Every year he went to stay with another uncle who lived in York and had a passion for the history of the city, which he loved to illustrate by its walls, its churches and the objects of history which it contained, and he loved to take his small nephew to Malham and Gordale Scar and tell him about its geography and geology. And the boy grew up in understanding of many things.

Then one day a learned educationist visited the island and met the boy and was astonished at his understanding of many things and at the knowledge which he had developed round these things, and the educationist said to himself how wonderful it would be if every child in the land had the learning which this boy has built around the simple experiences which he has had with bees, pigeons, flowers, vegetables, forestry and a visit to York and Malham. The

learned educationist was amazed to find out how well the boy spoke, mainly because his mother read and recited to him and because he himself had read much about the interests which derived from his own personal experiences. And the learned educationist reasoned thus:

> *It is impossible for every child to lead the life that this boy has led and to develop the knowledge which this boy's way of life has given him. But what we can do is give the children all the knowledge that this boy has without the experiences.*
>
> *First of all we will look at his numerical and mathematical ability which he has gained from reckoning areas from odd shaped bits of land and working out the number of trees they will take, and from his mother's shopping expeditions, and from the measuring which he has to do in making pigeon-lofts and bee-hives, and we will reduce these to simple symbolic formulae and tables and make children learn a lot of them very quickly.*
>
> *Then we will take the boy's speech and writing which is so good and subject it to careful analysis and if we teach other boys whose writing and speech is not so good how to subject what they say and write to this kind of analysis they will realise how badly they speak and write and will promptly set about trying to improve the way they speak and write.*

'Then,' said the learned educationist,

> *we cannot provide every child with the bees and the pigeons and the flowers and vegetables which had taught this boy so much, but we can cause books to be written and force them to learn what is in these books. We will have books written about all that has happened in the history of the city of York and all that is known of the geography and geology of Malham and Gordale, and we will make all boys learn these facts and they will then have this understanding that our original boy had who lived with his father and his uncle on an island.*

So the learned educationist went home and divided out the boy's knowledge into parcels which he called subjects, and he called together a lot of clever men called Hall & Stevens, and Warner & Martin, and Durell & Palmer, and Potter & Ridout, and many others, and handed them a parcel of knowledge and told them to write a book about that parcel. And then he went to the schools and he said: 'I have met a very remarkable little boy named Fred who has derived great understanding from his bees and his pigeons, from shopping with his mother and listening to her recite poetry, from visiting and seeing and finding out about all the ancient buildings in York, and from trips to Gordale. His

understanding of these things had led him to read about them and derive great knowledge of them. What I want you to do is to reverse this process, give your boys the knowledge that you will find in the books by Messrs Hall & Stevens, Warner & Martin, Durell & Palmer, and Potter & Ridout, and when you give them this knowledge the understanding will follow.'

And so it came about that all over the land children were assembled in groups of 40 and made to learn the facts set out in the books written by Messrs Hall & Stevens, Warner & Martin, Durell & Palmer, and Potter & Ridout. And the learned educationist began to entertain a horrible suspicion that the reverse process didn't work. In other words, whereas the little boy named Fred grew in understanding because he started with experience and read to feed the interest which derived from it, those who started with the reading failed to develop understanding because the interest was not there; the facts were in a vacuum unrelated to the context of the lives of those who absorbed them. But the learned educationist thrust these horrible suspicions aside and said to himself:

The facts derived from books are making no impact because they are not properly learned. It is all these inefficient teachers who cannot impart facts that are causing the trouble. What we want is something wherewith to prod the teachers so that they impart more facts more efficiently.

So he said:

We will have external examiners who will set tests to the children to find out whether they have learned the facts. Those who have had facts imparted to them effectively will pass the tests and those who have not will fail to pass the tests, and when the lists are read out on the Speech Day the incompetence of the bad fact-imparters will be revealed to the world and this will act as a goad and make them impart their facts better in future.

But then before many external examinations had taken place the learned educationist died and he never learned whether or not the sound learning of facts about pigeons and bees and flowers and vegetables and York and Gordale produced the same understanding in the mass of children that practical experience of them had given to Fred on his island with his mother and father and uncle. Fred died as well, but once all this machinery had been put into motion it went on turning. Children were still brought together in groups of 40, and Messrs Hall & Stevens, Warner & Martin, Durell & Palmer, and Potter

& Ridout, and thousands of other people all wrote books full of more and more and more facts, and these were forced into millions of children and the capacity of the children to disgorge them at will was tested by thousands of examiners hired to do this job by scores of external examining agencies. And what was entirely forgotten was that all this started in an attempt to give the understanding which derives from experience to those who have never had the experience.

Then in 1931 a Government publication known as the Hadow Report on the Primary School made a statement which harked right back to Fred who started all this by stating that education should be thought of in terms of activity and experience, and not in terms of knowledge to be acquired and facts to be stored, but this made no impact whatever on the schools at that time. However, in due course a few, a very few indeed, intelligent teachers came to take a cool look at what was happening and they realised that for the vast majority of children the majority of our educational processes add about as much to the mental stature of our children as a diet of sawdust would add to their physical stature. And things began to happen. Children were less and less told how to do things and were encouraged to do things in their own way. They were given fewer and fewer facts by the teachers and encouraged to find out more and more for themselves.

Above all, there was a realisation that it is experience rather than factual knowledge which is the springboard to interest and understanding, and the problem then arose as to how to give experience to batches of 40, the kind of experience which had produced the understanding in Fred which had first excited the interest of the learned educationist. It was decided by these wise teachers that they would keep pigeons and bees in the school, where they would also grow flowers and vegetables, and that they would take the school to visit York and Malham, and that in the meantime they would bring a great variety of material into the classroom. They would bring Roman pottery and glass which the children could handle, they would show models of Roman villas and forts and walls and gates, and heating systems, and before the school went to Gordale and when it came back the pupils would see models of the geological formations they were going to visit, and they would handle specimens of the rock they found there. And in this way, many of the pupils in the school gained the understanding which derives from doing, and were no longer content with merely remembering what they had read. And thus, it was that by the year 2000 AD many, many children who did not live on an island grew up like Fred.

Notes

1 In the period in which Clegg operated (1945–1974), the Chairman of the Policy and Resources Committee of the County Council was the acknowledged most powerful elected member who, if the authority was organised along party lines – as was the case in the West Riding – was answerable acting as Chair to his political group.
2 Edward Boyle, Secretary of State for Education and Science 1962–1964, later as University of Leeds Vice Chancellor, maintained a trusting friendship with Clegg (Darvill 2000: 177, 271–272, 290).
3 Cooperrider, D. L. and S. Srivastva (1987), 129–169. Here and elsewhere, Cooperrider and Srivastva have written about the need to balance Appreciative Inquiry with Problem Solving, both clearly a necessary part of management. The first, which *creates energy*, involves four stages of: (i) identifying correctly good practice; (ii) dialoguing about possible even better practice; (iii) seeking and visiting other practice; and (iv) deciding on further action. The second, which *uses energy*, also involves four stages of: (i) identifying the problem; (ii) analysing the causes; (iii) brainstorming possible solutions; and (iv) deciding on action. Cooperrider and Srivastva argue that you need three parts of Appreciative Inquiry to every one part of Problem Solving in order to preserve a positive and hopeful culture. In retrospect, Clegg's practice follows similar patterns whether in his observations of teachers in schools or in his illustrations of solving problems in the West Riding's administration.
4 See also the archived collection of Clegg's speeches at the NAEA (note 6 below).
5 To a modern eye, his use of language appears insensitive but that is to overlook the change in linguistic conventions over time in response to a less deferential and more gender-aware society. In practice for his time Clegg was extremely aware of the subtle impact of language use on audiences and over time its impact on behaviour. As Newsam, himself a beautiful example of good and persuasive language, put it when reading the 'Fable of Fred', 'I wish I could write as simply as that, I found myself thinking when I first encountered the cadences that floated their way through the rest of the fable' (Newsam 2014: 259).
6 Clegg's speeches, including those given on trips to other countries (see Chapter 8 on Clegg and global education) are found in the NAEA Sir Alec Clegg collection.
7 The text of this speech comprises the final chapter of Clegg's memoir (Clegg 1980: 160–178).
8 In an e-mail from John Coe to the author dated 29 May 2019: 'I have been reflecting on our recent conversation regarding Alec Clegg and what made his work and his person so long enduring in everyone's minds. Most important of all was his commitment to children who lacked advantages in life. This was coupled with an unshakeable belief that teachers were essential agents of change. Most of his time in the West Riding was spent in classrooms and schools who knew and supported his priorities. Major developments… were prompted by his wish to widen the horizons of the many vulnerable children in the… county. Needless to say, he had a strong personal yet unassuming charisma… admirably suited to the tough but tender nature of teachers in Yorkshire'.
9 It may be argued correctly that the middle school movement is in retreat after the National Curriculum and assessment arrangements with its emphasis on key stages and tests at 11 caused many authorities to abandon middle schools.

10 Clegg, A. (1970) The Centenary of Public Education. Speech at Central Hall Westminster on the occasion of the centenary of the 1870 Education Act. (Audiolink available at Derek Gillard, Education in England, www.educationengland.org.uk/documents/speeches/1970clegg.m4a.)
11 Written in 1965, the year following publication of Clegg's *The Excitement of Writing*, a collection of children's writing with commentary. The book had a widespread impact, going through seven impressions in its first five years, and provoked appreciative comment from many experts on children's language development, in Britain and around the world. (Clegg 1964; Darvill 2000: 156–170).

References

Brighouse, T. and D. Woods. (2013). *The A–Z of School Improvement*. London: Bloomsbury.
Clegg, A. (1964). *The Excitement of Writing*. London: Chatto and Windus.
Clegg, A. (1980). *About Our Schools*. Oxford: Blackwell.
Clegg, A. and B. Megson. (1968/1973). *Children in Distress* (1st and 2nd eds.) London, Penguin.
Cooperrider, D. L. and S. Srivastva. (1987). 'Appreciative inquiry in organisational life', in *Research in Organisational Change and Development*. Vol. 1. ed. Woodman, R. and W. Passmore. San Francisco: Jossey-Bass, 129–169.
Darvill, P. (2000). *Sir Alec Clegg: A Biographical Study*. Knebworth: Able Publishing.
Fullan, M. (2001). *Leading in a Culture of Change*. San Francisco: Jossey-Bass.
Fullan, M. (2019). *Nuance: Why Some Leaders Succeed and Others Fail*. London: Sage.
Newsam, P. (2014). *The Autobiography of an Education: Part One. From Bangalore to the West Riding*. Pickering: Greenlea Books.
Pring, R. and F. Roberts. (2015). *A Generation of Radical Educational Change*. London: Routledge.
Rutter, M. et al. (1979). *Fifteen Thousand Hours: Their Effects on Children*. London: Open Books Publishing Ltd.

Chapter 2

Creativity and redemption
The work of Alec Clegg in post-war England

Martin Lawn

Clegg was a major education figure in the post-war period. The notion of a 'figure' in the education 'policy-scape' has changed meaning considerably over recent years. 'Figures' in education in the past were usually people – headteachers, inspectors and teachers – who were significant in the landscape and who produced the narratives, reports, texts and even novels upon or about their education service. They appeared to 'produce' education through their character, stories, daily interactions and judgements, and were known for this. They personified and represented the values of the service. They were few in number but had influence. Today the figure has changed, and the landscape has been reconfigured. Now the figure is not human but numerical, tabular and digital. Clegg worked in a period of transition, still able to present a moral and educational argument although increasingly interested by the need to present evidence, preferably the 'facts' or data, through inquiry.

I met Alec Clegg in what was, I realised recently, probably the last year or so of his tenure in the West Riding. I was helping to make a TV programme and study unit for an Open University Course (E203) on West Riding education. I was pleased to return to Yorkshire as I had grown up in Leeds. Now as a researcher, in Wakefield, headquarters of the education service, I had only just begun to collect documents on Clegg and knew very little of his reputation except through his journalism. I had trained as a junior/secondary teacher, taught in London a few years before, and was still discovering the nature of educational research. Whatever I thought a Chief Education Officer (CEO) would look like, I was pleased to meet Clegg. Sent by lift to the top floor, we found a corridor lined with children's artwork on both sides, and a figure emerging from a far door. The next moment, he was standing beside us, introducing us knowledgeably to the framed paintings, one by one. This was impressive. My pleasure was increased seeing Yorkshire education in a good light, discussed by someone I assumed to be a native speaker.

Filming took place in Balby Street primary school, an old building among terraced houses, some of which were under demolition. One scene was filmed of a junior class observing, discussing and drawing the heavy machinery in

action. Their imagination was turned by the teacher towards an emotional and expressive response in words and drawing, heavily loaded with metaphors of myths and monsters. I admired what the pupils were doing, light years away from my own early experience of primary schools in Leeds. But the teacher I had become, teaching social studies in secondary school, influenced by new 'Schools Council'[1] urban studies projects focused on contrast and comparison, standing in an area of social deprivation and coal mining, the teacher in me wanted social critique and engagement with life experience. During the course of researching this chapter, I realised that Clegg himself was an educational amalgam of creativity and social critique. He wanted these children to thrive, working to encourage this at all levels of primary and secondary, but he also wanted the unfair and obstructive practices of a class-based society to be revealed and attacked. Children's potential had to be released, fostered and protected.

Clegg's stature regionally in the West Riding, and nationally among his fellow education officers, was high. Our understanding of his importance, like theirs, rests on his ability to articulate critiques, generate and manage innovations, the recollections of his colleagues, and the institutional frameworks created in his time. His public and national engagement with educational issues in state schooling during the 1950s and 1960s was matched by only a very few directors of education at the time. He was a significant champion of education when most CEOs were quietly dutiful in their bureaucratic efficiency. Clegg was invited often to speak to local and national audiences and these speeches are a rich source of information on his views and actions. His articles in *Education*, the journal for leaders of Local Education Authorities (LEAs), are sources for understanding problems and, together with indications from the major West Riding reports, reveal the way he justified or provided evidence for his arguments.

In his long career, Clegg managed the education service across a series of national priorities, beginning with residual problems of wartime damage and disruption, and designing a post-war education system; at the same time, he was advising and encouraging teachers and managers about what could and should be done in schools. In his later years as CEO, he dealt with the onset of retrenchment in education and the decline of local industry. Overall, Clegg worked within an emerging social democratic, post-war narrative in England, of the professionalism and responsibility of the teacher, the construction of a new society, of equality and fairness, and the role of a democratic state in supporting and creating its citizens. The English education system was described at the time as a 'central system, locally administered' or a 'partnership between central and local government, and the teaching profession'. These ideas are present in Clegg's writings, not as shibboleths, but as commonly understood ideas which needed nurturing. He went beyond the empty repetition of partnership ideas, and by humorous observations and forthright argument, with evidence and research, he challenged his audiences about the real problems of the time.

This chapter is concerned with Clegg's perspective on education and schooling: how it emerged and became strengthened over time. Based upon the role of school as a creative force in society, and the enabler of individual growth, his viewpoint was also involved with problems of class, schooling and society. This was not a separate argument in his thinking; it was bound together with his encouragement of school change and freedoms. Good schools and teachers were the answer to societal dysfunction and inequality. They were *the* answer and not *an* answer. Even more striking than his views on education, written from within the system, were the audiences he addressed. Like him, these audiences were managers, administrators and inspectors of the system. They were not part of social movements or university experts. They were a significant and influential group: his peers. Using three published lectures, written in the 1960s: 'Attitudes' (1962), 'Dangers Ahead' (1965) and 'Education in Society' (1970), with additional information from West Riding reports, my intention is to explore Clegg's social and educational thinking as one perspective, beginning with his early experiences in Birmingham and Worcestershire, leading on to Yorkshire's West Riding, its management and prospects, and later his writing on the state of English education.

Experience

Clegg was educated at Long Eaton Grammar School, where his father was headmaster, as well as at the Quaker Bootham School, York, and started his career in another grammar school, where he taught for five years. While this, combined with graduation from Clare College, Cambridge, validated his entry into local authority administration, it does not explain his educational radicalism. How did Clegg manage to develop his educational philosophy, his perspective on learning and schools? He described his focus as:

> the child's loves, hates, enthusiasms, hopes and fears, his imagination, his creative force, his initiative and a whole host of qualities which we can neither measure nor examine and which, because of this, we tend to grossly undervalue, [but which] mattered above the facts of the syllabus.
>
> (Clegg n.d.)

This viewpoint was rare in a senior administrator both at the time and later. Along with the national school inspectorate, Her Majesty's Inspectors (HMI), administrators were chosen for their judgement; that is, as graduates of Oxford and Cambridge, they had to apply classically trained judgement with authority. When they did so, it was likely they would express a preference for either a classical curriculum, or a curriculum and pedagogy suited to elementary school pupils. It was unlikely they would express a preference for new progressive ideas emanating from the 1920s, as these were outside the education mainstream and a cause for concern to a regional director of state education. How did an

educated administrator develop this emphasis in his work? What steered him in this direction?

He started working as an administrative assistant in Birmingham in 1936, in the corridors and panelled rooms of the Education Office in Margaret Street. In those days, and until the 1970s, no expenditure by schools was possible unless allowed by the CEO. Even in the 1970s, while there were over 400 schools in the city, permission to purchase short curtains for a staffroom required a typewritten note of agreement (Lawn 1997: 114). While there were very few assistant administrators, there was a pool of typists. Clegg moved on to Cheshire briefly and then Worcestershire in 1942, meaning he gained experience of administration in an urban and a rural county. He left Margaret Street in 1939 and two years later the surrounding area including the Council Offices next door was bombed. While Birmingham was heavily bombed and many schools suffered bomb damage, Worcestershire continued with only random and light bomb damage, able to develop its education practice. For example, the noted HMI Christian Schiller organised summer schools in Worcestershire when Clegg was an education officer there. One of the course tutors was Arthur Stone, a Birmingham teacher who might have been known to Clegg from his time in Birmingham. This was probably the first event in a new direction in Clegg's thinking about education, involvement with Worcestershire summer schools and with Schiller, a major catalyst in new thinking about children's creativity, on literature, graphic and performing arts. Schiller worked closely with his colleague Robin Tanner HMI, printmaker and pioneer of children's art in schools.

> For ten days teachers would paint, write poetry, perform movement and mime, all intended to boost their image of their own potential, so that ultimately, they might heighten expectations for their children.
> (Griffin-Beale 1979: xi)

Clegg visited Stone's school in Birmingham with Schiller. Stone had become head of Steward Street school in 1940 (Burke and Grosvenor 2013). He described the school's local environment as poor-quality, crowded accommodation with few bathrooms, bounded by factories, and the nearest park a half-mile away. It had a 'stark ugliness' (Stone 1949: 7). One biographer of Clegg observed that in Worcestershire he came to understand what it meant to be part of a humane education service. The broad experience from these three Education Authorities gave him some insight into the contrasting social ambience of local districts, and he committed himself to the welfare of children, alert to the many inhibiting situations they could suffer (George 2000: 17, 30, 158).

The roots of Clegg's thinking on creativity and children, and his reflections on schools, may well have been due to conversations that he and Schiller had

together in Worcestershire between 1942 and 1945, Clegg as Worcestershire's Deputy Education Officer and Schiller as a district HMI for the county. Clegg said that Schiller 'exercised the greatest influence of any single person on the development of modern English primary education' and possibly upon himself (Griffin-Beale 1979: x). County education offices had few personnel (often less than a handful in this period) and Schiller dealt directly with the Director of Education on school business, but with Clegg in discussions on education (Griffin-Beale 1979: xiii). Schiller wrote little but made clear that his significant experience as HMI in Liverpool in the late 1920s and early 1930s exposed him to hungry, poverty-stricken children in very large classes and dilapidated schools.

It is these two influences upon Clegg which surface in his West Riding work: the experience of creative arts in the school and how to embed it, and the inequality of its social conditions. Arriving in early 1945, he soon became the youngest CEO in what was the third largest Education Authority in England. It stretched from Sedbergh in the north-west, past Ripon and Harrogate, along to Leeds and onto Sheffield in the south. The cities were not subject to the county, but most significant towns were included, centring on Wakefield, the administrative centre. It was also varied in landscape from the valleys of the Dales to the southern industrial woollen manufacturing and coal-mining districts, with many small towns and villages. It was an area where

> 'great contrasts' could be found between the more densely populated industrial regions in the Yorkshire coalfield to the south-west, which contrasted with the rich agricultural and less densely populated areas whose level topography contrasted with that of the Pennine Hill regions.
>
> (Hobson 1921: 2–3)

The greatest contrast was in the cultural and political outlook of the different areas and social classes on the one hand, and a need for a unity of purpose and agreement in the policies of the Authority on the other.

> When I was appointed as Deputy Education Officer and, within months, as Chief Education Officer of the West Riding, one of the largest Authorities in the country, I had to forget the gentler qualities of Worcestershire and face the tougher facts of the coalfields and wool [manufacturing] valleys of Yorkshire.
>
> (Clegg 1980: 139)

To move from the deliberations of a quiet county and the peace of his home near the rural Worcestershire town of Ledbury, to the mining villages and mill towns in the south of Yorkshire was a journey across the extremes of England, then and now. In 1951, the West Riding contained over a million and a half

Figure 2.1 Denaby Main in the early 1970s, and rural landscape of the West Riding

Denaby Main, a colliery village from Victorian times known for extreme poverty and poor housing. In 1968, the colliery closed, causing large-scale unemployment. Identified as an Educational Priority Area (EPA), the Red House project for community education was the subject of an Open University documentary film. Rebuilding of houses on a large scale was begun, but the urban environment suffered meanwhile. There was starkly contrasting idyllic Yorkshire moorland nearby, alongside a landscape of industrial decline.

Martin Lawn photo collection

people with 1,300 schools and 300,000 pupils. In addition to over 100,000 students in LEA further education colleges,

> the service included optional nursery schools for children under five years of age, compulsory education for children of 5 to 16, optional schooling for youngsters beyond that age, and Technical and Teachers' Colleges for older students. We were responsible for all the education in the area, except that provided by the Universities and by the independent schools, which cover perhaps 5 percent of our school population.
>
> (Clegg 1974b)

The West Riding was a major enterprise requiring strong political control and administrative expertise, and what this LEA argued for or against was nationally important. Clegg maintained his connection to Schiller, soon to be made

the national Staff Inspector for Primary Schools, and to Stone, whose *Story of a School* was printed and sent to every school twice over by the Ministry; a follower of Rudolf Laban, Stone described his curriculum centred on movement, dance and the expressive arts. This official pamphlet was hugely influential nationally for more than two decades (Stone 1949). Whether the Education Committee knew what it was getting in 1945 is a moot point. Clegg must have developed a good sense of the Committee's politics, its members and the communities they served:

> the political and leadership skills required to navigate the political environment of the West Riding should not be underestimated. Labour and Tories had strongholds in different areas of the county and political control of the authority changed often. This required Clegg to be a consummate political operator who could articulate a vision and gain full support for it from both the Labour strongholds of the south Yorkshire coalfield and the Tory heartlands of rural north Yorkshire.
> (Wood et al. 2018: 306)

So, the combination of a powerful Education Authority, good management, a clear educational sense and practice, and a select team of people, allowed Clegg to lead 'the way in a focus on primary education and the arts' (Brighouse 2002: 188). Education Authorities had the wind of change behind them and could innovate if they had the will, the budget, the leadership and the expertise. The West Riding was in a good position to lead in the creative arts and develop leadership, institutions and expertise across its area of responsibility;

> whether in their everyday curriculum, or in access to the peripatetic music services, or the youth orchestras and other ensembles which became a feature of almost all LEAs' central activity.
> (Brighouse 2002: 189)

If the West Riding can be viewed as a network, then Clegg instituted a number of points in which teachers and advisers could meet: they include Bewerley Park Camp School (1945); Bretton Hall (1949), a teachers college and centre for the arts; Woolley Hall, which opened in 1952 as a residential teachers centre; Buckden House (a joint venture in outdoor education with Bingley Teachers College); and Red House, Denaby, formed in 1969 as a multi-professional project in an Educational Priority Area. This local network of forums and projects for educational innovation gained strength and earned prominence within the LEA and nationally.

It was the case that the 1944 Act did not result in immediate changes across England. Clegg was regarded by the Ministry of Education as a key point of reference on new ideas for education; Stone's pamphlet was commissioned by the Ministry after Clegg had brought him to the West Riding. In his *Yorkshire*

Post obituary, Clegg's sense of humour and his ability to articulate complex ideas were said to have enabled him to gain the 'enthusiastic co-operation' of the Education Committee and his shrewdness in selecting advisers, his ability to get the best out of them and the 'creative and anti-bureaucratic spirit' in which he led his administrative team allowed many of his ideas to be fulfilled (Cook 2000: 97–98).

Clegg assumed the role of CEO in 1945 against a backdrop of post-war England, an era of optimism in which it was anticipated that people's wartime sacrifices and the defeat of fascism would be rewarded with increased access to education, universal health and welfare provision leading to a more equal society. Schools in the West Riding had to be refurbished, if possible, or temporarily rebuilt, later to be newly designed and built. War damage had to be repaired, the post-war 'bulge' in child births accommodated, raising of the school leaving age (to 15 from 1944, 16 in 1972), and school mergers managed. It was also a period in which the education system came to be described as a partnership between central and local government, and the teachers. For Clegg, this partnership was part of his daily and strategic work, not often remarked upon in his writing; partnership with teachers, however, featured in nearly all his writings. Teachers were the audience and the exemplars, the innovators and the encouraged. During Clegg's long and influential leadership of the LEA, the economic and political realities changed, central government became less aloof and more interventionist, and proof of success was demanded increasingly often.

Writings and addresses

Fruitful sources for understanding Clegg include his writings for *Education*, the journal of LEAs and their officers. He wrote on a variety of subjects, including sport in schools, and a short piece on the weakness of programmed learning. In three articles in particular, his wide-ranging views and critiques of education come clearly to the fore. They are not so much about what his LEA had achieved than the problems of education and society. They cover ground from curriculum and pedagogy, social exclusion, teachers and democracy, to the evaluation of success. Three papers reflecting this range, and all delivered as lectures, are selected here. Two appeared in the journal in 1962 and 1965, and one was published independently by a distinguished charitable trust in 1970, during a decade that saw the height of his national influence.

Addressing the renowned and influential North of England Conference in 1962, he spoke of 'Attitudes' (Clegg 1962). It is clear that Clegg, though not religious, had a secular approach to education with a strong moral perspective, in which his 'ex-cathedra' statements represented a teacher among teachers, but as first among equals. In this lecture, published in *Education*, he discussed social stratification in the early years of the century that he himself had experienced, when each social class had its own standards of behaviour, different relations with the church, and displayed jingoism. One reflection recurs in different forms

later on, the idea of the submerged poor, the unacknowledged possessors of poverty, disease and wretchedness. Authority was represented by the church and the chapel with compulsory attendance as he himself experienced when young.

> We respected authority and knew who wielded it in the district in which we lived.
>
> (Clegg 1962: 75)

New secondary schools were being created but:

> …great care had to be taken that not too many of the lower orders were extracted from their station – 10% was quite enough. As for the rest of society, anything that was done must on no account cost money.
>
> (Ibid.)

Then he compares his childhood period with the early 1960s. It is about improvement:

> disease and poverty as they then were have virtually gone. Authority as we once knew it has gone. The influence of church and chapel has declined. It is not easy any more just to sack a man, neither is it easy to starve him into submission.
>
> (Ibid.)

Our view from the 21st century may differ, but he was writing from the high point of post-war improvements in social relations and, as we now know, before they started to erode. He went on to make an interesting aside:

> Gradually we built our post-secondary [grammar] schools… by 1930 we had overdone it and there was considerable unemployment in the teaching profession.
> But by and by vast new industries… built up a demand for the kind of folk who previously went only into teaching. Now we can't get enough and the carefully contrived dam of the 11-plus is in fact holding back too many and we are having to syphon them off from behind it by developing extended courses in Modern schools.
>
> (Ibid.)

The '11-plus' selective test for entry to secondary schools had become a problem, acting as a control valve on opportunity, and its underpinning idea of intelligence as a limited quantity forced schools to invent new extension courses for able children.

Clegg noted that affluence was far from evenly spread. He wrote to a dozen headteachers asking about examples of the home background of the pupils.

Generally, stories were returned about violence, sex and undernourishment. In what he referred to as 'squalid homes', families were violent to the children or sexually abused them, which produced lying, bullying and vicious pupils. He suggested that more research was required on the percentage of pupils in schools who grew up in such circumstances. In turn, he condemned the sexual revolution of past decades and the exploitation of children. He argued that in a school with high standards, these social problems wouldn't occur. This idea of a school as the foundation and the builder of society emanated from Teachers College New York in the 1930s, and in particular in the work of George Counts and his *Dare the Schools Build a New Social Order?* (Counts 1932). Counts had argued that educators must participate in rebuilding democratic traditions and prepare pupils for life in a rapidly changing society. Clegg's critique took schools to be the radical agents of change, more significant than social movements and state legislation. This was a radical view, in its time and for its audience. For Counts, if society was not working or out of control, good schools were the solution.

So, how were good schools to be achieved, and society renewed? Clegg offers five points of action. Firstly, it is not through religious education nor the sacred scriptures, but the influence of behaviour and attitudes set by headteacher and staff, and a compassion for children. Teachers would be the shock troops, with high morale and training to undertake this. Teachers were the key. Secondly, Clegg was opposed to school subjects which are there simply for purposes of examination or tradition; instead, subjects should be taught for imagination, the development of the mind, and enjoyment. Teachers again were the key. Thirdly, following small-scale research on schools, both formal and informal, he argued that delinquency was higher in the products of formal school. So, teachers must produce new forms of informal pedagogy. Fourthly, based upon other inquiries, he argued that streaming was harmful, not on the grounds of attainment but from the social consequences of failure. Fifthly, authority and discipline, and even caning, must be replaced by consideration and respect. All in all, in sum, it was vital that schools need a well-paid taskforce of highly competent teachers and a system of in-service training for teacher development, including improvement of poor teaching.

In the second of Clegg's papers, 'Dangers Ahead', an address to the Association of Chief Education Officers in 1965, Clegg produced a critique of the previous decade based upon reflection and inquiry. He begins with praise for the 'revolution, a change in kind, not degree, in the educational processes in our junior schools' (Clegg 1965: 238). But then follows a series of major arguments about selection and social cohesion, and inequality, fundamental aspects of well-being and one of his prime concerns. He refers to 'disquieting' problems in the system, revealed when he asked colleagues to make inquiries in local shops about aids to get a child through the 11-plus examination. These aids included a special medicine and a high pile of books, all promising to get a child through the examination. Then Clegg obtained a collection of written work from the most well-regarded schools in the county and, after evaluation, sifted out the best

and then asked the schools what use they made of these commercial exercise books for 11-plus preparation. None of these books had been used and teachers argued that they inhibited 'good English teaching'. Addressing the audience of chief officers, Clegg said:

> we here represent authorities which spend hundreds of thousands of pounds of ratepayers' money every year on books of this kind, which the best teachers believe to be a menace to good learning.
>
> (Ibid.)

Again, in a discussion about schools gaming the 11-plus selection examination, he refers to actual cases, for example, one of his grammar schools had put the same 28 pupils into one examination board and the same pupils into another board. With one board, 27 pupils passed, and 25 failed with the other. He argued that, instead of this inadequate system, teachers should be trusted and the responsibility for grading pupils firmly given to them, something which many local teachers looked forward to. A new system, known as the 'Thorne scheme', comprising internal grading, external moderation, and feeding back on performance, is his proposition, and how radical that looks from the perspective of the early 21st century. There is no means of judging in retrospect the response of his peers in the audience, but Clegg made his critique as a prominent public figure and leading professional. Researchers, such as Robin Pedley (1963), Brian Simon (1990) and John Vaizey (1970), had made similar attacks upon the 11-plus, its processes and effects, but Clegg's critique was made to an audience which, presumably, hoped that the year in which a major comprehensive school reform was instituted would eliminate the problem he described. His next point to the audience wouldn't have helped them. Certainly, 'our society has reached a stage when the social and intellectual stratification of our school system is no longer acceptable' (Clegg 1965: 239). But then he criticised his fellow administrators for the 'speed and expediency with which some authorities are proposing to push through any old reshuffle' that will avoid the 11-plus and its problems. He opposed the establishment of any comprehensive school that had widely separated school buildings; single secondary schools until age 14, then an unsound division of pupils; continued social segregation, selection by examination, by fee and by parental choice:

> it leads to a school which, judged by the normal criteria of comprehensive education, can only be described as a bastard sired by the politics out of expediency or parsimony.
>
> (Clegg 1965: 240)

This is tough talking. The West Riding had been at the forefront of thinking about new school structures at different levels, so his audience knew that his critique was based on actual practices in his local authority. Fudging comprehensive

reorganisation with cosmetic alterations would certainly continue the deeper structural fault lines in society that underlie the failure of schools to promote well-being.

> What we are doing is changing the framework to avoid an educational and social division which has become repugnant to our society. But there is no guarantee that changing the framework of secondary education will improve its quality.
>
> (Clegg 1965: 241)

He argued that 'makeshift arrangements may well get rid of the 11-plus, but prove in others ways to be an educational disaster, particularly for the socially underprivileged child whom they are mainly designed to help' (Ibid.). If the poorest teachers, or absent teachers, minimal choice of subjects, the most meagre of facilities and the least homework remain a continuing pattern of 'sinister importance', if all such features were to continue, then comprehensive reform would be nominal. Providing more data, he returned to the problem of stratification and social exclusion. In 1965, white-collar workers (20% of the population) produced 40% of the brightest children, who secured 60% of 'Sixth Form' places, and 80% of university places. Conversely, manual workers produced 60% of the ablest children and yet secured only 20% of university places. Such data is at the heart of West Riding schooling. Many of its schools producing able children would have difficulty in achieving university places, even if other factors, such as family finance, were taken into account. If all was fair and equal in the state system, in his view, society was still let down by the 'Direct Grant' and independent 'public schools' [the private and semi-private 'elite' schools]. They were still allowed to select the top 3% of the ability range, in the case of the state-funded 'direct grant' schools: [if] 'we think this should be done on principle, we should say so, stating the principle' (Clegg 1965: 242). Independent 'public schools' were quite indefensible in relation to teacher supply:

> when teachers are in such short supply and are so strictly rationed… that schools in the private sector should be able to employ as many teachers as they wish, most of them trained no doubt at public expense.
>
> (Ibid.)

The way that England had managed its economy through national planning (which applied to West Riding schools, across its teachers, buildings and resources), was now being unfairly skewed by a powerful part of society, operating through a market. His point about principle still stands: if there is a principle operating here, rather than *force majeure*, then what is it? This address to fellow officers, an education elite, is fundamental. It attacks privilege and fabrications. The audience is both criticised and enlisted. It is passionate and inquiry based. Essentially, it exposes fundamental flaws in the education system

and rejects simplistic reforms. He opposes political reform of schooling, in the name of equality, when it leaves privilege and exclusion intact, well-being for some but not for all.

In a third lecture, in 1970 for the Arthur Mellows Memorial Trust in Peterborough, Clegg doubles down on his critique of society, and discusses a future of social disorder, where the gap between the materially well-off and a resentful minority will increase. Nearly 50 years later, his argument, centred on his work in West Riding and his critique of societal exclusion, influenced by Michael Young's earlier thesis on the rise of the meritocracy, is apposite and still radical (Young 1958).

Referring to the technological age, echoing Labour Prime Minister Harold Wilson's 'white heat of technology' speech of the early 1960s, Clegg offers a dystopian view of its effects on society. Fundamentally, it will strengthen the divide between the clever, those who count, and the others, who don't: '...the power which will derive from cleverness may be even more corrupt than that which in the past has derived from birth and wealth' (Clegg 1970: 3–4).

Those who can invent and use complex machines will eliminate the work of those doing simple jobs and as they rise in sophistication, they will even take the work of those who are more able and 'what we do not know is whether the service industries can increase to absorb those who are thus rendered unemployed' (Clegg 1970: 4).

As evidence, he stated that over 12 years previously, in the late 1950s, manual workers ceased to be the largest social group in the United States, and in England, there were now more teachers than miners: 'In my own County there are now 80,000 miners employed and this number is expected to be reduced to 21,700 within ten years' (Ibid.).

The pace of these changes was going to be more rapid still (by 2015, coal mining in Yorkshire had disappeared altogether), and the 'less clever' would be held in increasing disregard, whatever other qualities they may possess. Also, children in school would be trying to earn their living doing work not yet in existence. One consequence will be, he said, that

> We over value the able whom we think will make us even more prosperous, and we discard the least able and they, resentful and bitter at our lack of concern for them, force themselves on our attention in ways which they believe will offend us most.
>
> (Clegg 1970: 7)

Offence will be provided by increased crime rates, violence, illegitimate births, abandoned children, divorce rates, and work shyness. Children will be under stress, unwanted, lacking support, and with separated or divorced parents. The technological age, the machine age, will increase the reproduction of this 'bitter and resentful, dangerous minority', and society will be rent asunder (Clegg 1970: 13).

It is interesting that, after describing the effects of industry and the economy on youth and on work, he returns to his critique of the education system, with its emphasis on the quick and its abandonment of the slow, as generating social disorder.

> To isolate slow learners, many of whom have had a bad start in life, to give them the rawest deal in the school and then to make sure that they are the last to get a job and that a poor one, is a way leading to trouble.
> (Clegg 1970: 10)

Society would have no choice but 'ruthlessly to suppress the disorder bred of resentment which must follow' (Ibid.). His hope is that education will change, and so change the course of society. It must pursue a policy of positive discrimination in favour of the under-privileged more than heretofore, and in this context, Clegg is focused on exclusion and on the less clever.

He renews his advocacy of the junior school, 'in which children work as individuals each exploring the limits of his own abilities, the teacher can offer that praise and encouragement to the least apt who stand so much in need of it, with the result that they too progress' (Clegg 1970: 7). Strengthening, and not just trying to fill, the young mind is likely, in Clegg's summative view, 'more than anything I know, to fit the young for the changes which our society is likely to undergo' (Ibid.). We have returned here to Clegg's foundational view, that schools and teachers can create a better society.

Data and research

Clegg had a long career in education as a senior administrative officer, and during that time, the post-war West Riding education service had shifted from being a 'make do and mend' response to the crises of war damage and the baby boom, to a source of innovation and inspiration, and at its end, a more defensive and critical service. As we have seen, Clegg increasingly offered evidence-based arguments over the years but by the 1970s, a systematic production of data was required. If he was to defend the importance of education, arguments about society, democracy and creative practice had to be made in other than regional and professional contexts. Over the years, Clegg had to move from the creation of data from small-scale research on aspects of schooling to the collection and collation of data on all aspects of his county's education service. Generally, only two kinds of data needed drawing together – the growth of the school population through demographic changes in the area or a rise in child births. In both cases, this information was for use in an annual meeting at the Ministry of Education where its purpose was to secure an increase in the general grant of central funds to the West Riding. Locally, data served to predict need for school places; birth data helped to map the right schools in the right place. Headteachers monitored reading scores and IQ scores. In addition, Clegg

would have statistics on staffing and resource management, and allocation of pupils to schools, planning provision in line with projections of pupil numbers and places needed, and in-service provision for teacher development (Bell and Stevenson 2006: 100). Generally speaking, by contrast with present times, there was very little management information available, which depended on manual returns and routine accounting outputs. Schools would have to register information, school meals data (including free school meals), expenditure accounts and examination results. The system ran on the judgement of local officers.

In infrequent series through the 1950s and 1960s, LEAs would publish bound reports containing information about their schools, buildings and new areas of work. For example, the West Riding produced three reports in 1954, 1964 and 1974, discussed in Chapter 3 for their photographic illustrations. The 1964 volume made a comparison with its previous major report in 1954. This was the background information used by Clegg in his articles. One table, headed 'Random Comparisons' (WREC 1964: 11), listed a series of key features in the county and compared them: total expenditure on education trebled, as did the number of students going to university, and the acreage of playing fields; the total cost of teacher salaries more than doubled; new schools and major extensions increased in number five-fold.

This process of comparison and explanation, using key data as its foundation, worked its way through 16 chapters and 32 appendices. Each section of the authority was explored and reported on – from the museum service to building maintenance. It was a report to be read by professionals and the public. Officers undertook small-scale inquiries, and reported on them to the Policy Sub-Committee. For example, by analysing national statistics, they revealed the unfair spatial distribution of access to grammar schools, and so universities, in the county. This work continued into the social and cultural backgrounds of pupils, on selection and absenteeism. Appendices had more detailed information, for example percentages of pupils taking school dinners and milk, categories of books lent by the libraries, youth service costs, teacher-training student numbers, in-service courses for teachers, the rising cost of the dental service, stationery and postal costs of the schools, teacher salaries and costs per child for education services.

To produce the report, officers would have had to draw together information filed across the county's departments. Targets for income were set by the authority but there were no penalties if they were not met; expenditure for materials etc. had to be agreed with a central office, and school maintenance with another office. This report compared its progress against its past, and usually in terms of product or resource, but one table compared West Riding figures with national statistical data on other English counties. In that table, comparisons were made at three points – 1953/1954, 1961/1962 and 1962/1963 – across a range of factors, for example, cost per pupil (salaries, premises, transport and debt charges). This table was not referred to in the text but must have been a topic of discussion among the authority's management.

APPENDIX XXXI

SOME COMPARISONS BETWEEN THE EDUCATION STATISTICS OF 1953–54, 1961–62 AND 1962–63 PUBLISHED BY THE SOCIETY OF COUNTY TREASURERS

	1953–54 W.R.	1953–54 English counties	1953–54 Position in table of 48 English counties	1961–62 W.R.	1961–62 English counties	1961–62 Position in table of 48 English counties	1962–63 W.R.	1962–63 English counties	1962–63 Position in table of 48 English counties
Food cost per meal	8·49d	8·26d	12/48	9·67d	10·02d	44/48	9·63d	10·14d	46/48
Cost per pupil —	£	£		£	£		£	£	
Primary schools									
Salaries and wages	18·21	19·24	42	39·61	41·17	35	44·07	45·75	35
Premises	5·78	4·95	2	8·30	7·24	4	9·25	8·02	3
Supplies, equipment, etc.	1·05	1·47	47	1·86	2·34	47	2·02	2·40	46
Miscellaneous	0·65	0·25	1	0·08	0·24	48	0·23	0·29	36
Transport	Not available			0·65	0·74	29	0·41	0·74	40
Debt charges	Not available			3·35	4·20	32	3·40	4·48	35
Totals	25·69	25·91	31	53·85	55·93	38	58·97*	60·94*	37

*Transport not included

APPENDIX XXXI *(continued)*

	1953–54 W.R.	1953–54 English counties	1953–54 Position in table of 48 English counties	1961–62 W.R.	1961–62 English counties	1961–62 Position in table of 48 English counties	1962–63 W.R.	1962–63 English counties	1962–63 Position in table of 48 English counties
Secondary schools									
Salaries and wages	30·61	33·85	42	58·88	62·52	39	70·52	72·39	32
Premises	10·04	9·32	12	12·37	12·37	22	13·86	13·96	26
Supplies, equipment, etc.	2·03	3·30	48	4·32	5·23	48	4·81	5·47	46
Miscellaneous	1·60	0·86	3	0·76	0·93	43	1·10	1·11	27
Transport	Not available			3·02	3·98	43	3·66	4·15	40
Debt charges	Not available			11·04	13·67	43	12·95	15·39	40
Totals	44·28	47·33	36	90·39	98·70	46	103·24*	108·32*	38

*Transport not included

Cost per 1000 population									
Primary and nursery schools	Not available			5314	5084	18	5851	5580	16
Secondary schools				6016	6341	35	6703	7029	37
Further education				1909	2202	36	2406	2571	28
Other expenses				3766	3525	10	3975	3884	16
Totals				17005	17152	25	18935	19064	23

Figure 2.2 West Riding Education Report 1964, Appendix XXXI, pp. 225–226

The 1964 report had 32 Appendices of mostly statistical data. It is noticeable that data on people and services took precedence over tables of finance and budgets. Appendix XXXI made significant comparisons against other LEAs in expenditure.

Published by permission of WYAS, Wakefield

Clegg tried to use research evidence drawn from local data, collated in the reports, to justify his published and spoken arguments; in later years, he realised that data was the way in which local authorities would be nationally governed and disciplined, and the means by which it could study itself. He used small-scale inquiry in his papers but the final West Riding report for 1974, *The Final Ten Years*, makes mention of the following: partnership with the Educational Priority Areas Project; an extensive investigation on reading standards (with 10,000 pupils); a major maladjustment inquiry, with its own research officer; and a project with colleges of the Universities of Oxford and Cambridge ('Oxbridge') for encouraging access of students from manual working-class families (WREC 1974: 79–94).

Finally, he commissioned a project on the workload of the central administrative office, across the whole range of LEA work, employing a firm of management consultants to report, subsequent to which a major reorganisation of the Authority followed. Clegg created, to a degree, a reflexive institution which did not simply rely upon the 'less formal modes of reasoning and communication because their political and administrative leaders made up a cohesive elite' (Porter 1995: 76). Traditionally, local administrators produced education through their character, stories and daily interactions, and judgements, and were known for this. They personified the service. Data now began to define the system: not moral purpose or even administrative description alone (Lawn 2009, 2013).

Conclusion: Creativity and redemption

In these addresses, and their published texts, Clegg expressed important key elements of his perspective on education. They were generated from his experiences in the three education authorities he worked in, the experiences of families and children and the socially neglected or excluded. This concern was melded into a deeper perspective on education through close encounters with creative educationists in Worcestershire and Birmingham. It was not just a question of individual growth through the creative arts in education, a feature most commonly associated with him, but the reconstruction of a divided society. Society could only be saved or redeemed through its schools and teachers. Often in his arguments these two elements are brought together, and a damaging social critique is balanced with the redemptive, secular power of teachers and schools. For every argument about the deepening fractures in society, there is an argument about good teachers and schools. Indeed, there is a constant thread of thought that giving teachers more autonomy and responsibility would overcome major educational and societal problems. Clegg spoke from a position of authority in English education, based on the consistency of his viewpoint, a track record of innovation, and the size and complexity of the West Riding Authority. Some of his statements might have been more

44 Martin Lawn

Data on school population and grants to students

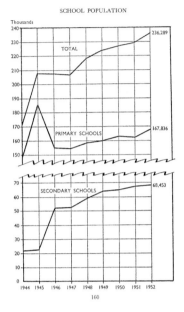

Figure 2.3 1954 Report, School population, p. 160

GRANTS PAID TO STUDENTS AT UNIVERSITIES AND OTHER INSTITUTIONS OF FURTHER EDUCATION

1943–44 £		1952–53 £
18,626	To students at Universities and University Colleges	131,885
18,304	To students at other Institutions for Further Education	64,701
4,285	Supplementary Grants to students at Training Colleges	11,538
41,215		208,124

OTHER FORMS OF AID TO STUDENTS

6,499	Maintenance allowances to pupils at Secondary Schools	13,600
—	Allowances for distinctive clothing and other school expenses	3,244
6,499		16,844

Figure 2.4 1954 Report, Grants to students, p. 163

APPENDIX II

	1954 £	1964 £	1972/73 £
Expenditure			
Gross total on Education	13,666,999	38,812,022	102,684,864
Teachers' salaries	5,636,141	14,666,667	34,984,609
Maintenance of schools	1,779,993	3,831,015	9,399,243
Aid to pupils and students	696,440	2,652,320	5,183,219
Teachers' annual salaries			
Basic maxima — Man	670	1,250	2,279
Woman	536	1,250	
School population (excluding Nursery and Special)			
Primary	179,593	164,605	194,263
Middle	—	—	15,960
Secondary	69,081	103,374	118,947
Totals	248,674	267,979	329,170
Staffing of Schools (excluding Nursery and Special)			
Average number of full-time teachers	9,190	10,567	15,532
Average number of pupils per full-time teacher	27·0	25·4	21·2
Further Education			
Students in the five West Riding training colleges	542	1,416	2,708
Full-time students in further education colleges and institutes	101	1,163	2,029
Student hours	3,862,900	5,370,654	7,894,492

	1954 £	1964 £	1972/73 £
Students at universities	885	2,433	4,993
Students at other further education establishments	217	1,680	2,969
West Riding students at teacher training colleges	1,370	2,853	4,811
County Continuation Scholarships	680	3,072	3,470
Travelling assistance to part-time students	1,513	3,700	3,400
Building			
Certified capital payments for completed works	1,406,939	4,703,349	9,400,000
Certified payments for repairs and maintenance	739,177	1,047,000	2,375,000
Purchase of land — number of cases	300 (approx.)	665	626
Playing Field Service Teams — acreage covered	1,750 (approx.)	5,000 (approx.)	5,000 (approx.)
New schools and major extensions during the preceding decade	32	153	361
Schools supplied by the County Library	636	995	1,212
Pupils on Yorkshire/Lille exchange	256	878	(1972) 839
Pupils on Yorkshire/Westphalia exchange			(1973) 355
Office Staff			
Central Office	219	196	237
Divisional Education Offices	244	255	332

Figure 2.8 1974 Report, Appendix II, pp. 112–113

The work of Alec Clegg in post-war England 45

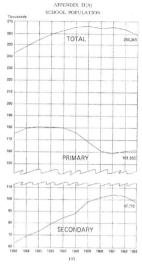

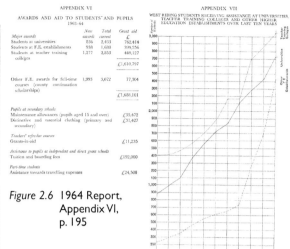

Figure 2.5 1964 Report, Appendix II(A), p. 193

Figure 2.6 1964 Report, Appendix VI, p. 195

Figure 2.7 1964 Report, Appendix VII, p. 196

1954 Report:
19 statistical tables and graphs.

1964 Report:
32 statistical appendices.

1974 Report:
8 statistical appendices, mostly financial, quite brief and no graphs.

APPENDIX III

SOME EXAMPLES OF PERCENTAGE INCREASE OVER 1954

Further Education	%
Students in the five West Riding Training Colleges	399·60
Full-time students in further education colleges and institutes	1908·9
Students at universities	464·1
Students at other further education establishments	1268·2
West Riding students at teacher training colleges	251·2
County Continuation Scholarships	410·3
New schools and major extensions during the preceding decade	1028·1
Schools supplied by the County Library	90·6
Pupils on Yorkshire/Lille exchange	227·7
Office staff	
Central office	8·2
Divisional Education Offices	36·1

Figure 2.9 1974 Report, Appendix III, p. 114

Figures 2.2–2.9 published by permission of WYAS, Wakefield

common among established academics of the time, but were unusual among senior education officers. Increasingly, his arguments depended less on his trusted judgements and expert knowledge of schooling, but on his evidence. Often, he pointed towards small-scale inquiry and then large-scale research in his support. Additionally, he drew material from analyses of the LEA's own functioning, and this was still unusual yet increasingly significant.

Clegg's ideas about teachers and schools might have been radical but later they have become a means of describing and explaining the politics of education in the post-war decades. Formal descriptions or concepts talk of teachers as partners in the management of education with local and central government. This began with the influence of Sidney Webb (influential Fabian Society thinker in the decades around Clegg's birth and childhood) with his comments on professional responsibility:

> ...it is the duty of each profession to take the needs of the whole community for its sphere... it must claim as its function the provision of its distinctive service wherever this is required, irrespective of the affluence or status of the persons in need... it must emphatically not regard itself as hired for the service only of those who pay fees and it must insist therefore on being accorded by public authority and where necessary at the public expense, the opportunity and the organisation that will enable this full professional service being rendered wherever it is required.
> (Webb 1918: 8)

It is this command, influential upon the Labour Party of the time, that is taken further by Clegg in his sense of education being delivered by good schools and teachers. Through writings by Clegg and others, the idea of the teacher as a highly skilled professional and partner in the system becomes part of a mythology about the English system (Lawn 1999).

> This gradual correlation between professionalism, a mass schooling, welfare and reconstructionist ideologies, and the making of a democratic society, acknowledged the crucial position of teachers: as heroes of reconstruction, as pedagogic innovators, as carers, as partners of and within the public.
> It is this association with the emerging welfare services which probably affected teachers' work the most, not only with its prevailing sense of public service... but with an emphasis on universalism and equality of opportunity.
> (Lawn 1999: 102)

Clegg was one of the very few writers of his time who clearly articulated these ideas, and specified details and examples. He provided creative leadership most clearly at a time when the democratic and professional service of education was under threat, and LEAs were being dismantled. Their sustaining mythologies began to wane as well.

Following his retirement, Clegg wrote a sharp piece of commentary on the state of education of England for the *Times Educational Supplement*, in an article entitled 'Much to Worry Us'. The education partners were under attack, and his association, the Association of Education Committees, had been 'emasculated'. But it was with the teachers that his hopes still lay: 'What they do will determine whether they emerge as a fully-fledged profession in control of their own destinies or remain at the technician level…' (Clegg 1974a: 25), where they will be told by everybody how to do their jobs. He asked teachers a range of specific and tough questions about the service they were in: for example, is it penury or parsimony that affects staff ratios and school refurbishment so badly? Who ought to take decisions to devise the syllabuses?

> Why is it that these days teachers are allowing national policies to be framed which surely cannot earn their professional support… will performance testing… spread?
>
> (Ibid.)

Asserting that our Infant and Junior schools are the envy of many other countries, he wanted the teachers to defend spending on education, which others resented, and warned against the centralisation of the education service as 'lamentable'.

When he began working in LEAs, it was of little concern in society if the majority of schools were poor, but more money and great effort had been committed to education, and schools and teachers had been the dynamic force in these creative changes. His career shadowed almost exactly the post-war education changes in society, from the end of war to the oil crisis of the early 1970s. It preceded the rise of Thatcherism (neo-liberal conservatism) and decline of the idea of public services. Because of people like Clegg, the possibilities of the system had been realised and a critique of its weaknesses made. It was a different time, but for contemporary education, it still lies as a place of hope and redemption. It contained a view of the child and of society, of creativity and of constraints. The hope for the emancipation of the child and society lay with schools and teachers.

Note

1 Schools Council for the Curriculum and Examinations (1964–1984) was established to disseminate ideas about curricular reform in England and Wales.

References

Bell, L. and H. Stevenson. (2006). *Education Policy: Process, Themes and Impact* (Leadership for Learning series). London: Routledge.

Burke, C. and I. Grosvenor. (2013). 'The Steward Street School experiment: A critical case study of possibilities'. *British Educational Research Journal* 39(1): 148–165.

Brighouse, T. (2002). 'The view of a participant during the second half: A perspective on LEAs since 1952'. *Oxford Review of Education* 28(2–3) 'A Century of Local Education Authorities': 187–196.

Clegg, A. (n.d.). 'What It Means to Me'. National Arts Education Archive AC/PL/12/2. Cited in Wood et al. 2018.

Clegg, A. (12 January 1962). 'Attitudes' (Address to the North of England Conference). *Education* 119: 75–83.

Clegg, A. (5 February 1965). 'Dangers Ahead' (Presidential Address, Association of Chief Education Officers). *Education* 125: 238–242.

Clegg, A. (1970). *Education in Society* (Arthur Mellows Memorial Lecture). www.educationengland.org.uk/documents/speeches/1970clegg.html

Clegg, A. (1974a). 'Part 4: Much to worry us'. *Times Educational Supplement*, 11 October, 24–25.

Clegg, A. (1974b). 'Change in Education' (The Sir John Adams Lecture).

Clegg, A. (1980). *About Our Schools*. Oxford: Basil Blackwell.

Cook, L. (2000). 'Outdoor education: Its origins and institutionalisation in schools with particular reference to the West Riding of Yorkshire since 1945', PhD Thesis. University of Leeds, School of Education.

Counts, G. S. (1932). *Dare the School Build a New Social Order?* New York: John Day Company.

George, N. J. (2000). *Alec Clegg: Practical Idealist*. Barnsley: Wharncliffe Books.

Griffin-Beale, C. ed. (1979). *Christian Schiller in His Own Words*. Published by

Hobson, B. (1921) *The West Riding of Yorkshire*. Cambridge [England]: The University Press private subscription.

Lawn, M. (1997). 'The puzzle of the public: (Re)constructing the teacher within the public service'. *Historical Studies in Education / Revue Historique d'Éducation* 9(1): 107–115.

Lawn, M. (1999). 'Following the Third Way? Teachers and New Labour', in *State Schools: New Labour and the Conservative Legacy*. ed. Chitty, C. and J. Dunford. London: Woburn Press, 100–110.

Lawn, M. (2009). 'Shifting from judgment to data in educational systems – a short visit to the 20thC' [Symposium] Network: 27 Didactics – Learning and Teaching ECER 2009, Vienna.

Lawn, M. (2013). *The Rise of Data in Education Systems – Collection, Visualization and Use* (Comparative Histories of Education series). Abingdon: Symposium Books.

Pedley, T. et al. (1963). *Comprehensive Schools Today*. London: Councils and Education Press.

Porter, T. M. (1995). *Trust in Numbers: The Pursuit of Objectivity in Science and Public Life*. Princeton, NJ: Princeton University Press.

Simon, B. (1990). *Education and the Social Order, 1940–1990*. London: Lawrence and Wishart.

Stone, A. L. (1949). *Story of a School*. Ministry of Education Pamphlet no. 14. London: HMSO 7th Impression 1970. www.educationengland.org.uk/documents/minofed/pamphlet-14.html

Vaizey, J. (1970). *Education for Tomorrow*. Harmondsworth: Penguin Books.

Webb, S. (1918). *The Teacher in Politics*. Fabian Tract. London: Fabian Society.

Wood, M., A. Pennington and F. Su. (2018). 'Pre-figurative practice and the educational leadership of Sir Alec Clegg in the West Riding of Yorkshire, England (1945–1974)'. *Journal of Educational Administration and History* 50(4): 299–315.

WREC (West Riding Education Committee). (1964). *Education 1954-64*. Wakefield: Education Committee.
WREC (West Riding Education Committee). (1974). *The Final Ten Years 1964-1974*. Wakefield: Education Committee.
Young, M. D. (1958) *The Rise of the Meritocracy*. London: Thames and Hudson; Harmondsworth: Penguin Books.

Chapter 3

Reporting in images
Portraying progress in West Riding education

Peter Cunningham

Reporting on education over three decades

Reporting on education might seem a humdrum task. Administrators report to their committee of elected councillors, who must account to their taxpayers for policy and expenditure. Accountability procedures in public service are necessary, but not normally expected to fire the public imagination.

Lawn (Chapter 2) has described Alec Clegg's skills of communication, and one of his creative innovations was turning Education Committee reports into an art form, the content and quality of which deserve evaluating. They were a vehicle for conveying the idealism of West Riding education, and reached an audience not just locally, but much further afield. Brighouse aptly described one of these reports as a 'book', for the three reports can be read now not simply as historical documents recording the growth of West Riding education over three decades, but as an educational treatise. Their contents include philosophical reflection on principles, sensitive concern for children's needs and child development, consideration of teachers' roles and the skills they require, and evaluation of school buildings as a crucial factor in successful teaching and learning.

Striking evidence of their impact at the time is found in the words of an authoritative commentator, reviewing the first volume in 1954. This review includes key quotations from the report (italicised below for emphasis):

> No one reading this report... will be inclined to under-rate the potency and virility of local educational administration in this country – a handsomely produced publication *"not a survey of the service but of changes that have taken place"*... reveals the intangible innovations that have taken place within the schools *"in aims, method, discipline, and the relations between child and teacher."* This ambitious and exacting task is accomplished with rare skill, and the report bears the hall-mark of good craftsmanship both in its writing and its illustrative material. Because it tells of change during a kaleidoscopic period in our educational development, the report deserves to survive as an important contemporary source of educational history...

All readers of this excellent Report will… express appreciation of the service rendered by Mr Clegg, the West Riding Officer, and his staff in producing it.

(Lester Smith 1954: 83–84)

Lester Smith, himself an experienced administrator, sociologist and Professor of Education, saw the report as serving not just a local purpose, but benefiting a wider national audience, disseminating and encouraging new understandings of, and approaches to, schooling for a post-war generation of children. He also foresaw its value to future historians and educationists. The national and professional reach of these reports is indicated to researchers today where the British Library's multiple copies bear stamps of institutions in which they were used, including University Institutes of Education, teacher training colleges and a College of Art.

A range of audiences, political, professional and popular, read these reports. Local councillors would be monitoring closely the provision of schooling and its cost to the county's budget. Their constituents across the extensive and differentiated local communities of the West Riding comprised a widespread body of Rate (Council Tax) payers, including parents whose children attended schools, and family members making use of other services, such as further and adult education and public libraries. Accountability was also to central government that distributed resources to local authorities, and as Lawn indicates in Chapter 2, these reports had a role to play in bidding for funds from the Ministry of Education. Professional readers included teachers at all levels throughout the authority. But such was the status and reputation of the West Riding that a substantial national readership would be found amongst academic educationists, teacher educators and educational administrators in other parts of the country, keen to keep up to date with the leading innovations and developments taking place in Yorkshire schools. The reports' illustrations need to be viewed today with those various audiences in mind, not only local teachers but also a national audience of practitioners and even of policy-makers, remembering that Secretary of State for Education, Sir Edward Boyle, named Clegg as one of three people who commanded respect throughout the field of education (Darvill 2000: 177, 271–272).

Worth remarking is how this series of three weighty decennial reports evolved initially by accident, a reflection of Clegg's opportunism as well as his creative thinking. A Preface to the first, in 1954, entitled *West Riding Education: Ten Years of Change*, explained that the convention of yearly reports had ceased on the outbreak of war, and hadn't resumed. 'Here we make up for its long absence – a review of the past and an indication of the work and problems ahead' (WREC 1954: 3). It promised that annual reports would appear normally in future.

Following the accolades that greeted it, however, the virtues of a longer perspective were recognised. Prefacing the next report in 1964, *Education 1954-64: A Report on the Development of the Education Service in the West Riding of Yorkshire*, the Committee chairman explains 'We have been so busy that we

have failed to keep our promise' and – in offering a retrospective of ten more years – 'its impact we hope will be more effective than that which a series of annual reports would have made' (WREC 1964: 5). With wide circulation and readership, the national reputation it earned for Yorkshire education seemed to have set a precedent. One further decade, and 1974 saw implementation of a Local Government Reorganization Act that devolved West Riding education to nine smaller authorities, so a third report, tersely entitled *The Final Ten Years*, marked the end of an era. These three volumes encapsulate for posterity the three decades of Clegg's administration.

Though each title page bears the names of both the Committee chairman and the Chief Education Officer (CEO), their substance was the work of Clegg and his team. Dual responsibility of councillors and officers was an innate feature of Local Education Authorities (LEAs). The elected members gave political direction to local policy, while the administrative team between 1944 and 1974 comprised increasingly knowledgeable and experienced education professionals, who advised politicians as well as turning policies into action. For Clegg, the personalities of successive chairmen required negotiation with tact and strategic skill. Walter Hyman (Labour) was his first chairman, experienced, energetic and liable to pressurise officers. Hyman occupied the Chair from 1937 to 1949, and returned to the Chair in 1952 following a three-year interlude in which two Conservatives successively held the post. While the majority party took the Chair, a vice-chairman was drawn from the opposition, so Hyman maintained a close relationship with the CEO. In 1958, Labour regained the majority and Hyman returned to the Chair for one more year before handing over to C.T. Broughton, who continued in that role to 1967. Conservatives were then in post for Clegg's last seven years (Gosden and Sharp 1978: 44).

Clegg and Hyman worked well together for almost 15 years, with compatible attitudes to education and social justice, as well as differences between them openly aired, on matters of comprehensive secondary education for example. Clegg described Hyman's 'customary vehemence' and once noted how 'He loved a struggle and would create obstacles if none existed... He invariably took the line of most resistance' (Darvill 2000: 71, 139). But Hyman and his wife received friendly humorous letters from Clegg on his travels overseas, and when asked by the University of Sheffield to make recommendations for an honorary degree, Clegg proposed Hyman. A co-opted member of the Committee, Professor Niblett of Leeds University described Hyman as 'one of the most formidable and knowledgeable members of an Education Committee in the country' while Clegg brought to their partnership 'keen aesthetic interests and great devotion to the education of children...' (Niblett 2001: 95).

Images in context

A striking feature in the West Riding Education Committee's reports of 1954, 1964 and 1974 is their abundant photographic illustration, and these images

merit close study for their role in portraying educational progress. More will be said in conclusion on the significance for education historians of visual sources, and on a long history of 'progressive images', but two national publications preceding the West Riding reports may suggest sources of influence in Clegg using photography for this purpose. With a specific aim of promoting interest in developing young children's expressive skills through the arts, especially drama and movement, the Ministry of Education in 1949 published West Riding advisory teacher Arthur Stone's *Story of a School* as a pamphlet with six pages of photographs (MOE 1949).[1] This was followed by a pair of handbooks for teachers on physical education in primary schools; the two volumes were elaborately illustrated by an outstanding social documentary photographer, Edith Tudor Hart, and published in 1952 and 1953, immediately preceding the first of the West Riding Reports (MOE 1949; MOE 1952, 1953).

West Riding's reports emulated these powerful images, and it is worth reflecting on relationships between images and the text that they support. They appear in 'signatures' (sewn sections) of each volume, on glossy paper that lends a luxurious feel to the book. Collections of pictures on double-page spreads are accompanied by captions. The photos were black and white and of high quality, most by professional photographers with a few credited to individual headteachers. Readers would doubtless enjoy browsing these snapshots of school life, as well as finding them informative. Within each report the chapter texts were also varied in content, richly descriptive and discursive.

It will be seen in these reports that visual images, like the chapter texts, are presented to set up a dialogue. 21st-century readers are familiar with the visual arts challenging viewers to engage in argument, through photography, painting and sculpture, as through literature and drama. In Clegg's time, this practice was less overt and less widespread, where book illustration like other art forms might be more generally aimed to delight and entertain or to tell a story. Yet juxtaposition of pictures and sometimes captions too, in these reports, pose implicit questions. Just as art in some of the most progressive West Riding schools was not only an outlet for children's creativity, but also a medium for thinking and provoking discussion, as Hoare discusses in Chapter 5, so these published accounts of West Riding education can be seen to present an argument in print and pictures, describing but also questioning.

A small selection of images from each report is reproduced below for close examination. Leading themes are buildings, architecture and school environment, seen by Clegg as fundamental prerequisites of pupils', students' and teachers' well-being. For him they were vital to the quality of children's learning experiences, and in teachers' capacity to provide a stimulating and creative curriculum. It was, incidentally, a concern inherited from his schoolmaster father (passed on in turn to Sir Alec's son Peter, whose architectural practice became noted for its school designs). It was a goal that required informed and committed leadership in the local authority.

Ten Years of Change (1954)

The national context in 1954 was one of optimism following struggle. A decade of economic depression and six years of war took its toll on educational progress, but a post-war government committed to social reconstruction, education and health laid foundations for renewal. In 1951, a 'Festival of Britain' celebrated revival in the arts and architecture, all features reflected in West Yorkshire's educational progress. The coronation of 1953 heralded a 'new Elizabethan age' following wartime sacrifice and post-war austerity.

Walter Hyman's preface gives an insight into this report's context and production that set the tone for what became a highly distinctive series (italics added for emphasis):

> The annual reports of the West Riding Education Committee ceased with the issue for 1939 and will appear normally in future. Here we make up for its long absence – a review of the past and an indication of the work and problems ahead. It is to me a fascinating document, and will, I think, be found so by all readers… It has *clearly involved much thought and energy within the Department*, and *members of the Committee express their admiration of its Education Officer and of his staff* who have contributed, and their thanks are also due to the *many teachers who have supplied so much information*, particularly for the section dealing with the curriculum. Throughout this report we quote a Yorkshire Schoolmaster, one Charles Hoole, educated at Wakefield Grammar School, who lived and taught in these parts 300 years ago. I feel happy in the thought that *future generations may be able to say of us* as he said of "Queen Elizabeth's dayes, in whose time, *more Schooles were built, than there were before in all her Realm*."
>
> (WREC 1954: 4)

'Thought and energy' characterised the local authority's administration as well as the collaboration of teachers; it was by no means typical of LEAs to witness harmony and unity of purpose between councillors and administration or between administrators and schools.

This report carried 80 photos with 178 pages of text and Appendices running to 25 pages. The '*Ten Years of Change*' are visually represented in pairs of images illustrating a 'then and now' contrast, a positive story of post-war renewal. While a quarter of the illustrations show learning in action, almost three-quarters, 58 pictures in all, show buildings. Three pages are devoted to six images of fine new schools, modern designs with generous expanses of glass overlooking well-tended gardens, fields and trees.

As with all images in the chapter, this juxtaposition demands attention both to its production and its likely reception. It draws attention to old and new, after wartime struggle followed by a decade of recovery. The contrast here is in fact a longer one, the earlier school dating back to Victorian times, but indicating that

Portraying progress in the West Riding 55

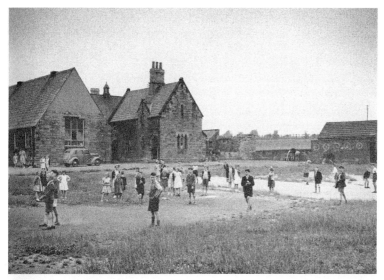

A recently Controlled School not yet renovated
NEIGHBOURING SCHOOLS PHOTOGRAPHED IN JULY 1953
A new County Infant School

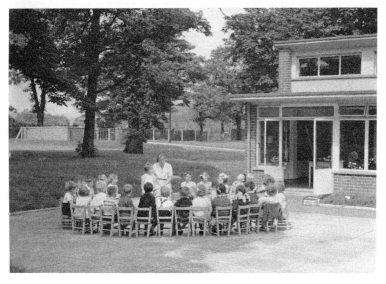

Figure 3.1 Two schools from different eras show the starkly contrasting state of schools that children in any one community might attend

(WREC 1954: facing p.24)
Published by permission of WYAS, Wakefield

many of these old buildings were still in use, their narrow neo-Gothic windows replaced in part by larger windows, perhaps in the inter-war years. In the background, upper right, outdoor lavatories are probably still in use, screened by a wall with painted targets for throwing balls. But pupils' trips to the toilet are across an unkempt playground, where at break time they mill about aimlessly it seems, with no apparatus to climb or equipment to encourage play. The presence of a photographer was novelty enough to attract some children's gaze, as there's little else to stimulate their view. Infants in the lower image are not at play but their modern classroom has large windows and doors open to the outside environment, through which they've carried their light chairs into the open, grouped around their teacher for talk and learning in the sunlight and fresh air. Compared with the upper image, their grouping around the teacher suggests order and purpose, but in a relaxed and caring relationship. Mature trees provide attractive natural forms and foliage, shading contoured stretches of well-kept lawn. For West Riding residents, this page represents investment and renewal, and for parents the contrast might evoke their own less favourable experience combined with hope in future progress for their children.

Managing expansion to meet the post-war 'bulge' in birth-rate was inevitably a staged process requiring temporary classrooms. How the local authority met needs, while working towards an ideal school environment, is symbolised in a succession of images. Immediate functional provision on a military model was the prefabricated 'Horsa' hut. ('Hutting Operation for Raising the School-leaving Age' – its acronym the name of a legendary Anglo-Saxon warrior, resonant as the name also given to a celebrated wartime aircraft.) This hut was soon replaced by 'Hengist' (Horsa's brother, his name also bestowed on a weapon of war), more humane with its brick walls and large windows. Then within two years the 'West Riding Classroom', more 'modern' still with its prefabricated steel structure clad in wood. Flowering shrubs and a young tree enhance the school grounds, figuring new life, elevating the spirits, providing a source and a focus for learning about nature.

A necessary expedient, too, in increasing accommodation for the growth in birth cohorts, was to make good existing schools. In architectural terms a school's appearance, how it featured in the townscape, was important, but a more urgent priority was to ensure classroom interiors that would allow and encourage new approaches to curriculum and pedagogy. The pair of images in Figure 3.3 makes this point, where a 'forbidding exterior' is made to be 'pleasant inside'. Readers of the report are invited to empathise with a single youngster absorbed in painting from his memory and imagination. Creativity is supported by an aesthetic interior, well decorated, with flowers and children's work on display. The cut-out model above the cupboard is a procession of coach and horses, a royal coach and flags suspended above, which doubtless recalled the royal coronation of the previous year, a popular celebration heralding a new Queen, Elizabeth II, and a new era for the nation as well as for education.

Portraying progress in the West Riding 57

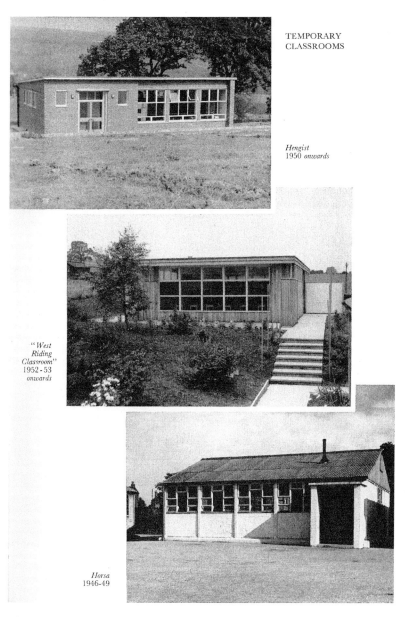

Figure 3.2 Three examples show progress made in the post-war decade to provide a decent learning environment, albeit temporary, suited to the urgent needs of a new generation of pupils

(WREC 1954: facing p.120)

Published by permission of WYAS, Wakefield

58 Peter Cunningham

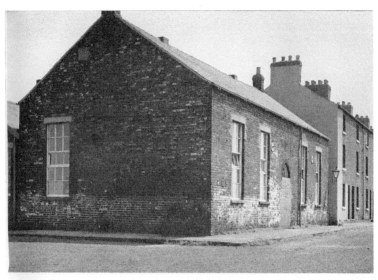

Forbidding exterior

AN OLD SCHOOL

Pleasant inside

Figure 3.3 Refurbishment of interior spaces were a temporary measure where finance was unavailable to replace old school buildings

(WREC 1954: facing p.72)

Published by permission of WYAS, Wakefield

Portraying progress in the West Riding 59

For Clegg, physical well-being of pupils and students were foremost considerations, so the very basics of convenience and comfort in school feature prominently in the text and especially in illustrations of the reports. Sanitary conveniences are treated to a double-page spread at the end of this volume, old communal 'privies' emptying into open 'middens' contrasted with modern water closets and chemical closets. These mundane features and stark images embellish a factual report by the education authority, yet also doubtless induced an emotional response on the part of parents or teachers apprehensive for the health and happiness of schoolchildren.

In this photo the humble facility of cloakroom spaces, suitable storage of outer clothing and a place for rainwear to dry during the day, reflect the contribution of orderliness and good interior design to support learning.

Buildings of a different order were surprisingly ostentatious, and certainly controversial additions to the education authority's estate. Their appearance in this first report provokes some critical questions, now with the hindsight of history, just as then, in the committee rooms of the West Riding. What did these images aim to communicate? How were they likely to be appraised by citizens and taxpayers?

One is Wentworth Woodhouse, the largest private residence in the UK and reputedly the longest country house façade in Europe. Requisitioned by the government during the Second World War, in 1945 the Ministry of Health wanted this mansion to house 'homeless industrial families'; its owner, Lady Mabel Fitzwilliam, avoided such a fate by leasing it to the County Council, who adopted it for teacher training in physical education. Another historic mansion, Bretton Hall near Wakefield, after similar wartime requisition was sold to the County Council, when Clegg seized the opportunity to instigate a specialist college for training teachers of art, music and drama.

The aim to prepare highly qualified teachers, especially for creative, expressive and physical development of children, was realised in notably visible premises! Prestige was to be earned by the quality of teachers produced and their influence in schools, but these grand buildings might be seen to symbolise their importance to educational quality and teachers' professional status. On the other hand, questions of cost were inevitably raised: costs of acquiring, converting and adapting the buildings for their purpose. The cost of refurbishing these new training colleges met criticism even in the national press, the *Sunday Express* newspaper describing Wentworth Woodhouse as a '£250,000 temple for keep-fit girls', but the then Conservative Chair of the Education Committee defended them publicly for the large numbers of teachers they would provide for local schools (Darvill 2000: 75–76). Eminent architectural historian, Nikolaus Pevsner, recognised the quality of refurbishment and additional buildings at Bretton Hall. A double-page spread of photos (WREC 1954: 104–105) includes four smaller historic properties acquired for other purposes: an Adult College, a College of Housecraft and a Special School, and most notably Woolley Hall (discussed in Chapter 4), celebrated nationally and emulated in

60 Peter Cunningham

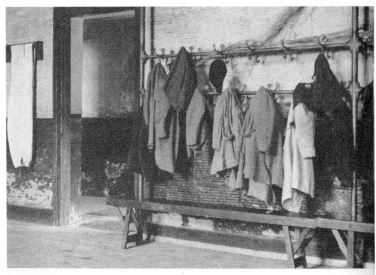

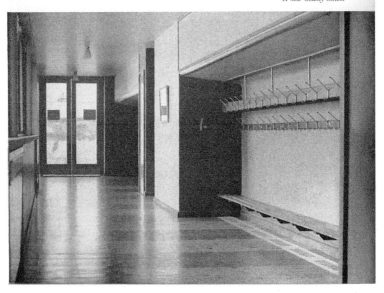

Figure 3.4 Good functional design to accommodate outdoor clothes was necessary for well-being, ease of use by children and easy to clean by caretakers

(WREC 1954: facing p.73)

Published by permission of WYAS, Wakefield

Portraying progress in the West Riding 61

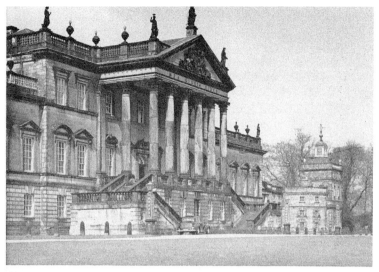

Lady Mabel College of Physical Education

Bretton Hall College of Music, Art and Drama

Figure 3.5 Two buildings that symbolised a new importance accorded to physical education and the arts in the school curriculum and teacher training

(WREC 1954: facing p.104)

Published by permission of WYAS, Wakefield

other LEAs as a 'Teachers' Refresher Course College', a residential facility for teachers' professional development in a dignified and comfortable setting that might enhance teachers' morale and motivation.

Images of stately homes for training teachers contrast uncomfortably with others of schools 'in disrepair' (WREC 1954: opp. p.137), and might conceivably have been read as an affront to families living in deficient housing through post-war austerity. But they can also be seen in retrospect as a successful educational investment in the broadest sense. Wentworth Woodhouse later became a centre for physical education and environmental studies for Sheffield City Polytechnic, now managed as a site of historic interest and outdoor recreation for families, while Bretton's site became the Yorkshire Sculpture Park, a nationally renowned and highly popular resource for art, art education and recreation.

Education 1954–64

1964 saw the return of a Labour central government with strong commitments to educational opportunity. A government report (Robbins Report) the previous year had promised expansion of access to higher education, followed by the launch of the Plowden enquiry that highlighted the importance of well-being and the arts in primary education. Plowden's report suggested a welcome but steady evolution, though educationists in the United States greeted it as evidence of a 'revolution' in British primary schools. Revolution became the meme of the mid-1960s, in education as in popular culture; in 1964 the Beatles and Rolling Stones exploded into national self-consciousness as emblematic of a new youth culture, and the second West Riding report appeared in a dust jacket designed like an early Beatles' album cover.

Its frontispiece displayed innovation, not revolution, respectable modernism of the new County Education offices, with smartly suited staff enjoying the spring sunshine in its grassy forecourt, a tree already in blossom. The architecture department had been busy designing new schools as part of the West Riding development plan, 32 reported in 1954 at a cost of £1.5 million and a further 155 by 1964 at nearly £5 million (WREC 1964: 11). County architects networked with other progressive LEAs and school architects in designing facilities and furniture of high quality.

An optimistic decade of growth is described in this volume with 75 images in all, and an upbeat text of 228 pages, a third longer than the previous report, supported by tables of detailed statistics. In 1964, pictorial representations of curriculum and pedagogy increased noticeably, though a majority of images continue to focus on buildings and environment. Two of these show new swimming pools in use, and two are of dining halls populated by students and staff. But the prevailing emphasis, a characteristic preoccupation of Clegg, is maintenance of decent conditions in school buildings, illustrated by 14 photos. A further 14 depict 'remodelling' of old school buildings, less immediately eye-catching than the bright new architecture of the previous volume, but reflecting

Portraying progress in the West Riding 63

Figure 3.6 In 1964 an emotive pictorial dust cover drew attention to early childhood and creativity, and also gave a distinctive 'modern' appearance to the new Report
(WREC 1964)
Published by permission of WYAS, Wakefield

continued concern for quality of the learning environment, coupled perhaps with a sound Yorkshire sense of economy.

The earlier report had developed a narrative of 'then' and 'now', on a timescale dictated by wartime neglect or damage and, despite the drive for post-war reconstruction, by inevitable economic constraints. By now in the mid-1960s, the focus on 'remodelling' old buildings was a practical and necessary compromise, to cater for a second surge in school rolls with increased numbers staying on at secondary school beyond the minimum school-leaving age. Where in 1954 the prescription had been small-scale improvement

Figure 3.7 A stylish new office building in the civic heart of Wakefield signified the centrality of an expanding education service

(WREC 1964)

Published by permission of WYAS, Wakefield

through redecorated classrooms (Figure 3.3 above), ten years later, attention was drawn to more ambitious structural reordering of interior spaces within older schools.

The photos invite close scrutiny and comparison of two images in representing change. In its previous state, the old hall is seen from a high angle, implying a Victorian vaulted roof and a balcony from which the camera looks down. The remodelled hall is viewed from a lower angle, a new ceiling inserted, with corbels supporting the vault just visible beneath its surface. The old hall appears to be in daylight, which is streaming through the windows; the improved hall has modern lights that hang from its new ceiling, while the shadows cast suggest the scene is shot under floodlights. Characteristic markers of 'old' and 'new' are the wooden dado panelling replaced by clean, flush plastered walls; rows of coat hooks give way to a wall-mounted radio set and loudspeakers. The 'old' shows a sedate school lunch, a few years previous to the remodelling, trestle tables furnished with table-cloths and well-dressed well-fed children, beneficiaries of the 1950s economic recovery, mostly with folded arms, smiling for the camera.

Portraying progress in the West Riding 65

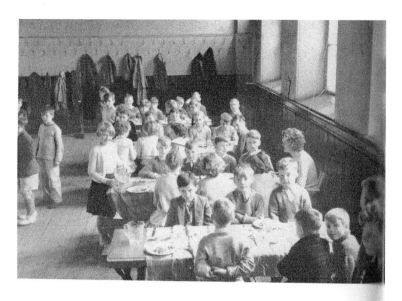

REMODELLING OLD SCHOOL BUILDINGS
The old hall and the improved hall

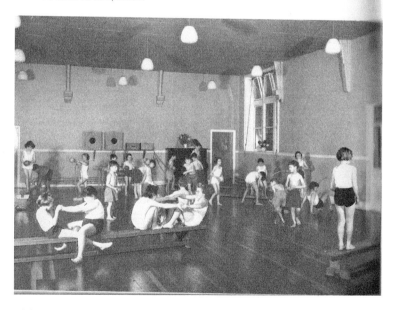

Figure 3.8 The school hall has been substantially modernised to equipped with apparatus for physical education and movement, loudspeakers for music and school broadcasts

(WREC 1964: 182–183)

Published by permission of WYAS, Wakefield

Their younger brothers and sisters in the lower picture, however, are children of the 'sixties, enjoying their remodelled hall for physical education with specialist apparatus, whether or not it may also still be used for meals at lunch-time.

Dining arrangements get further attention in the same report, in this instance not just a case of reconstruction and décor, but also one of furniture and philosophy. A traditional scene is of tables laid in rows, children seated on benches, and a well-regimented queue for service. The photographer's high viewpoint from a balcony reveals floor markings for a badminton court, highlighting the regimentation of this arrangement, as well as the room's dual function. By contrast in the picture below, children sit on comfortable chairs with backs, at round or octagonal tables in a more domesticated environment enhanced by patterned wallpaper and fabrics, and teachers join their pupils for lunch with the appearance of 'family groups', a school ritual akin to a civilised domestic lifestyle.

The Final Ten Years 1964–74

A downbeat title following two buoyant reports, 'The Final Ten Years' reflects an economic downturn in 1974, as well as local government reorganisation that dissolved the West Riding education authority, devolving its work to smaller local units just as Clegg reached retirement age. Yet a three-page 'personal footnote by the Education Officer' that ends the report, while acknowledging 'failures and tribulations of our service, which undoubtedly exist', goes on to enumerate 'points of gratitude' to his Committee for what they have made possible. For 'the many youngsters whose lives need educational compensations' these have included Outdoor Pursuits Centres, Area Music Centres, a Museum Service, and original works of art in schools. Facilities to train and support teachers, and to allow experiment in their ways of working, have been provided, and the Committee has 'made time available to me to visit schools and colleges and keep myself acquainted with experiment and developments within them'. He thanks the Committee too for recognising the importance of caretakers and their training: 'They have realised that their work helps to create a civilising environment' not merely making schools ready for education 'but part of the education which those schools provide' (WREC 1974: 108–110).

This valedictory report was half the length of its precursor, the shortest of the three reports (understandably as there were no future plans to discuss), and only half the number of illustrations – 38 in all. It catches attention, however, this time with a glossy laminated binding and sharp pictorial cover that foregrounds creativity in the form of musical performance in schools. In 1973, the authority had been awarded the first national award of the Music Council of Great Britain for what was described as 'imagination in conception and vigour in execution in the field of music' (WREC 1974: 6).

The proportion of themes was reversed from the previous report, two-thirds now representing curriculum and children's work.[2] But reflecting Clegg's

Portraying progress in the West Riding 67

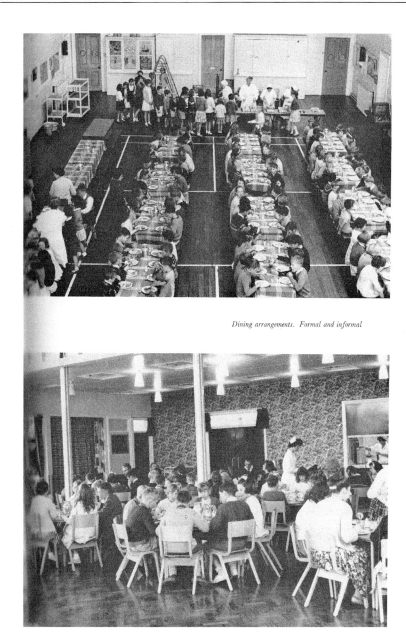

Dining arrangements. Formal and informal

Figure 3.9 Views representing modernisation but the centrality of dining together as a function of the 'informal curriculum' contributing to young peoples' social development

(WREC 1964: 150–151)

Published by permission of WYAS, Wakefield

Figure 3.10 The 1974 pictorial front cover designed, in common with the 1964 cover, to portray the intense concentration of a student's artistic performance, with musical achievement as a leading theme of the report

(WREC 1974)

Published by permission of WYAS, Wakefield

particular concern for the maintenance of decent conditions, a significant picture shows the Caretakers' Training Centre.

This late page in the final report, perhaps mundane at first sight, is significant for an historical evaluation of Clegg's style of leadership, treated by Brighouse in Chapter 1. It sustains a theme introduced in 1954 with a long

Portraying progress in the West Riding 69

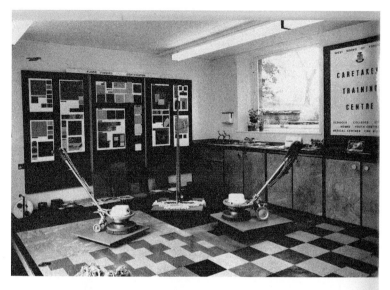

CARETAKERS TRAINING CENTRE

Figure 3.11 Several images throughout the three reports illustrate Clegg's emphasis on the importance of caretaking in its contribution to a school environment

(WREC 1974: facing p.71)
Published by permission of WYAS, Wakefield

chapter on maintenance and equipment of schools, and key statements on 'colour schemes', on 'school surrounds and playing fields', as well as on 'sanitary conveniences'; in 1964, this topic had included an additional chapter specifically on 'The Cleaning of Schools'. A 'persistently crusading' Ernest Peet had been appointed Superintendent of Caretaking in 1948, and produced a manual, 'A New Approach to Clean Schools'. Peet was scientific in his approach to efficient and effective cleaning, its aim to achieve attractive, clean and safe facilities in schools, with an emphasis on improved decoration. In his long career with the West Riding, almost as long as Clegg's, he gained a national reputation for his ideas and inventions. Elsewhere are photos of 'Contrasts in caretakers' store rooms' (disorderly and orderly), and of rubbish culpably stored in a playground (WREC 1964: 54–55). Clegg himself almost always gave the introductory talk for Courses in Caretaking at Woolley Hall. That background may lead to viewing Figure 3.11 with renewed interest. In its time, readers would have recognised this image in contexts like the national Ideal Home exhibitions, a major annual event in the consumerist 1950s, and rapidly growing interest in furniture and furnishings from designers like Terence Conran in the 1960s. They would have been struck by the technology, variety of floor and wall coverings, and fashionable furniture, as well as fresh flowers that might be seen especially in primary schools.

Visual history and images of progressive education

Clegg's creativity in adopting visual means to promote educational progress leaves a rich seam of evidence for historians to mine, not just a question of one person's work, but also of the age in which he worked. When Clegg began his teaching career in the early 1930s, 'new education' had made its presence felt for some time, through international networks such as the New Education Fellowship. New ways of teaching and learning that focused on individual child development, active learning and social interaction were increasingly covered. School environments and children's activities were central features, and photogenic, so the developing media of photography, film and TV were opportune ways of conveying the message.

We know of his interest in educational models from the past, and illustrated books that crossed his desk might have included Harriet Finlay Johnson's *Dramatic Method of Education*, John and Evelyn Dewey's *Schools of To-Morrow*, while the pictorial press had delighted in the entertaining potential of schools such as E.F. O'Neill's at Prestolee in Lancashire (Cunningham 2018; Burke 2005). Film-makers began to explore child-life for its dynamic and captivating emotional imagery, soon exploited by governments in wartime propaganda, during the very years that Clegg was discovering the arts of movement and dance in Arthur Stone's primary teaching methods (Cunningham 2000).

The second West Riding report appeared soon after the launch of the Plowden enquiry into primary education, on which West Riding practice, and Clegg in person, had considerable influence. Its extensive published report in 1967, *Children and their Primary Schools*, was lavishly illustrated with photos, in colour as well as black and white, of pupils at work and play inside classrooms and in school grounds (DES 1967). The high media profile gained by Plowden also resulted in prolific coverage in illustrated magazines and TV documentaries. Eileen Molony was one BBC producer who particularly stood out as interpreter on screen of child-centred primary education (Burke and Cunningham 2011).

Educationists and visual historians have turned their attention to interpreting these representations of schooling, to understand their significance in public understanding, the conditions under which local authorities may have acceded to or commissioned such filming, how directors and photographers approached their work, and how it was received by parents and the general public. Undoubtedly, visual images came to play a significant part in popular discourse on schools and schooling. A seminal study was *Silences and Images: The Social History of the Classroom*, published in 1999, where Ian Grosvenor introduced a framework that might help us today in interpreting the illustration of these West Riding reports, recognising that photographs:

> ...are products of cultural discourse... photography constitutes a site of production and representation... a photograph must be read not as an image, but as a text, and as with any text it is open to a diversity of readings.
> (Grosvenor et al. 1999: 88)

In the 20 years since, international scholarship has provided new insights in this field. Educationists have viewed visual media as a factor in interpreting the dynamics of change over time. Braster, Grosvenor, Pozo Andrés and a team of researchers critically reviewed a variety of sources, including photographs, for understanding children's and teachers' experiences in the 'black box' of the classroom, and Dussel has explored a 'visual turn' in the history of education (Braster et al. 2011; Dussel 2013). Their approaches are central to evaluating Clegg's work, as seen in several chapters of this book. His own aesthetic sensibility is evident, and his appreciation of a central role for the arts in school. Moreover, as we continue to learn from his work, there's abundant contemporary relevance in deploying visual images to spark debate and provoke discussion about educational ideas and practices.

Notes

1 The pamphlet ran into seven impressions by 1970 and had sold over 63,000 copies by 1974 (WREC 1974: 5). See also Chapter 2 (Lawn).

2 Throughout the three reports, almost 200 images reflect a distinct shift in focus:

	1954	1964	1974
Total images	80	75	38
Buildings and accommodation	75%	60%	24%
Pedagogy and curriculum	25%	40%	76%

References

Braster, S., I. Grosvenor and M. Pozo Andrés. eds. (2011). *The Black Box of Schooling: A Cultural History of the Classroom*. Brussels: Peter Lang.
Burke, C. (2005). '"The school without tears": E. F. O'Neill of Prestolee'. *History of Education* 34(3): 263–275.
Burke, C. and P. Cunningham. (2011). 'Ten years on: Making children visible in teacher education and ways of reading video'. *Paedagogica Historica* 47(4): 525–541.
Cunningham, P. (2000). 'Moving images: Propaganda film and British education 1940–45'. *Paedagogica Historica* 36(1): 389–406.
Cunningham, P. (2018). 'Picturing progressive texts: Images of "democratic schooling" in the work of John and Evelyn Dewey and contemporaries'. *History of Education* 48(1): 118–141.
Darvill, P. (2000) *Sir Alec Clegg: A Biographical Study*. Knebworth: Able Publishing.
DES (Department of Education and Science). (1967). *Children and their Primary Schools: A Report of the Central Advisory Council for Education (England)*. London: HMSO. www.educationengland.org.uk/documents/plowden/plowden1967-1.html
Dussel, I. (2013). 'The visual turn in the history of education: Four comments for a historiographical discussion', in *Rethinking the History of Education: Transnational Perspectives on its Questions, Methods, and Knowledge*, ed. Popkewitz, T. Basingstoke: Palgrave Macmillan, 29–49.
Gosden, P. and P. Sharp. (1978). *The Development of an Education Service: The West Riding 1889–1974*. Oxford: Martin Robinson.
Grosvenor, I., M. Lawn and K. Rousmaniere. eds. (1999). *Silences and Images*. New York: Peter Lang.
Lester Smith, W. (1954) 'West Riding education. Ten years of change', book review. *British Journal of Educational Studies* 3(1): 83–84.
MOE (Ministry of Education). (1949). *Story of a School*. Pamphlet no. 14. London: HMSO.
MOE (Ministry of Education). (1952). *Moving and Growing: Physical Education in the Primary School*. Part 1. London: HMSO.
MOE (Ministry of Education). (1953). *Planning the Programme: Physical Education in the Primary School*. Part 2. London: HMSO.
Niblett, W. (2001). *Life, Education, Discovery*. Bristol: Pomegranate Books.
WREC (West Riding Education Committee). (1954). *West Riding Education: Ten Years of Change*. Wakefield: West Riding County Council.
WREC (West Riding Education Committee). (1964). *Education 1954-64: A Report on the Development of the Education Service in the West Riding of Yorkshire*. Wakefield: West Riding County Council.
WREC (West Riding Education Committee). (1974). *The Final Ten Years 1964-1974*. Wakefield: West Riding County Council.

Chapter 4

Progressivism and art in the West Riding
The role of its Chief Education Officer

Peter Cunningham

'Progressivism' suffers at once from soft interpretations and hard emotive responses. Historically, it has stood for advocacy of social justice, reducing or ameliorating economic inequality, liberal and democratic political reform, but at the same time for advancement in science, technology and economic development for the human condition, two strands that can be in ideological conflict. In educational settings, its vague definition and over-use, especially in antithesis to 'traditionalism', has attracted justifiable critique. In a post-war context of social reconstruction, however, we recognise advocacy of progress for positive change in extending democracy, social or economic equality, and improved well-being of a population. Clegg's West Riding provides evidence of progressive interest in liberal education for personal development and for community cohesion.

In that post-war period, a number of Chief Education Officers (CEOs) were committed to innovation, such as John Newsom in Hertfordshire (Parker 2005) and Stewart Mason in Leicestershire (Jones 1988), who along with Alec Clegg were notable for fostering progressive practice in their schools generally, and particularly through the arts. Clegg's work was influential locally and nationally, where the West Riding was the second largest county by population after London, setting a highly visible example of innovative ideas in practice. This chapter introduces a focus on the arts. It will be instructive first to consider the influences on Clegg's progressive philosophy, and his distinctive application of this in his role as CEO. How this might translate into teaching approaches, relationships between teachers and taught, within school and beyond, is then reviewed for his ultimate interest in effective and enjoyable learning, acknowledging the controversies aroused by 'progressivism' in education. The chapter then concludes by discussing the progressive role of art in the curriculum, against a wider background of progressivism and the arts in society.

Progressive philosophy

Though many factors were at work in place and time, much of the credit for change in the West Riding was due to Clegg's idealism, leadership qualities and

administrative skill. Progressive principles, such as child-centredness, curriculum reform and concern for the school environment, ran through his administration, guiding its development and innovations. He admitted having schools in his blood as his grandfather and father had both been teachers, as had also his wife. Nurture, as well as nature however, played an important part in his professional formation, and while studying modern languages at Cambridge, he worked voluntarily with Henry Morris, Director of Education in Cambridgeshire (Clegg 1980: 138). Morris advocated provision of art in schools, along with encouraging the use of schools for adult education and leisure outside the school day (Rooney 2013). He exerted a direct influence on several Cambridge undergraduates such as Alan Chorlton (later CEO for Oxfordshire) and Harry Rée, Morris's biographer (Rée 1973), university students who carried his idealism into notable careers in educational administration, and other future CEOs such as Stewart Mason when posted to Cambridge as a young inspector (HMI) in the 1930s.

After graduating, Clegg went on to the London Day Training College in 1931–32, commenting 35 years later that 'the privilege of work with the Nunn, Burt, Dover Wilson trinity' placed him amongst 'the most fortunate intending teachers to have been trained in this country so far' (WREC 1967). Professor Percy Nunn's advocacy of student-centred learning no doubt contributed to his progressive philosophy, psychologist Cyril Burt's research focused on differentiating individuals as learners, and promoted child guidance, while Shakespearean scholar John Dover Wilson advocated a creative role for literature in the curriculum. (All three, like Clegg himself, were later awarded knighthoods for their outstanding contributions to education.) Clegg's own quirky spirit embellished these influences. One of his former deputies, Jim Hogan, wrote of Sir Alec's disregard for conventionality, while another, Len Browne, described him as 'The Puck of the educational world. To work with him was occasionally exasperating but never dull or mechanical' (Browne 1986).

He began his career as a grammar school teacher at a time when, in his view, the curriculum had become ossified by examinations and 'people no longer had to think *why* they were teaching what they were teaching' (Clegg 1974a). Progressivism in practice required critical philosophical reflection by teachers. His commitment to problems of deprivation and educational disadvantage was integral to progressivism as a social and political movement.

> Schools should be, for the less fortunate, what the home is for the more fortunate, a place where there is work but where there is also laughter; a place where there is law but there is also grace; a place where there is justice but where there is also love.
>
> (Clegg 1974b: 14)

So, education of the spirit took precedence for Clegg over education of the mind, a priority illustrated in the best of the primary sector:

> The richer understanding of a child's needs has made the best of our primary schools places of beauty, and communities in which eager activity and loving concern prevail.
>
> (Ibid.)

Characteristic of Clegg, he drew on history to give these principles a political edge, their implication for timeless principles of democracy and social justice. He quoted a school inspector of a previous century, a statement made by HMI Reverend Moseley reporting to the Lords of the Treasury in 1847:

> Education is not a privilege to be graduated according to man's social condition, but the right of all, in as much as it is necessary to the growth of every man's understanding; and into whatsoever state of life it may please God to call him, an essential element of his moral being.
>
> (Clegg 1980: 159)

In this vein, Clegg applied his progressive philosophy to oppose the practice of selecting and segregating young people of different abilities and social backgrounds at the age of 11 for their secondary schooling.

Clegg's interest in taking up the post of CEO was to improve the practice of education, and administering a local authority was a means to this end. A skilled administrator, he imprinted his personal idealism on the education service of the Riding, while at the same time committed to teamwork. This sharing of ideas, collaboration with and delegating to his team of professionals, can be seen as progressive against hierarchical traditions of local government at that time. It applied too in his relations with councillors, the politicians to whom he was answerable. In his first year of office he worked with Walter Hyman, Chair of the Education Committee, to simplify the policy-making process and concentrate decision-making in a single Policy Sub-Committee, leaving himself free to spend more time in schools and colleges to keep himself fully acquainted with their development and needs (Gosden and Sharp 1974: 33). Attendance at other sub-committees he delegated to the trusted deputies he had gathered around him.

His political philosophy was reflected in his personality. Visiting schools and addressing conferences, his personal charisma made a lasting impression. On 17 June 1955 he recorded 'A Day in the Life of a CEO': it was a long day that lasted into the late evening but notable events included a midday visit to Carlinghow School, where discussion took place with teachers about 'the best way of spreading ideas which the headmaster had worked out', and at 7.00 pm a meeting with advisory staff at Woolley Hall teachers' centre to help coordinate a course of professional development, followed by an address to the course on 'Brighter School Environment' (WREC 1955). His classroom visits counted for a great deal and would be remembered years later; their impact was such that for thousands of teachers far-flung across the West Riding, the possibility of an unannounced visit by Clegg remained a powerful and motivating myth.

Progressive pedagogy

Clegg's lively critical thinking on pedagogy was expressed throughout his career in over 200 speeches, now archived at the NAEA. Their content and significance were deftly summarised and interrogated in question-and-answer form in a memorial lecture by a former Deputy, Peter Newsam (Newsam 1990). Questions that Clegg posed, for himself and for others, begin in characteristically simple terms: 'What main theories underlie the way people have tried to explain what teachers should do to cause children to learn?'. The images he chose for response were 'pot-filling' and 'fire-lighting'. Pot-filling he described as exposition by the teacher, followed by drills, exercises and written compositions designed to show the child has understood or memorised what the teacher has said. Most of us, he told an audience at the Royal College of Art in 1960, did most of our learning that way. On 'fire-lighting', he explained:

> The main aim of education is not just to prepare for something that is to come in the future, but to promote healthy growth and development now. The best way of doing this is to place the child in a stimulating environment, give him [sic] a wealth of experience rather than a welter of facts, and let his training and technique come through the activities into which he is guided by a wise and sympathetic teacher...
>
> Each child is encouraged to mount the ladder of his own achievement, building it rung by rung as he goes. His own success kindles the fire, and he no longer measures himself to his own detriment against his more successful fellows. The emphasis is very much more on making the child want to learn, and this, of course, is in essence real education.
>
> (Newsam 1990: 4)

As an expert witness to the Plowden Committee, a few years after that speech, Clegg set out clearly and concisely what he saw as the distinguishing features of 'informal' and 'formal' primary schools; though both types of school produced similar results as far as basic skills were concerned, he suggested that informal teaching would increase, due to its concern for an individual child's family background ('important in these days when so much is done to and for the mass'). This approach resulted in happier and better-behaved school communities where a superior quality of work was produced; these were not just subjective judgements, he claimed, and could be demonstrated (Clegg 1964).

Peter Newsam observed that Sir Alec's achievements 'stemmed from a rare ability to understand and trust the relationship between teacher and taught, between child and adult. And to that understanding he brought a sustained commitment to use the resources of a powerful education authority to support and enhance that relationship in every possible way' (Newsam 1986). It might be said that his own progressive disposition and behaviour fostered a similar philosophy and practice to prevail in classrooms within his authority. His respect for

teachers' professional judgement, for example, was reflected in a proposal that the 11+ selection process should include a record of personal qualities alongside attainments in arithmetic and English, with an opportunity to expand the scheme as teachers became familiar with its use and able to advise the authority on its shortcomings:

> It will be necessary, if this scheme is to succeed, not only to rely completely on the integrity of the [junior] school teachers but to make them very clearly aware that diagnosis of the child's capacity and interests must more and more become a part of their professional duties.
>
> (WREC 1946)

Clegg attached importance to improving both initial and continued education of teachers. Circumstantial factors assisted him in this: a well-established precedent in the Riding of in-service provision through the Annual Vacation Course, dating back to 1912 and traditionally overseen by the executive; and the Ministry of Education was very supportive of his efforts at setting up new training colleges after the war (Gosden and Sharp 1974: 101–115).

A noteworthy achievement for its national influence was the foundation of a residential college for continuing professional development of teachers, a quite original concept for that time, in Woolley Hall. The special atmosphere of Woolley Hall and its courses reflected his progressivism, but he had to use his powers of assertion and persuasion to navigate local opposition, as well as some astute deployment of contacts in national government. He foresaw that this project would be thought an expensive addition to the already costly development plan for new school buildings, but stressed that good teachers are more important than good buildings, and to neglect the teachers would be to put the cart before the horse (WREC 1945). The project was to purchase and refurbish a former stately home to ensure what he saw as fitting accommodation for cultivating the conviction, commitment and skills required by the teaching force to implement new approaches to their work. Diana Jordan, significant as a charismatic adviser in dance and movement (Chapter 6), was appointed its first Warden.

Another means of improving quality and professionalism of teaching was judicious use of the teachers' advisory service, and here again Clegg was able to benefit from a well-established tradition in the West Riding; although the Plowden Committee found in 1965 that less than one-third of Local Education Authorities employed their own inspectors, the West Riding had appointed its first inspector back in 1891, and its first adviser in 1906 (Gosden and Sharp 1974: 122). Clegg's most inspired appointments to the advisory service were in the field of the arts and included individuals whose work he had come to know personally, such as Arthur Stone and Diana Jordan. His philosophy was that advisers, like teachers, would work most effectively not by instruction in technique, but by interest, encouragement and enthusiasm, and this bore fruit

in the 'family feeling' which was said to characterise the West Riding: 'A feeling of belonging as an individual to a large body of people linked by a common attitude towards children and learning' (Tattersall 1976). A *West Riding Schools Bulletin*, in which teachers were encouraged to publish, was one manifestation of this policy.

Clegg's gift of communicating progressive pedagogy was reflected in his art of using language. Most memorable and frequently cited from his speeches was the framed verse about Loaves and Hyacinths that he saw as a child on his aunt's wall.

> If though of fortune be bereft, and of thine earthly store hath left,
> Two loaves, sell one, and with the dole, buy hyacinths to feed the soul.

Aesthetic and spiritual qualities are as important to sustain well-being as is food for the body. He sought to disseminate educational principles and approaches to teaching, and to encourage debate, not only locally but nationally. On writing as an art form, *The Excitement of Writing*, the first of his anthologies of children's work, was originally produced in 1963 as a 'report by the West Riding Education Committee' edited by C.T. Broughton (Committee Chair) and A.B. Clegg, and circulated amongst West Riding schools to disseminate good practice and encourage a creative approach to children's language learning. Published commercially the following year, its success was huge: by 1974, over 30,000 copies had been sold, and a special edition commissioned in the United States. A typically pragmatic spin-off was that royalties from this and later books were paid into a special education fund at the disposal of the Education Officer for educational amenities (WREC 1972).

Progressivism and the arts

'Progressivism' in education and the arts emerged in the United States at the turn of the 19th century in its political 'Progressive Era' and continued through to the period of the Great Depression in the 1930s. John Dewey's *Art as Experience* (1934) aimed to 'restore continuity between the refined... forms of experience that are works of art, and the everyday events... and sufferings that... constitute experience' (cited in Dimaggio 1988: 72). Art museums came to be seen as active educational institutions, as instruments of public service, and the art museum's role was to bridge the gap between art and experience. There emerged a 'conscious direction of effort to further the arts by leaders in education and recreation' (Ibid.: 74). Teachers College at Columbia University, New York, where Dewey taught, became involved, and wealthy American foundations such as Carnegie supported innovative efforts to integrate art with everyday life.

In Britain, the government commissioned and purchased works by leading artists of the time as a record and memorial of the First World War, later

exhibited at the newly established Imperial War Museum in London. In London also, in 1933 a radical left-wing group of artists founded an Artists International Association, to promote 'unity of artists for peace, democracy and cultural development'. They held a series of large group exhibitions on political and social themes and promoted wider access to art through travelling exhibitions and public mural paintings. A state initiative in 1939 was the War Artists Advisory Committee administered by the government's Ministry of Information; here, the primary purpose was to produce propaganda images, but at the same time trying to preserve the lives and talents of some of the country's leading artists. Although an official recognition of a public, conceivably educational, role for art, in this case the project was problematic and divisive, seen by many as constraining artistic freedom that should characterise liberal and progressive values. Probably the most notable war artist, however, was the thoroughly independent spirit, Henry Moore, born and educated in West Riding, who became an icon for local art consciousness in Clegg's time.

Yorkshireman Herbert Read gained worldwide influence as a leading cultural critic, art historian and philosopher in the inter-war years, an exponent of quietist anarchism. His *Education through Art* (1943) was prompted by a wartime government commission, curating an exhibition of British children's art to tour allied and neutral countries (Thistlewood 1994). Clegg appointed as art advisers Basil Rocke, who had worked with Franz Cižek, international pioneer of children's art, and Ruth Scrivener, whose pupils' art at Bedales School illustrated Read's book. Read as an intellectual commentator, like art teacher Marion Richardson, author of *Art and the Child* (1948), had been touched by the expressive power and emotional content of some young artists' works, and between them generated a persuasive rationale for art education, its importance for a liberal society and its effectiveness in the classroom.

During the inter-war years, official bodies with commercial interests such as the Post Office, Empire Marketing Board, British Railways and London Transport had commissioned leading modern artists to produce posters of such quality that they were distributed to schools. These 'Prints for Schools' made a significant contribution to the aesthetic environment of classrooms, at the same time as children's art was being encouraged and valued. Post-war cultural policy included the establishment of a national Arts Council in 1946, and a 1951 'Festival of Britain' on London's South Bank, which provided a showcase stage for contemporary art, design, architecture, music, drama and other performing arts.

In these respects, West Riding initiatives reflected a wider trend in the 'spirit of the age'. London County Council's 'Patronage of the Arts' scheme (1957–65), like Hertfordshire and Leicestershire, inspired by earlier ideas and policies of Henry Morris in Cambridgeshire, advocated aesthetic values in the design of new school buildings and acquired works of modern art for the school environment, to redress a relative cultural impoverishment in urban and rural areas. Funds were provided to embellish urban environments and schools with new

works of art (Pereira 2013; Historic England 2016). Mason in Leicestershire followed this path with particular emphasis on supporting a new generation of young artists, especially those working with abstraction, buying their sculptures and paintings for schools. At the same time, he encouraged instrumental music in the curriculum, school orchestras, public concerts and even international tours (Whitechapel Art Gallery 1967, 1980; Jones 1988: 69–94; Henry Moore Institute 2016–17).

Such policies harmonised with advancing the status of art in the curriculum. Clegg's personal engagement and emotional response was distinctive. In proposing a training college for teachers of art and music in 1946, he made a passionate argument that reflects Herbert Read's thinking:

> It might not unreasonably be claimed that the catastrophe of the last six years was due to the failure of man's sensibilities to temper the use of the forces placed at his disposal by his highly developed intellect. It is undoubtedly true to say that in the schools, we tend to teach what can be tested and memorized to the neglect of the more civilizing subjects and activities of which Art and Music are two. There is thus a case for strengthening the teaching of these subjects and raising their standard and status in the schools.
>
> (WREC 1946)

Clegg's penetrating insights on curriculum and teaching came into play. He noted that the Ministry of Education prescribed courses for teachers of physical education, handicrafts and domestic subjects, and for teachers of art, which included pedagogical consideration of all children's needs. By contrast, music teachers, recruited for instrumental expertise, were focused on narrow technical skills rather than broad appreciation. The native aptitude of talented musicians and lack of pedagogical training might hinder their understanding of most pupils' needs.

Moreover, there were sound educational arguments for an element of integration in the arts:

> Music and Art are almost invariably taught as isolated subjects despite their common purpose, which is to stimulate and train the child's sensibilities and, furthermore, the training in each subject, particularly in Music is apt to be narrow.
>
> (WREC n.d.)

His proposal was to train teachers of the arts in an interdisciplinary environment, with the aim that students might gain 'a wide conception of the Arts generally and their effect on the education of the child' (ibid.; Thistlewood 1990). The outcome was Bretton Hall, a highly original foundation, the life and experience of which is described in rich detail by Mills in Chapter 7.

Conclusion

Though not without critics and opponents at the time, inevitable in the leadership of such a large local authority and in the field of education where ideological differences are bound to polarise opinion, there was widespread appreciation of Clegg's achievements, his contributions to thinking and discourse along with his modelling changes in practice. Historians of progressive education reform are wary of the hagiography that key figures such as Rousseau, Montessori and Steiner have generated, and are alert to divisive aspects of their heritage. But the estimation of Clegg's influence for good has been almost entirely positive. His final years of office however also coincided with a range of attacks on progressivism triggered by the Plowden Report: by philosophers who challenged the principles of child-centred learning; by sociologists and social psychologists who identified it as a middle-class mode that alienated working-class families, or who questioned the sustainability of the teacher's role; and most publicly by polemicists and politicians who saw it as undermining traditional discipline. His years of retirement in the 1970s and 1980s witnessed a backlash in central government policies against progressivism.

Clegg's inclusive concept of the arts' place in personal, social and emotional development is revealed in his thoughtful and self-critical reflection on a 14-year-old's self-portrait that he kept in his personal collection, currently exhibited in the NAEA. (see 'Art in the West Riding classroom' p. 104 below). Clegg described this work as 'the most moving picture I have ever seen', explaining that the boy had left school at the earliest opportunity to work as a labourer but also engaged in delinquency. 'This picture came from a child who was branded an educational failure.' [but] 'We have no right to talk in these terms. His fate is a failure for me and for the West Riding …'. Clegg's response to children's artwork valued their quality of engagement in the creative process rather than the aesthetic qualities of the work itself: '…good expressive work induces a success, a zest and an eagerness which cannot do other than stimulate the child's intellectual as well as spiritual growth…' (NAEA n.d.).

References

Browne, L. (1986). Sir Alec Clegg (Obituary). *Education*, 24 January 1986: 82.

Clegg A. (1964). PL/6/4 Paper 91 'Aims of education' by Sir Alec Clegg; Plowden papers PL 10/5 'Evidence from A.B. Clegg'. Newsam Archive, UCL IOE.

Clegg, A. (1974a). 'A subtler and more telling power'. *Times Educational Supplement*, 27 September: 24

Clegg, A. (1974b). 'The shadow and substance of education', in *The Changing School: A Challenge to the Teacher* (conference report). London: Goldsmiths College.

Clegg, A. (1980). *About Our Schools*. Oxford: Blackwell.

DiMaggio, P. (1988). 'Progressivism and the arts'. *Society* 25: 70–75.

Gosden, P. and P. Sharp. (1974). *The Development of an Education Service: The West Riding 1889-1974*. Oxford: Martin Robertson.

Henry Moore Institute. (2016). *City Sculpture Projects 1972*. Leeds: Henry Moore Institute.

Historic England. (2016). 'Out there: Our post-war public art' exhibition at Somerset House, London.

Jones, D. (1988). *Stewart Mason: The Art of Education*. London: Lawrence and Wishart.

NAEA Bretton Hall. (n.d.). Text accompanying 'Doncaster schoolboy' self-portrait. This artwork is held in the NAEA collection, currently (2020) displayed with Clegg's words (undated).

Newsam, P. (1986). 'Sir Alec Clegg (Obituary)'. *Education*, 24 January 1986: 82.

Newsam, P. (1990). 'What price hyacinths?' in *Bramley Occasional Papers* 4, 10–21. Bretton: NAEA.

Parker, D. (2005). *John Newsom: A Hertfordshire Educationist*. Hatfield: University of Hertfordshire Press.

Pereira, D. (2013). 'London County Council's "Patronage of the Arts Scheme" (1957–1965)', in *The Decorated School: Essays on the Visual Sculpture of Schooling.* ed. Burke, C., J. Howard and P. Cunningham London: Black Dog, 52–58.

Read, H. (1943). *Education Through Art*. London: Faber & Faber.

Rée, H. (1973). *Educator Extraordinary: The Life and Achievement of Henry Morris*. London: Longman.

Richardson, M. (1948). *Art and the Child*. London: University of London Press.

Rooney, D. (2013). *Henry Morris: The Cambridgeshire Village Colleges and Community Education*. Cambridge: Henry Morris Memorial Trust.

Tattersall, E. (1976). 'The West Riding philosophy', in Open University. *The West Riding: Changes in Primary Education*. E203 Case Study 2, 16.

Thistlewood, D. ed. (1990). *The Sir Alec Clegg Memorial Volume*. Bramley Occasional Papers, 4. Wakefield: Lawrence Batley Centre for the National Arts Education Archive (NAEA).

Thistlewood, D. (1994). 'Herbert Read', in *Prospects: The Quarterly Review of Comparative Education* 24(1–2): 375–390. (Issued by the International Bureau of Education at UNESCO, with headquarters in Paris.)

Whitechapel Art Gallery. (1967). 'British sculpture and painting from the collection of the Leicestershire Education Committee' (Exhibition catalogue).

Whitechapel Art Gallery. (1980). '"Growing up with art": The Leicestershire Collection for Schools and Colleges' (Exhibition catalogue).

WREC (West Riding Education Committee Papers, Brotherton Library, University of Leeds). (1945). Box 2/G1: Sub-Committee: Post-war education, 16 October 1945, Agendum 4, Memorandum.

WREC. (1946). Box 15/LT25: Policy Sub-Committee, 19 November 1946.

WREC. (1955). Box 2/G8: 'A day in the life of a CEO', 17 June 1955.

WREC. (1964). Box 2/ U2: Comments on Plowden Working Paper re middle schools, 28 May 1964.

WREC. (1967). MS 731 Box 15/0063: Letter from Clegg to Cyril Burt, 16 August 1967.

WREC. (1972). Box 15/LT56: Policy and Finance Sub-Committee, 11 June 1972.

WREC. (n.d.). Box 2/BB1: Proposal to establish Bretton Hall.

Chapter 5

Arts education and oracy with Muriel Pyrah in the West Riding, 1967–1972

Lottie Hoare

'If someone cares enough to bother, [the children] will care enough to give.'
(Pyrah 1972)

Muriel Pyrah, a West Riding teacher, acquired a high profile only in the penultimate years of her career. This came about, in part, because the Chief Education Officer, Alec Clegg, brought her distinct pedagogy to the attention of a wide audience. A primary and middle school teacher, she worked at Airedale School, Castleford, from 1953 to 1972. Clegg knew Pyrah's work in the early 1960s but took a particular interest in her pedagogical approach from 1967 to 1972, following publication of the Plowden Report. In those years, she taught mainly pupils aged ten to twelve before they moved to secondary school. In a film about her teaching, Clegg's commentary advocates others to reflect on her teaching, as evidence of how working-class children could develop their artistic and academic potential, and confidence in speaking to a group.[1]

This chapter explores the reasons why Clegg wanted Pyrah's reputation as a teacher of arts and oracy to be better known, and how her pupils' recollections can be interwoven with Clegg's hopes, to re-tell the story of how pupils were educated for an uncertain future. I draw on recent interactions and anonymised interviews with a small sample of former pupils.[2] National Arts Education Archive (NAEA) holdings inform the chapter, including artwork and writing created in Pyrah's classes, sound recordings and documentary film.[3] Clegg's published reflections are also drawn on. There was sometimes a gulf between his perception of transformative power in Pyrah's teaching, and how some of her former pupils recall their experiences, but the story of her approach still resonates locally, in conversations about well-being and arts education, almost 50 years after her retirement.

Muriel Pyrah and the context of Airedale School

The term 'oracy' is usually attributed to researcher and educator Andrew Wilkinson, who coined the phrase to define ability to sharpen understanding through use of spoken language (Wilkinson 1965). Oracy highlighted links

between language and experience, observing the significance of talk to order experience and to learn from it. Oracy, alongside dialogic teaching, is now developed with a contemporary focus on how such skills can be explicitly taught and assessed (Mercer et al. 2017; Mercer 2019). Over 50 years ago, Pyrah devised her own method, known as 'asking out', in response to the needs of pupils aged ten to twelve. She had no direct connections with oracy programmes developed in English primary schools in the 1960s, rather evolving her method through trial and error, encouraging children to speak freely in class, in pursuit of knowledge and understanding. Pyrah's approach may have been choreographed in film and media coverage to play into debates of the late 1960s and early 1970s. Sociologist Basil Bernstein, whose work on language made a leading contribution to the field, visited her classroom and subsequently wrote to her, enthusing about her impact on the language skills of local children (Pyrah Collection Letters 1971). Pyrah's conversation on film does not, however, suggest she was actively inspired by other practitioners' experiences or by sociological research.

In Pyrah's classroom, group discussion took place while children were simultaneously making things with their hands. Addressing your peers around you was part of the physical experience of being active. Pupils remained seated at their desks or stood painting at easels and busied themselves making topic books, artwork and needlework, while asking questions of the rest of the class, expanding their vocabulary and receiving feedback from classmates on their making. There was no set order in which pupils spoke and Pyrah acted as a kind of informal chair, nurturing and monitoring the ongoing conversation throughout the school day. Pyrah taught in a classroom crowded with objects and materials. There were nature tables, and children's art festooned around the walls. Each desk was used to make space for books, paper, art materials and sewing all at once, with children not appearing to mind the proximity of shared items useful to their work. Materials used to research, observe and create were constantly visible, not tidied away in cupboards. Resources such as books and art materials were generously provided, and children were encouraged to bring in specimens from the natural world, perhaps discovered on their walks to school, to share and discuss. Useful or evocative words were chalked on the blackboard, awaiting spoken definitions. Pupils were encouraged to join the Royal Society for the Protection of Birds, and to take part in pursuits that furthered their skills of observing and of summarising their research for an audience.[4]

Pyrah's teaching background was not apparently one that might have inspired Clegg's confidence. She was born, Muriel Graham, in Yorkshire, the daughter of a nursery gardener. She attended Pontefract High School but her family refused to allow her attendance at college or university. Instead, she began to teach in local schools, initially as an unqualified assistant, but over the years developed increasing responsibility. She had no experience of Higher Education and remained for her entire teaching career without formal

training (*Sunday Times* newspaper 1968: 28). She did not undergo the kind of training enjoyed by her peers in arts education at Bretton Hall, or the immersive in-service professional training offered at Woolley Hall, highly regarded institutions initiated and championed by Clegg since the 1940s. Archive evidence suggests she neither participated in conferences, read progressive education journals such as *New Era*, nor engaged with organisations such as the National Association of Teachers of English (NATE) which took an interest in oracy. There may, however, have been a tendency to overplay the media story of Pyrah as a hidden secret, given that her husband Clifford, headmaster at Airedale, was already contributing to Woolley Hall conferences in 1959, and arts adviser Diana Jordan was taking an interest in his wife's work by 1962 (Pyrah Collection Letters 1962). Pyrah was primarily self-taught and to a certain extent isolated from professional networks of discussion, apart from with her husband and her sister who was headmistress of the Airedale Infant School (*Sunday Times* newspaper 1968: 28).

Figure 5.1 Muriel Pyrah in her classroom

The Sunday Times Magazine, 7 July 1968

© The Sunday Times Magazine / News Licensing

However, her seeming isolation needs to be understood in the context of the West Riding education authority. Here, proximity of training and pioneering arts education were familiar and local developments, with international contributors. In interviews, former pupils recalled that Clifford was a kind and patient teacher of maths to his wife Pyrah's class, but knew less about art 'than one could fit onto a fingernail'. The school secretary, Joyce Morgan, remembers Pyrah as 'aloof' and tending to avoid socialising with other teachers in the school. She took her coffee in her husband's office, not in the staff room (quoted in Ewan 2019). The Pyrah couple had no children of their own. Former pupils confirmed she did not make time for dance and movement for her pupils, and discouraged her classes from participating in dance activities, in favour of making more time for academic work.

Clegg's publications, such as *The Changing Primary School* (1972a), often made space for the recollections of teachers who favoured reassuring their pupils through the use of imagination, poetry and the power of movement and dance. Pyrah's priorities on the other hand were science, precise observation of the natural world and a shared articulation of factual knowledge. And Clegg's contemporaneous book, *Recipe for Failure* (1972), suggests that as he approached his own retirement, he focused his hopes for the future on some of Pyrah's methods:

> The careful mounting and display of work by the child who has tried hard is a more powerful motive force than the old competition for marks… the child arranging his own study is the beginning of a training in initiative, discrimination and judgment… Minute observation is a training in sensitivity. Readiness to tell others what you have discovered is a way of developing a concern for others.
>
> (Clegg 1972b: 53)

Perhaps Clegg saw an uncertificated teacher like Pyrah as offering a multilayered education for the child, imbued with a sense of developing social confidence, responsibility and a discerning mind. No other individual West Riding teachers were plucked from obscurity and made the focus of newspaper and documentary film coverage the way Pyrah was, and one reason for this strategy may have been Clegg's awareness of needing to protect the West Riding from wider national attacks on progressivism, by highlighting the work of a teacher for whom self-expression was not central. In light of *The Black Papers on Education* (1969–1977) and other doubts voiced by critics of progressive practice, Pyrah may have been a compelling case to champion, as her approach did not align precisely with progressive claims that success in one area of the curriculum would necessarily inspire and motivate the child to flourish in other areas. Her pedagogy sought deliberately, rather than subtly, to impart certain attitudes and values to be gradually assimilated into the community; namely, that a certain way of speaking and a confident ability to research and retrieve

information in both the humanities and the sciences was a crucial priority for life-long learning. This deference towards a core body of general knowledge did not challenge convention, but Pyrah placed a more overt emphasis on the child voicing their curiosity rather than being subjected constantly to the teacher's talk. Religion also seems to have played no dominant role in her curriculum, and in film footage of 'Asking Out' in her classroom, Darwin was introduced as 'the great man'.

Airedale School was one of several Local Education Authority (LEA) schools in the industrial town of Castleford. It served a community where some fathers worked in coal mines, or as manual workers, but not all families did. As one former pupil observed in an interview, a few children travelled from a distance to the school once Pyrah's reputation was well known. There was little unemployment in the period under consideration, and widespread provision of council houses for this stable community where many families had been resident locally for generations. There was little migration into the area. Former pupils remember how local libraries were well used and their use was encouraged by Pyrah. This was not a community that experienced great luxuries, but nor was it faced with striking deprivation. Nonetheless, Clegg was, by the early 1970s, voicing his foresight and apprehension for the future of communities such as Castleford where 45 per cent of families were working class. The town had been designated an Educational Priority Area (EPA). Clegg wondered whether education could intervene to bring hope when confronted with the looming doubts about stable employment long term. In *Recipe for Failure*, he drew on the Hunt Report to affirm that the Yorkshire coalfield had an unfavourable male employment structure, together with little opportunity for female employment; the villages were seen as lacking resources as an adequate basis for renewal of the area, and the 'ravages' and subsidence caused by mining were seen to deter other industrialists who might otherwise be attracted to a ready supply of male and female labour (Clegg 1972b: 34–36).

Clegg was vocal that the school must aim to offer what society lacked. We can speculate that Pyrah also saw school as an agency for change in a mining area, but she didn't commit to writing any views about how schools might change society. On film she comes across as quite detached and abrupt in her outlook, with little interest in contradictions or clash of perspectives when discussing pupils. Airedale was a two-form entry school, so while Pyrah was established as teacher of one of the final-year classes, there was always another class taught in parallel that did not experience her pedagogy. Interviewees recalled that she and her husband Clifford between them picked the most academically able pupils for her class. Former pupils referred to being chosen for Pyrah's class as being associated with a kind of dread: 'we drew the short straw'. They recalled parents as generally favourable to Pyrah, however. She had worked in the community for so long and had also taught some of the parents, even though for the earlier generation her methods were not so focused on 'asking out'. The 'Thorne Scheme' operated in two-thirds of West Riding areas by 1964, and

had been encouraged by Clegg, based on teacher recommendation, instead of selection tests to enter secondary school. Castleford had rejected participation in that scheme (Gosden and Sharp 1978: 179). Media coverage of Pyrah's approach by 1968 suggested that her pedagogy increased the likelihood of a pupil from a relatively poor background passing the 'eleven-plus' exam and gaining a place in a selective secondary grammar school (*The Times* newspaper 1968: 4).

Clegg's commitment to the innovatory concept of a 'middle school' coincides precisely with the years of his interest in Pyrah. Castleford had been identified by him back in 1963 as an area that might benefit from reorganisation of middle schools for the 9–13 age group, with the *Yorkshire Post* newspaper heralding a 'buffer school' to prevent exam fear (quoted in Crook 2008). In 1964, an Education Act permitted establishment of middle schools for experimental purposes, but the West Riding did not implement the first stage of reorganisation until 1968, when Castleford resisted change at that point and was determined to retain the junior and senior system (Gosden and Sharp 1978: 189). Airedale pupils reaching age 11 in 1968, in Pyrah's class, were taking the eleven-plus test, but by 1972 the school was operating fully as a middle school. This point needs emphasis because 1967 to 1972 were the years when Pyrah's classes came under the scrutiny of the media and film makers, and Clegg was himself deeply concerned with the well-being of young people. He was simultaneously working with Barbara Megson on the book *Children in Distress* (1968). Middle schools could draw on a consensus of psychologists and child development experts, that for adolescents, the 9–13 age grouping provided a strong pastoral environment for children undergoing physiological change. The parading of Pyrah's work may have been envisaged by Clegg as an example of how this age group should be left to explore discursive learning and expression through arts and crafts to build skills and confidence for various experiences of secondary education. Whether or not children were attending selective secondary schools, the pressure on an EPA to show greater academic progress for working-class children was omnipresent in Clegg's final years. From evidence available on film, Clegg also appears to have hoped that Pyrah's efforts in the classroom could provide empirical evidence that oracy, an absence of streaming and a focus on arts education as a means to record and learn from the immediate environment, all contributed significantly to pupil success in standardised tests aged 11. This was not because of any belief in testing for selection on his part, but because of his awareness of a national popular assumption that tests were a way of measuring success.

Muriel Pyrah's approach to arts education

Both Clegg and the Chairman of the West Riding Committee, Walter Hyman, had long promoted the importance of children producing art their own way rather than the way a teacher imposed. They quoted a 17th-century Yorkshire

schoolmaster, Charles Hoole, to recognise the pleasing variety of 'children's dispositions and fancies' (WREC 1954: 51). At the same time, they saw representational accuracy as a goal to be worked towards, as the child moved out of the junior school age group. The 'freshness, zest, imagination, and exciting use of colour and form' (WREC 1954: 52) could be worked through in the primary school years, but it was not seen as appropriate for this self-expression to dominate secondary school learning, where accurate 'recording' would most likely take precedence (Clegg 1964: 5). That was perhaps why Pyrah's work so fascinated Clegg, as she guided children through the transition from junior to middle school learning, on the cusp of experiencing this pedagogical shift. Their artwork resonates with a sense of being dutifully created, but her emphasis on careful recording of the environment through art should not necessarily be viewed negatively as a limitation derived from her lack of training. In *Recipe for Failure*, Clegg wanted all children to experience what might be seen by some as the 'frills' of education, because in his view these very activities were not frills at all, but rather enriched life and developed sensitivity. He felt dismay that the less fortunate child was seen as hardened by their upbringing and perceived by some as impervious to cultural experience (Clegg 1972b: 51). At the same time, however, he tended to speak on camera, and write in publications, about children and families in these communities in deficit terms rather than drawing attention to positive and constructive aspects of their home lives.

Another factor that may have shaped the pupils' confidence in their own artwork became apparent in sound recordings made at Airedale during the late 1960s, where no adult voices are included. These recordings were made not for public broadcast, but instead for educators and researchers interested in pupils' speech.[5] Recorded topics of conversation include buying notebooks and pens on market stalls and in shops, which is discussed with particular excitement in 'Value for Money'. The children discussed with one another, in detail, the different pens and paper that they bought in local shops and markets, with moments of excessive formality: 'I obtained a pen in Woolworths'. But they also explained the number of pages in jotters, the kind of pens that enabled them to draw in very thin lines or lines that looked like watercolour, and the varying prices for such items in Dewsbury and Pontefract. Even though school provided ample resources and the environment for making art when they were aged 10 to 12, these children had been drawing at home for years, and parents had been providing materials. Home support was a starting point to be acknowledged, though Pyrah's sharing a fascination for the natural world, and her guidance in encouraging observational artwork, no doubt furthered such precise and memorable development. Voice-overs from adult narrators on film present the children as living in an under-resourced vacuum before Pyrah became their teacher. But sound recordings made for educational rather than media interest inform us that Pyrah's pupils were very familiar at home with drawing and jotting notes, and significantly this habit had been ongoing for years. Interviewees also recalled drawing contemporary events both from

imagination and influenced by news broadcasts at home, such as the Vietnam war and the first landings on the moon.

The artwork produced in Pyrah's classes, preserved at the NAEA, show a marked absence of spontaneity but a dedication to carefully observing nature. By contrast, work created at nearby primary schools such as Whitwood Mere Infant School, Brookfield Infants and Simpsons Lane First School, show images of childhood chosen by and produced by children, their archive boxes brimming with paintings and collages of local scenes, of children with musical instruments, semi-cartoon people dancing, street scenes with pushchairs, and textured, layered reconstructions of nature made of hessian and felt and beads. By contrast, Pyrah's classes produced serious images, never comic or fanciful. The colours are murky and textures never as adventurous as the surviving material from nearby schools in the same years. From the evidence of what she guided them to produce, it is apparent that Pyrah had not been to art school or a teacher training college that might have emphasised cultivating self-expression. Surviving artwork arguably rejects childhood, performing and refining the future adult selves of those who created it. Despite this, the work reveals evidence of deep concentration and careful attention to detail on the part of the children. The making of their own topic books showed that they saw something through from start to finish. They gave the attention of a craftsperson to text and image, since both mattered. They recorded their local frogs, birds, logs and plants and were also directed to research cities beyond their immediate area. Seonaid Robertson, who worked as a senior lecturer in arts education at Bretton Hall from 1948–1955 and oversaw arts teacher training in the West Riding, praised 'the whole-hearted return to observation' that she had witnessed in schools (Robertson 1963: xxi). Robertson also warned however against ignoring the tactile sensations of art in favour of visual and intellectual experiences:

> An earnest teacher who insisted on… drawing from observation… would have taken away what was perhaps [the pupil's] only protection in a harsh world through which… [the] physically delicate, emotionally vulnerable must move… [their] own transfigured version of it.
>
> (Ibid.: 201)

Pyrah's scientific and factual approach was easier for Clegg to use in trying to persuade a wary public, than Robertson's interest in touch, symbolism and phantasy (see 'Art in the West Riding classroom', pp. 100 and 102–103 below).

Her impact as an arts educator was remembered fondly by former pupils wanting to discuss their experiences in both interviews and informal conversations. None of their memories suggested that being in her class had deterred pupils from a lasting enthusiasm for creative artwork. One pupil had profoundly negative recollections of being 'forced to ask out' in front of 32 classmates, yet recognised that her own activity in adulthood, creating paper

sculptures from recycled books, and collaborating in groups to pass this skill and enjoyment on to others, still owed something to her primary education. Lack of a rigid timetable was seen by several former pupils as beneficial. Collage, sewing and book-making had significant space within a school day, not designated as 'extra-curricular' and relegated to after-school clubs. Another individual paid tribute to Pyrah's long-term influence, given time and space as 12-year-olds, and access to a wealth of art materials, later reigniting an interest in arts that played a part in their recovery from a major accident. Viewing archived film of the classroom, this interviewee was struck by the attention to detail, the washes in watercolours, pondering what Pyrah had taught them, and what they had worked out for themselves. In other interviews, several pupils noted they did not precisely remember the kind of language she used when teaching art, or how they came to discover techniques that they used in painting and in collage. They tried to reconstruct whether this came through experimenting, having plenty of unstructured time to make things, or whether guidance was more specific. Peer support offering comments on artwork was recalled favourably. One former pupil, Gary Hyde, saw the 'asking out' process as having taught him to accept criticism as normal and constructive and 'in your system' (quoted in Ewan 2019: 26).

The 'Asking Out' film footage provides a useful clue about Pyrah's active guidance in the arts: one child speaks of the need to start learning how to observe carefully by making an image of a shell, and trying to record all those small details. They learned to observe by choosing something small like a shell, looking closely and recreating it on paper. Just as they turned to the immediate community for criticism or praise of their art, they focused first on a small surface and depicting it faithfully, before painting Big Ben or images beyond the locality. Clegg's promotion of the children's work ensured it was exhibited in spaces beyond their community, and toured further than the local school. This was also perceived as a vote of confidence in the pupils' talents and determination. Clegg and Pyrah spoke of 'ferreting out' the pupils' interests rather than teaching the children to paint. This is a variation on later filmed conversations between Open University lecturer Bob Bell and the pupils at Balby Street School in Yorkshire. In that 1975 broadcast, the children explain that the teacher does not directly tell them how to improve their creative work; she makes suggestions and children then revise what they are doing, working together with peers. In that instance, the teacher does not actively chase their interests.[6]

The value placed on artworks created in her class was apparent when former pupils attended the opening lunch of artist Ruth Ewan's installation, a recreation of Muriel Pyrah's 1972 classroom. This exhibit 'Asking Out' opened at the Yorkshire Sculpture Park in July 2019. The walls of the reconstructed classroom at the Longside Gallery were decorated with actual artworks from Pyrah's classes dating from 1967–1972, lent by the NAEA. The pride and in certain cases amusement of finding themselves as middle-aged participants, inside an

artist's installation that included their own child art, elevated by a sense of tribute to the past, was palpable as guests moved around the opening. Ruth Ewan's *Asking Out* booklet that accompanied the exhibit gave space for praise and doubts voiced by former pupils, through both transcripts of interviews and essays (Ewan 2019). In the context of a formal opening, however, the narrative of unchallenged delight in Pyrah's legacy of teaching dominated the speech by Yvette Cooper MP. A few former pupils exchanged glances but no one heckled. Some former pupils felt glad they could laugh together without Pyrah's intense guidance in this installation, whereas in their original classroom they had been required to show themselves in recovery from poor 'habits of speech' and 'slipshod writing'.[7] Pyrah's teaching of art, and the experience of making by hand, was not what had caused the troubled recollections.

Muriel Pyrah's version of oracy

Clegg identified the arts as a crucial stage in a rounded education and yet they were not perceived as a beginning and an end in themselves. Oracy and the use of the spoken word to better yourself and extend your professional career was certainly of greater interest to the newspaper and film coverage of Pyrah than was arts education, and it could be argued that the arts were presented in these sources as an attractive backdrop for training in language development. For Clegg in his final years of office, use of the spoken word may well have taken precedence, as preoccupation with opportunities for working-class children became widely discussed in education and social science, while the arts did not register with sociologists as so potent for social change, when compared with language acquisition.

Clegg had been concerned about a declining quality of speech and range of vocabulary decades before he championed Pyrah. In 1953, he and Hyman warned: 'Whenever children attend cinemas regularly the language of the film is clearly reflected in their speech. Children copy the American habit of using a minimum number of words in expressing themselves like a telephone conversation' (WREC 1954: 40). Interviewed on screen in 1972 without her pupils present, Pyrah implied that in her view many parents are not caring enough, and Clegg also warned in print of 'feckless' parents not offering suitable guidance to the young (WREC 1954: 58). A brief clip of mothers pushing prams and talking in regional accents is edited into the film 'Language: One Teacher's Way' as if to provide evidence of deprivation. There are moments in 'Asking Out' footage, however, where Pyrah's compassion is forthcoming, particularly when she articulates the need for 'overall development of confidence, without that you can't do well'. In the 'Asking Out' film, Clegg insisted that children from the Airedale community come to school 'inarticulate', and that children from this area 'have great difficulty in speaking' before being taught by Pyrah. This particular footage was not seen by the pupils while still at school, but only in later years when it was revisited in archives or exhibition spaces. The way the

children were described may have shaped the former pupils' recollections about their training in language, being described as though Pyrah was entirely responsible for their becoming confident speakers in late childhood. Many other teachers from West Riding in this period wrote less dismissively of children's language. In *The Changing Primary School*, another West Riding teacher gave credit to the strong traditions and deep roots of long-established mining communities, where grandparents played a key role. Families from these stable communities were seen to have contributed, alongside the work of the teacher, to 'an outstanding degree of self-discipline… trusted to come into school early… get on with work of their own choice, read everything they could lay their hands on… reason and think for themselves' (Clegg 1972a: 97).

Pyrah placed great emphasis on drawing out the children's interests and giving them choice, but the range of books they had was inevitably shaped by the publications available and the dominant themes of educational publishing at that time, as well as by Pyrah's avoidance of contemporary children's fiction in favour of established literature with less playful vocabulary. Pyrah had no time for the whimsical. Books in her classroom were predominantly scientific, or factual studies from history. In archived sound recordings, there is an artificial awkwardness when Pyrah's class discuss famous authors: 'Charlotte Bronte deserved a place in history.' Clegg's contemporary and co-author, school inspector Barbara Megson, also remembers the way Pyrah's pupils were taught to speak in the classroom as 'very very mannered' and saw it as performance specific to the classroom.[8] Despite staged attempts to review literary classics in documentary film and original sound recordings, pupils also re-iterated Pyrah's advice that books 'protect us from loneliness', that 'you can never be alone with a book'. Former pupils argued in interviews that her encouragement to read gave a sense of entitlement about reading new material that had been absent in their home lives. As an interviewer, this point confounded my own assumptions. Having been told that children had pens and paper at home from age five, I had to conclude this did not necessarily imply that their parents read books with them. As one former pupil explained:

> I didn't have a book at home until maybe I made a bookshelf and then got a book from somewhere and started racking them up. My parents did not read to me or have conversations about books, not like I did with my daughter, no sitting down for a hug back then while we looked at a book.
> (Former pupil, Interview with Lottie Hoare, May 2017)

Preparations for school trips with Pyrah's class to London and Scotland, for example, involved preparing notes and drawings from books so that children were familiar with cultural knowledge in advance of their visits. In a 1975 Open University broadcast, 'West Riding Discussion', Bob Bell considered whether the LEA avoided acknowledging 'the cultural interests of the area', intent instead on 'infusing an alien metropolitan culture onto the school'.[9] To

Pyrah's credit, she seems not to have implied to pupils that any knowledge was alien. Their entitlement to any of it would stand the local child in good stead as they progressed through secondary school and were imagined moving into a world of work different from the current generation (see 'Art in the West Riding classroom', pp. 102–103 below).

In the late 1960s and early 1970s, oracy was usually associated with non-authoritarian listening and speaking, and small group contexts were commended. Pyrah's 'asking out', however, insisted the whole class was addressed rather than a small group. Arguably the most intrusive and uncomfortable part of Pyrah's pedagogy was, for some pupils, the demand to ask out. Pyrah demanded constant vigilance on the part of pupils, because they did not know when she would to try to ensure their individual participation, to demonstrate they were learning. In the film 'Language: One Teacher's Way', Pyrah can be heard: 'do you know what I mean by efficiently Roland? … where is he, Roland? … you should ask if you don't know. I don't like you being so quiet my dear…' Another former pupil described 'asking out' as a mode of operating where: 'You had to interact […] it was a game […] if you didn't say something, she made you say something, there was nowhere to hide.' Film evidence suggests that she did little to draw out discussion and nuanced understanding beyond correction. She sometimes put the lid on poetic expression, as when a boy speaks of insects being 'clustered up in a web', she corrects 'You mean caught in a web.'

Another oft-repeated fear of Pyrah amongst the interviewees was that her requests to children to speak out loud in front of the rest of the class led her to 'prod' them. She did not routinely administer corporal punishment, but could be physically forceful in the way she might thump a child in the ribs by way of forcing them to speak in front of their peers. Using physical punishment was not illegal in English state schools until 1986. One West Riding headmaster argued that corporal punishment was less serious a punishment than constant sarcasm (WREC 1954: 57). Pyrah was not known for being sarcastic. She was direct and wanted everyone to play their part. Nonetheless, her forceful gestures were remembered by several former pupils as a humiliating experience, and were presented in several instances as the reason people declined to take part in interviews, or to have their names quoted if they did. One former pupil recalled how if Pyrah saw a child speaking quietly to a neighbour, she would hit them on the back to correct this habit. On film in 'Asking Out' she described one-to-one conversation between children as potentially 'idle chatter'; the whole class must be addressed. One former pupil attributed her own avoidance in later working life of public speaking or reading aloud in a group to the memory of Pyrah's impatience and physical force used in motivating her to 'ask out'. From the small sample conversations that I experienced in interviews, the male pupils had more positive memories of Pyrah than the females. This divide was echoed when Ruth Ewan conducted focus group discussions with former pupils in 2019, as research for her exhibition.

Conclusion

In the context of its own time, Pyrah's teaching was presented as best serving what we might now call the 'well-being' of pupils. In that period, the concern was framed as increasing educational and long-term professional opportunities, and of reducing violence and deprivation in communities, rather than any overt discussion about anxiety and mental health. Clegg's career was marked by his consistent dedication to searching for ways that school could redress the balance of inequalities and deprivation in society. Pyrah provided a case study who was essentially home-grown, and who he may have hoped would coax sceptics into recognising the benefits of a disciplined and carefully performed adaptation of oracy and arts education for pupils from under-privileged backgrounds approaching adolescence. With the benefit of hindsight, most of the former pupils who wished to come forward to revisit and discuss Pyrah's legacy did so because of their ongoing interest in the arts, not in the written or spoken word. However, this research drew on a small sample, coinciding with research at an arts education archive, and an artist's exhibition at Yorkshire Sculpture Park, so further research might possibly make different links with those who championed the 'asking out' process. Another positive legacy of Pyrah's experiments was that for some pupils a lasting sense of entitlement developed: that curiosity was something to pursue in your formal or informal education. While 'asking out' may have made some pupils feel ill at ease, and Pyrah herself was more physically forceful than the ideal model Clegg sought, she played a part in enabling a number of pupils to feel that knowledge was something they could uncover in life-long learning, whether or not they pursued formal qualifications. Of course, numerous other influences had shaped the interviewees' lives since leaving primary or middle school, but a recurrent theme arising in conversation was how to use the arts and the spoken word in education today to inspire confidence in the next generation, and how pupils' home lives and experiences beyond school can co-exist constructively with their learning at school, and be complementary to them, rather than subjects of shame or condescension.

Notes

1 See Note 3 for details of films where Clegg contributes narration.
2 Interviews conducted by Lottie Hoare in Castleford and surrounding area during 2017. Six former pupils took part in a mixture of informal discussions and structured interviews, observations anonymised in line with their wishes. Implications of their testimony are critically discussed in Hoare 2019. Gary Hyde gave consent to be named for Ruth Ewan's 'Asking Out' exhibition booklet transcripts (not an original interviewee from 2017).
3 Films used here: 'Language: One Teacher's Way' (16 minutes), documentary by the Central Office of Information (COI) with the Department of Education and Science (1972); and 'Asking Out' (30 minutes), produced by the West Riding Department of Educational Technology in cooperation with Airedale School. Both

digitised from VHS cassettes held by NAEA and made available to the 'Sir Alec Clegg Revisited' project, 2017. Little archival evidence survived about the production of the films, both probably used for teacher training. See NAEA MPPL-132 Letter from Myra Levien at COI thanking Muriel Pyrah for cooperation with Bob Tyrell, 1972. NAEA holds topic books, paintings and textile samples created by classes 1967–1972 in the 'Muriel Pyrah' collection.
4 Descriptive evidence of classroom and classroom practice draws on interviews with pupils and details visible in film footage.
5 NAEA holds few details on these sound recordings but lists them as recorded in 1971 and part of the James Fairbairn collection.
6 'The Balby Street Kids' Open University and BBC 25-minute documentary (1975) broadcast on BBC 1 and BBC 2 repeatedly until 1982. Digitised by NAEA for the 'Sir Alec Clegg Revisited' project.
7 In the 'Asking Out' film, Clegg uses this vocabulary to identify what Pyrah's class are trained to avoid.
8 Barbara Megson, interviewed by Lottie Hoare, April 2017. Megson's testimony and its significance is explored in Hoare 2019.
9 Open University Faculty of Educational Studies, Course E203 'Curriculum, Design and Development', Programme 6 'West Riding Discussion' Friday 27 June 1975. (Presenter: Bob Bell. Speakers: Malcolm Skilbeck, Ted Tattersall, Arthur Naylor. Producer: Ken Little.) Broadcast script p.4. (Private collection).

References

Clegg, A. (1964). *The Excitement of Writing*. London: Chatto and Windus.
Clegg, A. and B. Megson. (1968) *Children in Distress*. Harmondsworth: Penguin Books.
Clegg, A. (1972a) *The Changing Primary School, Its Problems and Priorities: A Statement by Teachers*. London: Chatto and Windus.
Clegg, A. (1972b). *Recipe for Failure*. London: National Children's Home.
Cox, C. and A. Dyson. eds. (1971). *The Black Papers on Education*. London: Davis-Poynter.
Crook, D. (2008) '"The middle school cometh" … and goeth: Alec Clegg and the rise and fall of the English middle school'. *Education 3–13* 36(2): 117–125.
Ewan, R. (2019). *Asking Out: A Project Exploring the Work of Muriel Pyrah*. (Includes transcriptions of interviews with former teachers and pupils, text by Lottie Hoare and introduction by Helen Pheby, Head of Curatorial Programme, Yorkshire Sculpture Park.) Booklet produced for Ruth Ewan's installation *Asking Out* at Longside Gallery, YSP, July to October 2019.
Gosden, P. and P. Sharp. (1978). *The Development of an Education Service: The West Riding 1889–1974*. Oxford: Martin Robertson.
Hoare, L. (2019). 'Muriel Pyrah: Sources and myths from a West Riding of Yorkshire school, 1967–1972'. *History of Education Review* 48 (1): 109–121.
Mercer, N., P. Warwick, and A. Ahmed. (2017). 'An oracy assessment toolkit: Linking research and development in the assessment of students' spoken language skills at age 11-12'. *Learning and Instruction* 48: 51–60.
Mercer, N. (2019). *Language and the Joint Creation of Knowledge: The Selected Works of Neil Mercer*. London: Routledge.

Pyrah, M. (1972). Spoken commentary in 'Language: One Teacher's Way'. Film produced by the Central Office of Information in conjunction with the Department of Education and Science.

Pyrah Collection Letters. (1962). NAEA MPPL-4, Letter from Diana Jordan asking Pyrah to contribute to a NUT course for Knaresborough and District, 1962.

Pyrah Collection Letters. (1971). NAEA MPPL-129, Bernstein to Pyrah, 25/5/71.

Robertson, S. (1963). *The Rose Garden and The Labyrinth: A Study in Art Education*. London: Routledge and Kegan Paul.

Sunday Times newspaper. (1968). 'Mrs Pyrah, teacher'. *The Sunday Times Magazine*, 7 July: 28.

The Times newspaper. (1968). 'Children talk themselves into literacy'. *The Times*, 13 May: 4.

Wilkinson, A. (1965). *Spoken English* (with contributions from A. Davies and D. Atkinson). Birmingham: University of Birmingham.

WREC (West Riding Education Committee). (1954) *West Riding Education: Ten Years of Change*. Wakefield: West Riding County Council.

Interlude
Art in the West Riding classroom

 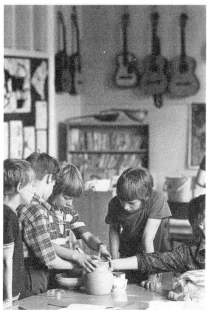

Art activities at Balby Street Junior, Denaby Main, 1974

The West Riding became renowned worldwide for its progressive art curriculum, as seen throughout this book. Here we reproduce a very small sample of treasures that remain available for study in the NAEA. A focus on creative work encouraged children and young people to observe nature and the material environment through drawing and painting, to explore at first hand the quality of graphic media and materials such as clay and fabrics represented in images here. Opportunities were made to express themselves, their ideas and emotions, by making images and objects, and also through music dance and movement. Classroom scenes here and in the following chapter represent just a few examples of the informal dynamics and relationships that ensued, complementing and enlivening the more exclusively directive and regimented pedagogies experienced by their parents' generations.

Martin Lawn photo collection

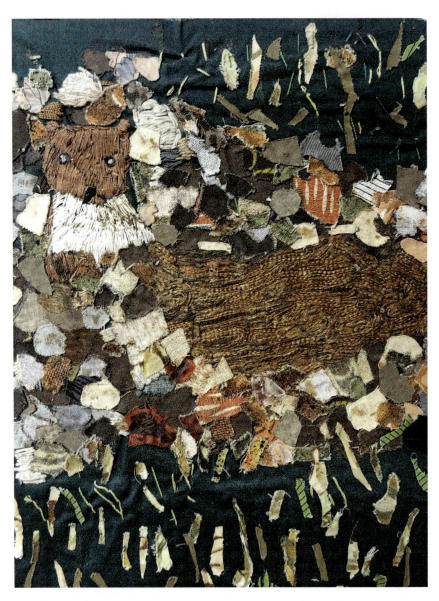

'A Weasel', mixed media collage by an Airedale pupil, c. 1968–1972 (see Chapter 5, p 90).

From collection of Airedale School artwork in the Muriel Pyrah Collection

Reproduced by permission of NAEA @ Yorkshire Sculpture Park

Art in the West Riding classroom 101

Collage of a West Riding home, produced by a primary school pupil in the 1970s
Reproduced by permission of NAEA @ Yorkshire Sculpture Park

Artwork produced during the 1970s by a child at Whitwood Mere Infants School, Castleford
Reproduced by permission of NAEA @ Yorkshire Sculpture Park

Topic Book covers (see Chapter 5, p. 94).
From collection of Airedale School artwork in the Muriel Pyrah Collection
Reproduced by permission of NAEA @ Yorkshire Sculpture Park

Art in the West Riding classroom 103

Self-portrait by 14-year-old Doncaster schoolboy, Michael Biggins, described by Clegg as 'the most moving picture I have ever seen… from a child branded an educational failure. We have no right to talk about this child in these terms… good expressive work induces a success… stimulate[s] intellectual as well as spiritual growth…'. (see Chapter 4, p. 81)

Reproduced by permission of NAEA @ Yorkshire Sculpture Park

Chapter 6

Movement and dance in schools

Catherine Burke

This chapter explores the place of expressive dance and 'movement' in the primary school curriculum during Clegg's years in office and examines how teachers in the West Riding were pioneering in this respect, not only in the UK but in other parts of the English-speaking world. Dance was considered an essential part of the physical education curriculum in infant and primary schools, largely as a result of the influence of émigré artists such as Rudolf von Laban who worked with a generation of English school teachers to develop their understanding and practice. But it was also believed to be an art in its own terms. Thus, 'children's bodies in movement and expression' was believed to be a core necessity upon which the whole curriculum should be built. The chapter draws some parallels and contrasts with how movement and dance is viewed today in mainstream schooling. The argument that exercise and physical artistic expression is conducive to good levels of self-value and emotional well-being is considered within this long view.

Physical education: Innovation and resistance

During the years of Clegg's leadership in the West Riding (1945–1974), the meaning, interpretation and spectacle of physical education in the primary school curriculum changed radically. From its early 20th century form of regimented gymnastics and drill, the introduction of a new curriculum, in the immediate post-war years, transformed the notion of physical education beyond recognition. 'Movement' and 'the dance' were to be understood by teachers as being at the core of learning and development, generally translated as 'growth' at this time. For a period of 20 years from about 1950–1970, the idea that movement and dance should at least stand in parity with competitive sports and gymnastics in the physical education curriculum was defended, particularly in the West Riding. There was, as dance historian Patricia Vertinsky has acknowledged, a gender dimension to this development. While all children, regardless of gender, were to experience the movement and dance curriculum, it was led in the main by female educators: male teachers, having trained in traditional physical education and competitive sports, largely resisted the new

practices. However, changing priorities of educational policy during the 1960s, combined with the growing professional power of male physical educators and a renewed focus on sports, games and skill development, eventually undermined the substantial achievements of movement and dance educators. By the time of his retirement, Clegg had witnessed a reassertion of a kind of physical education that his instinct told him was not conducive to the well-being of *all* children. Speaking in 1973, he observed:

> There has been a resurgence of Olympic gymnastics, floor work, beam work, bars at different levels – all excellent for those who want to do them. But apart from [...] movement in the primary school, and dance at its best, what we have contrived is a means of setting apart the skilled from the unskilled.
>
> (WYAS A.B. Clegg papers 1973: i)

For Clegg, one of the beauties of 'the dance', as he wished it to be interpreted in schools, was its affordance of a platform disabling any notion of individual success or failure. However, any success in defending this notion against a rising tide of emphasis on identifying and measuring success proved unable to survive the introduction of a national curriculum in 1988.

Movement for movement's sake

At the heart of Clegg's philosophy of education, as for a substantial group of curriculum thinkers, was an aspiration to provide for experience of education across the curriculum that enabled every pupil to flourish on their own terms. When schooling was designed for each pupil to respond to instructions and meet a required standard, according to this view, the able and gifted were easily discernible by pupils and teachers alike. This did not necessarily benefit the individual pupil or the well-being of the school community. In contrast, an education designed to encourage synchronous but essentially individual responses to instructions was not focused on visible or indeed measurable distinctions between the able and the less able. In movement and dance, each individual pupil was encouraged to respond in their own way to instruction or stimulus and eventually to their own inner motives. Clegg explained the rationale for this approach in the following terms:

> Once a child is challenged to solve a physical problem or surmount a physical obstacle in his own way rather than in accordance with specific instructions, all can achieve some success. In this way, physical education, as is also the case in other subjects, has proved that finding out may be more effective than being told.
>
> (WREC 1974: 29)

Implicit here was a critique of existing pedagogies that seemingly failed to acknowledge the limitless capacities of young children given an educational environment appropriately designed to release them. Dance adviser Diana Jordan encouraged infant and primary school teachers towards a recognition that, in observing a model lesson,

> ...what is being revealed is the means by which the potential physical abilities of children can be freed, until now seriously underestimated, and how this release can activate their ideas, their imagination and their powers of expression and communication.
>
> (Jordan 1966: xi)

Clegg agreed with a colleague of Jordan, Arthur Stone, whom he had first encountered at Steward Street School in Birmingham while visiting in his role as Deputy Education Officer (1942–1945) for Worcestershire Education Authority. Stone explained what he regarded as the pivotal nature of movement within his own philosophy of education in the following statement:

> If you become interested in the quality of how you move, then you go inwards, not outwards, and you find yourself in the world of yourself, and the imaginative world and the world of yourself are one. When you come into drama and into dance you are no longer concerned with an outside purpose, you are concerned with the whole of yourself.
>
> (Stone in Foster 1976: 96)

Being concerned with the wholeness of self was for progressive educators at this time an essential purpose of education. In *Story of a School* (1949), Stone outlined the experimental approach carried out during the war years at his school in a run-down district of the inner city:

> We tried to give the children opportunities to move and to express themselves. We believed that the qualities which are developed in this way are of tremendous importance to all activities, since expression in the arts gives not only a natural approach to academic subjects but also a more confident basis for tackling the difficulties of social relationships. If this is true, and I have a sincere belief that it is, it seems to me to be wrong to teach academic subjects *before* children have experience of expression in the arts.
>
> (Stone 1949: 36)

Clegg agreed with this point of view. Throughout his career at the West Riding, he came under criticism, frequently having to defend his position that children's experience of the arts was fundamental to any success in understanding and internalising knowledge and skills across the whole curriculum. Movement, to

Figure 6.1 Jessie Clegg dancing
Clegg family photo collection

his mind, was evident not only in physical education lessons but also demonstrable in the collection of children's paintings, drawings, textiles and embroidery that he carried with him to illustrate his talks at home and abroad. 'The dance', which he often referred to, was the modern dance form that had been powerfully introduced to English schools by teachers inspired by the training they had experienced in the 1940s led by the émigré Rudolf von Laban (1879–1958). An important influence at this time was Clegg's encounter with his future wife, Jessie, who in the late 1930s was working as a primary school teacher in Birmingham. As a dancer, Jessie became an enthusiastic scholar and practitioner of the modern dance of Laban.

But Clegg's view of the place of the arts in the curriculum was also shaped by a wider international consensus that had grown among networks of progressive educators during the inter-war years. This consensus was that education through the arts was not only viable but desirable in order to increase the humanity of the classroom, and, in a phrase often used by Clegg, to encourage

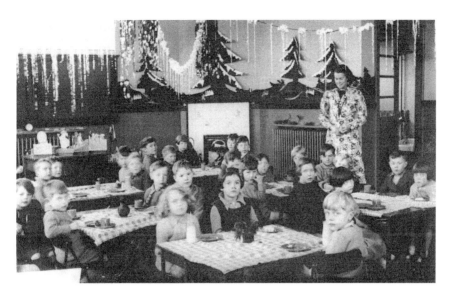

Figure 6.2 Jessie Clegg teaching
Clegg family photo collection

among all adults 'a change of heart towards children'. As Stone expressed it, movement was fundamental not only to all the arts but to healthy development of body, mind and spirit.

> …all the arts have a common beginning… That common beginning is movement – movement, something primitive and fundamental, so it seems to me: not movement for expressing emotion or ideas, which becomes Dance: not movement which makes us feel we want to say something, which is Drama: not movement for developing bodily strength or skills, which is Physical Training: but movement for movement's sake, the starting-point of all the arts.
>
> (Stone 1949: 15)[1]

Movement', 'the dance' and education through the arts

The roots of this philosophy are to be found in the 1930s, a decade that witnessed the stirrings of ideas about the rich possibilities of education through the arts, widespread interpretations of new education in an atmosphere of freedom, and the exile from Europe to the UK of many émigré artists. Reflecting on the essential role of the arts in human society at the opening of Impington Village College in 1939, Henry Morris, Director of Education for Cambridgeshire,

recognised the potential of schools to do more in nurturing the emotions of the young:

> ...the school must provide for the feeding and training of the emotions and the senses through the Arts – first by means of a building which is a work of art and gaily decorated, and also through music and drama and the dance. In all countries it is here that the school fails tragically. The result, everywhere, in all communities is wholesale, emotional and bodily maladjustment and unhappiness.[2]

In 1938, Diana Jordan, who was to become dance adviser for the West Riding, published her first book, *The Dance as Education*. That same year, modern dance educator Rudolf von Laban had arrived in England, hosted initially by Kurt Jooss (1901–1979) at Dartington Hall in Devon. The powerful attraction of the atmosphere created at Dartington Hall was an important dynamic at this time. Supported by the rise of educational psychology as a scholarly discipline, this period saw a wider acceptance of education designed to support the child's discovery and development of their individual identity. Various art forms – painting, sculpture, drama, music and dance – were regarded as vehicles for child development and growth. They were also seen as essential platforms upon which the whole curriculum might be more securely introduced.

Jordan, as a young adviser in Worcestershire during the 1940s, collaborated closely with Alec Clegg and would also have met Christian Schiller HMI, as District Inspector locally (later appointed as the first Staff Inspector for Primary Education). Like Clegg, she visited Arthur Stone in Birmingham, and saw for herself rooms full of expressive bodies of children in mime and in dance. Through that experience, Jordan was able to articulate clearly her vision for the revolutionary role of dance to transform primary education in the post-war world. In July 1945, she outlined her plan in a memorandum to Clegg on the future of modern dance.

> I think it is time to say that Modern Dance is a forerunner of a new concept of Education and that it will not make a full contribution until it can take its place as part of a whole rebirth of Education.
> (NAEA Sir Alec Clegg Collection 1945)

She was well aware of the challenges in effecting this 'rebirth' given the conditions in which the vast majority of former elementary school teachers had been trained. Her essential argument was that the dance was not a mere art form but a foundational aspect of human 'becoming' and therefore training for its provision should be part of the general preparation of new primary school teachers rather than a specialist responsibility (Ibid.).

The experience of Steward Street School and the influence of Laban's work with teachers across the country was represented vividly in the Ministry of

Education two-volume publication *Moving and Growing in the Primary School* (1952 and 1953), which launched the new physical education curriculum for primary schools. In these two volumes, skilfully and artistically illustrated throughout with photographs of closely observed individuals and groups of children, we are led by means of a discussion about the ways that human growth and educational development can be nurtured through regular and sustained engagement with movement and dance. Taken as a whole, the volumes contain so many images of children in extended postures that a cinematic quality is achieved in spite of the limitations of still photography. Volume 1 devotes 13 richly illustrated pages to movement as art and drama. The message is clear: movement and the dance were not to be taken as simply confined to physical education, but rather were integral to the development of body, mind, character and the whole education of the child.

The ideas and practices illustrated in these volumes directly influenced the physical education curriculum elsewhere, for example in Australia and Canada. After World War II, a number of English teachers familiar with Laban-based work in physical education migrated to Canada. In Ontario, English-trained educators such as Nora Chatwin, Rose Hill and Mary Liddell, together with

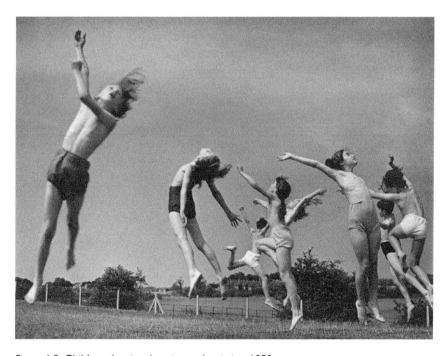

Figure 6.3 Children dancing: Leaping and twisting, 1953
Ministry of Education, *Moving and Growing in the Primary School.* Vol. 2. *Planning the Programme.* London, HMSO 1953. p.33, plate 20.

local administrators and teachers, supported this new approach (Lathrop and Francis 2011: 69).

Seeing it happening

> To recognise what is called 'Movement' one must have observed it in action, and to appreciate it fully one must have experienced it in oneself.
> (Schiller in Jordan 1966: vii)

This assertion by Christian Schiller underlined what came to be regarded as the vital importance of the professional development of teachers if a 'revolution' in the education of young children was to be achieved and sustained.

Courses for teachers at Dartington Hall in the south and Woolley Hall in the north of England provided opportunities for teachers to explore their own capacities to move and grow. In the West Riding, Woolley Hall courses gained an international reputation as the many visitors from abroad during these years were encouraged to attend.

Shortly after the publication of *Moving and Growing in the Primary School*, a group of German educationalists took part in a workshop led by Laban at Woolley Hall. Laban introduced the group to movement. Clegg expressed his own apprehension about the Laban session as the group was predominantly male and thus, he presumed, somewhat inhibited 'but when he got us bobbing up and down in our seats in the first ten minutes I realised that the battle was won'. His account went on to express his surprise and delight that,

> within an hour he (Laban) had us all, Studienrat and schoolmaster, Oberstudiendirektor and Her Majesty's Inspector, Schulraetin and Chief Education Officer, all rolling about together on the floor of the music room, so intent and determined that in five minutes the men took off their jackets and in ten their collars and ties.
> (NAEA Sir Alec Clegg Collection 1954)

The quality of movement and dance as practised in the modern primary school was impossible to measure in the usual terms. However, teachers were able to recognise excellent teaching in the process of observing one another's practice.

Nora Carlisle, a retired infant school teacher who had worked as a specialist physical education teacher at Girnhill Infant School, Featherstone, recalled the nurturing influence of informal opportunities for personal and professional development that always characterised courses held at Woolley Hall:

> You got a lot from each other rather than from the talks. You might talk a bit about that but then you'd talk about practices you did at your school. This is where the wider spread would be and then you'd say 'can I come and see it happening at your school?'[3]

This point was underlined by Sheila Mackie, who was headteacher at Girnhill school from 1959–1970 and had been introduced to movement and dance at Whitwood Mere School between 1950 and 1954 under the leadership of Mary Walker. She recalled:

> At Three Lane Ends (Whitwood Mere) I was introduced to movement and dance. I'm sure Diana Jordan came to the school and I sort of picked it up. And I saw one very good lesson taught by Bessie Bullough. She taught at Lock Lane, Castleford… it was an eye opener, what the children were capable of doing and their absorption in what they were doing.[4]

The high standards demanded were, it was acknowledged, difficult to describe in writing and were evidenced by visual means through direct observation, photography and film in various key publications and training courses.

Christian Schiller expanded on this point in his foreword to Diana Jordan's book *Childhood and Movement* (1966): 'Photographs help; but they help only a little, since movement is in its nature dynamic and a photograph freezes into stillness only one moment of a process' (Jordan 1966: vii).

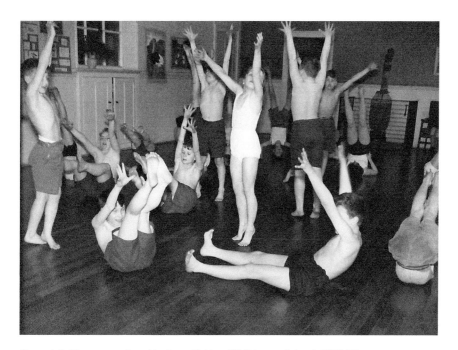

Figure 6.4 Movement class, Horbury Bridge CE Primary School, 1960/61

Reproduced by permission of NAEA @ Yorkshire Sculpture Park
Nancy Smith Collection no. 2

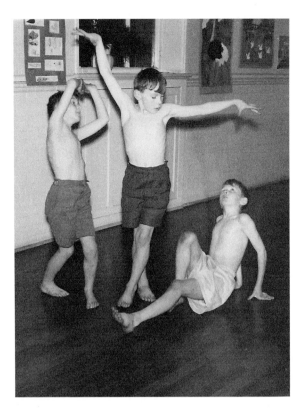

Figure 6.5 Movement class, Horbury Bridge CE Primary School, 1960/61
Reproduced by permission of NAEA @ Yorkshire Sculpture Park
Nancy Smith Collection no. 11

Educators promoting movement and dance relied heavily on images of pupils experiencing a dance or movement class, precisely because the individuality of interpretation and expression, anticipated and achieved, surpassed any possible standardised series of benchmarks that teachers and pupils might follow. In her book designed to entice teachers into embracing modern dance as part of the curriculum, Ruth Foster (1976) attempted to convey the intangibility of dance as '…that rhythmical process that we find hard to describe, but which we recognise at once as an expression of vibrating life' (Foster 1976: 26). One had to suspend judgement in order to encounter the true nature of the dance. 'Your reaction to the thing is not intellectually or with any kind of critical faculty but primarily because of the sense that it gives you of being alive in a living world' (Foster 1976: 26).

'The dance' (meaning European modern dance) was potentially revolutionary in English schools as it engaged directly with the primary emotions 'not

located exclusively in the head but… distributed throughout the entire field of relations' (Ingold 2011: 47). The dance challenged still prevailing notions that the bare-footed expressive body, reacting to and suffused with rhythm, was a 'primitive' ('non-civilised' by Western notions) being.

Movement and the built environment

> Clothes quickly pile up on the desks as children busily undress for the dance lesson. The first to change are soon by the door, ready to make their way to the hall, their bare feet wriggling impatiently in their shoes for the moment when they can kick them off and spring on to the hall floor. On the way along the corridor the bodies bustle and an animated walk threatens to break into running… Some rush across the space exhilarated by the feel of air against their faces, some pluck their feet off the floor in hops and leaps, and others swing wide their arms in unrestrained gesture which sweeps them high onto their toes, or pulls them into an off-balance suspension that dissolves into the slack of a downwards spiral. Soon the teacher calls for the class's attention and the lesson begins.
>
> (McKittrick 1972: 11)

At this time, there were important shifts taking place in the planning of state schools across the English-speaking world. These can be summed up as efforts in three linked directions. First, in experiments intended to harness the power of the arts across the whole curriculum, especially for younger children; second, in encouraging a view of the child as essentially a creative rather than technical being; and third, in enhancing the beauty, functionality and overall aesthetics of the built environment. Architects and educators who collaborated in the immediate post-war decades forged a 'common vocabulary of design' in relation to the planning of new school buildings, supported by a consensus in the dominant ways of envisaging the modern school. From the 1930s, there also developed a common vocabulary of progressive education that Clegg was later to draw on. Key concepts that were presented and discussed at international conferences in pre- and post-war decades included the phrases 'education for living' and 'education through art'.

'Movement' and 'the dance' were considered not as frivolous additions to so-called 'core' subjects of the curriculum, but rather foundational building blocks. Besides presenting new challenges to teachers who had not necessarily trained in the new approach, the spaces required to support these activities had direct implications for architects engaged in planning and designing new schools. As Leonard Marsh put it simply: 'The movement work, which is fundamental in the development of children requires a good floor surface' (Marsh 1970: 107). Dance adviser Diana Jordan was acutely aware of the potential influence of the built environment in shaping the experience of this new approach to the physical education curriculum. In her book *Childhood and Movement* (1966),

she acknowledged that, in the hands of exceptional teachers, even in a school building designed on the assumption of limited pupils' movement, astonishing achievements could be made. She was surely referring to her knowledge and memories of Arthur Stone's work at Steward Street School, when she noted that 'some of the best pioneering work has without doubt been achieved in the small crowded spaces of old schools' (Jordan 1966: xv). Stone had been able to demonstrate that despite inadequate material conditions, it was possible for primary school age children to experience the whole curriculum taught through creative and performing arts. Bare-footed pupils are pictured in full expression in the illustrations to *Story of a School* (1949). The architects of that Edwardian building could hardly have envisaged children moving out of their allotted place, never mind moving with such dramatic free expression that was now called for.

However, the built environment did matter, as Henry Morris noted above, and children's bodies in expressive movement required adequate space. Mass education in the past had cramped the natural energy of children and confined their bodies and minds to small spaces mainly for the purposes of book learning. Writing in the 1960s, Jordan acknowledged this, and with it the revolution that had come about in new productive relationships between educators and architects, resulting in school buildings that took the place of movement and dance in the curriculum seriously. She might have had in mind the new school buildings developed by the Hertfordshire Architects Department, or the celebrated Eveline Lowe primary school in London, which opened in the same year as her book *Childhood and Movement* was published, when she remarked:

> Latterly, the need for scope for freer movement both about the school and in the hall, playground and gymnasium, has been recognised not only as a physical necessity but as an educational one. All this has resulted in the spaciousness of new school buildings.
>
> (Jordan 1966: xiv)

She noted the inadequate conditions that teachers, however enthusiastic about the possibilities of movement, were forced to work with in West Riding school buildings directly after the war.

> Floors were hardly suitable to movement with bare feet and the shedding of garments... Gymnasium floors often showed the ravages of oiling combined with the grime from neighbouring pits which filled the atmosphere... Floors were knobbly with protruding knots which had resisted tile washing and channelled with splintery grooves where the wood had succumbed to it. Such was the setting for our great revolution in physical education.
>
> (Jordan in Sorkin 1997: 9)

Architects designing schools in the 1950s and 1960s were informed by these new developments and took seriously the various manifestations of movement now thought to be essential components of modern schooling for young children (Burke 2019). They were also inclined to value the qualities of wood used for hall floors, where it was intended that bare feet would be essential in the full experience of movement and dance. There is evidence in the several *Building Bulletins* published by the national Ministry of Education at this time that they did so.

> Very different forms of movement were taking place in the schools visited… there was movement merely to 'let off steam'; movement as an expression of children's own ideas, or of stories they had heard; movement related to the training of certain skills; there was also movement related to music, dance, mime and drama.
>
> (Ministry of Education 1958: 16)

The decline of movement and dance. Losses and gains?

In the mid-1970s, at the end of Clegg's career, a series of films were made capturing colourful and striking images of primary school children experiencing 'movement' and 'dance' lessons.[5] The films appear to have been made to record what were considered at the time to be the best examples of Clegg's legacy. At Balby Street school, Clegg is shown talking to the camera, talking to pupils and teachers about their work, and sections of the film show large numbers of children in expressive movement: each child moving differently and independently, but from the viewer's point of view a common mode of living is demonstrated. Effort is evident; music is minimal – a drum beat is the only reference point. Enjoyment is conveyed. We do not know precisely how this was experienced by the pupils themselves and recent research using oral history in a related context has revealed that adult perspectives concerning pupil experience are not always accurate (Hoare 2019). In this chapter, we have dealt with the intention and justification of the place of movement and dance in primary education. It is evident that since Clegg's time in office, there has been a shift in the importance that dance is accorded in education generally.

Movement and dance have, since their inception as aspects of schooling, had an uneasy relationship with other parts of the physical education curriculum. Regarded as on the curriculum periphery for most of the 20th century, for a time during Clegg's leadership of West Riding schools they were drawn by powerful advocates to the centre of educational experience. Their contextual rationale was education in its full breadth, and human development in particular. These aspects of school experience played a key part in a wider project to increase the humanity of the classroom (Burke 2018). Since the mid-1970s and the subsequent introduction and implementation of a national curriculum

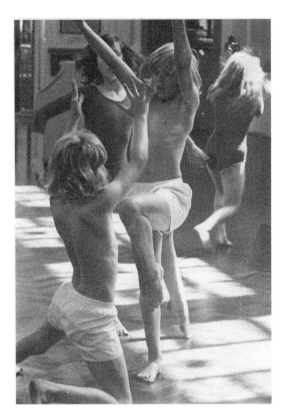

Figure 6.6 Movement class, Balby Street Junior School, Denaby Main, 1975
Martin Lawn photo collection

in England and Wales, this contextual rationale has been radically distorted from the vision espoused by Diana Jordan and teachers inspired by Laban. Today, the rationale for dance in schools is more likely economic; a steadily growing concept of cultural and creative industries in the UK has led to an emphasis on performance and employment. Alongside economic arguments is a health agenda that sees dance as a strategy to counter the increase in child obesity over recent decades. Dance, where practised in schools, is introduced for the maintenance of physical and mental health, as well as the notion of creativity. Important though that is, movement and dance as fundamental parts of what it means to be human, and as conduits to personal identity and growth, have been undermined. Where dance is introduced in primary schools today, with a few exceptions, classes of children will more likely perform identical moves in synchrony, rather than being encouraged to use their bodies to create shapes, colours and relationships of their own choosing.

Movement and dance, regarded as a necessary foundation for engaging with the world, and as fundamental preparation for accessing knowledge, might yet shape contemporary structures of provision. For Clegg and his advisers and teachers, a change of heart towards the young embraced a belief that children might learn most easily when their individual identities had been fully engaged through extensive experience of the arts. It was necessary not only to exercise the body and mind of the pupil but also to provide non-judgemental structures that would allow any child and all children to explore and experience the meaning of beauty in their own way.

Notes

1 Stone, who had experimented with the educational power of movement through dance and drama at Steward Street School, was recruited by Clegg to become an advisor for the West Riding.
2 Henry Morris, part of a radio broadcast on the North American Service titled 'British Education Look Ahead – The New Senior School in Britain', September 1942.
3 Nora Carlisle in conversation recorded at the 'Sir Alec Clegg revisited' seminar at the NAEA Bretton Hall seminar, 25 January 2017.
4 Sheila Mackie in conversation recorded at the 'Sir Alec Clegg revisited seminar' at the NAEA Bretton Hall seminar, 25 January 2017.
5 These were made by the Open University and are deposited at the NAEA at Bretton Hall.

References

Burke, C. (2019). 'Designing for "touch", "reach" and "movement" in postwar (1946–1972) English primary and infant school environments'. *The Senses and Society* 14(2): 207–220.

Burke, C. (2018). 'Humanism, modernism and designing education: Exploring progressive relations between Australia, New Zealand and the West Riding of Yorkshire 1930s–1970s'. *History of Education* 47(2): 257–268.

Foster, R. (1976). *Knowing in My Bones*. London. A & C Black.

Hoare, L. (2019). 'Muriel Pyrah: Sources and myths from a West Riding of Yorkshire school, 1967–1972'. *History of Education Review* 48(1):109–121.

Ingold, T. (2011). *Being Alive: Essays on Movement, Knowledge and Description*. London: Routledge.

Jordan, D. (1938). *The Dance as Education*. Oxford: Oxford University Press.

Jordan, D. (1966). *Childhood and Movement*. Oxford: Blackwell.

Lathrop, A. and N. Francis. (2011). 'Children who drill, seldom are ill; Fitness, movement and sport: The rise and fall of the "female tradition" in Ontario elementary physical education curriculum (1850s to 1990s)'. *Historical Studies in Education* 23(1): 61–85.

Marsh, L. (1970). *Alongside the Child in the Primary School*. London: A&C Black.

McKittrick, D. (1972). *Dance*. London: Macmillan.

Ministry of Education. (1952 and 1953). *Moving and Growing in the Primary School* (2 vols.) London: HMSO.

Ministry of Education. (1958). *Building Bulletin 16, Woodside School, Amersham.* London: HMSO.

NAEA Sir Alec Clegg Collection. (1945). Memorandum on the future of modern dance for A. B. Clegg, handwritten script by Diana Jordan. BHACPL00702.

NAEA Sir Alec Clegg Collection. (1954). Concluding address given by Clegg at the close of the Anglo-German arts course at Woolley Hall, April 1954. BHACPL00074.

Read, H. (1943). *Education Through Art.* London: Faber and Faber.

Sorkin, S. (1997). *Fifty Years of Dance. 1947-1997. A History of Yorkshire Movement and Dance.* Leeds: YMD.

Stone, A. R. (1949). *Story of a School: Ministry of Education Pamphlet No. 14.* London: HMSO.

WREC (West Riding Education Committee). (1974). *The Final Ten Years 1964-1974.* Wakefield: West Riding County Council.

WYAS A.B. Clegg papers. (1973) 'Notes on what has happened to education in recent years' A 398, Box 28.

Chapter 7

Bretton Hall
Teacher training through the arts

Allie Mills

This chapter discusses the formation of Bretton Hall College as a teacher training college for the arts, and how this influential creative institution shaped teacher training through the arts from 1949 in the West Riding. The philosophy of practice at Bretton Hall co-created satellites of being; students who had been nurtured and valued went on to bring this nurturing and value into the classroom. The college closed in 2001, The Mansion and the college's extensive buildings were, like Sleeping Beauty, left to sleep. Yet the legacy of Bretton Hall lived on, in the students who had attended, in the children who had attended West Riding schools and in the Yorkshire Sculpture Park. The voices of the West Riding Education Authority and of Bretton Hall have been drawn upon to convey first-hand experiences of how Bretton Hall was established, what it provided and its legacy, to reawaken Sleeping Beauty.[1]

> On the afternoon of September 25th the first fifty-six students arrived, just after the beds, and before the dining room chairs. Everyone was lost, misdirecting everyone else; furniture was being whisked into bedrooms just ahead of the students, while excited chatter and the sound of pianos being played filled the house with unaccustomed noise. That evening we sat down to our first meal together; everyone felt the excitement of being in at the beginning of a new education experiment.
> (Friend n.d.: 20)

The creative spirit

By 1945, there was much to look forward to, a rebuilding to take place, a new future to take part in, a Labour Government (Maclure 2000) and a new Education Act to enable. Sir Alec Clegg sets the scene himself when he said: 'I was the education officer of one of the biggest and most diverse authorities in the country, and for those of us who were education officers in those days, it was a golden era. Education was going to put the world to rights' (Clegg 1980: vii).

122 Allie Mills

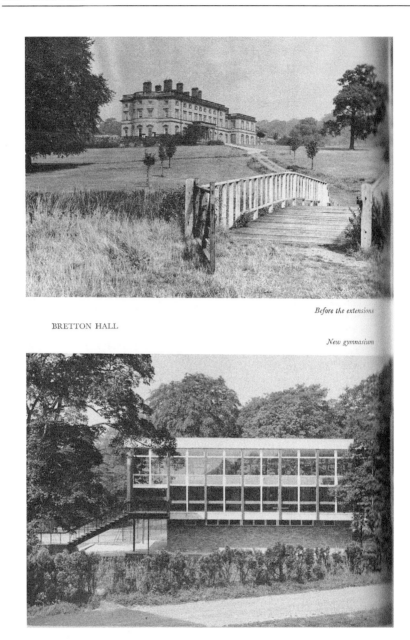

Figure 7.1 Bretton Hall and Gymnasium

The original stately home of Bretton Hall dates from 1720 with 19th-century alterations, and the gymnasium was built in 1962

WREC, *Education 1954-64*, facing p.86

At the start of Clegg's educational career, there was a 'mood of buoyant optimism which characterised the 1950s and 60s, the years of expansion' (Richmond 1978: 8),[2] though as his career came to a close it was 'replaced by one of profound scepticism, not to say sour disillusion' (Ibid).

This buoyant optimism included the full spectrum of education: nursery care; primary school; secondary school; further education; higher education and teacher training. In the West Riding this was underpinned by a core belief in principles succinctly stated by the Chief Inspector of Schools for London County Council in 1948:

> The most striking discovery made in this country about children in schools is that they are potential artists. They can make designs and paint pictures which have real aesthetic quality and they like to do so. When I say children, I mean every child and not exceptionally talented children here and there. This is more than a discovery, it is an exciting revelation and it has prompted the question whether children are not potential creative artists in other media, in movement and music making, in language and drama, in crafts and in human relationships. Evidence is rapidly accumulating that in all these branches of human activity children have potentialities for creation which we did not dream 50 years ago.
>
> (cited in Friend n.d.: 5)

The scene was set, bringing together these principles of children as artists, and the transformative nature of that recognition to the individual, coupled with Clegg's vision and commitment, began an era of creativity in the West Riding that was to influence the world. Recognising teacher training as fundamental in the West Riding vision for education, a training college for the arts was agreed upon, and in January 1946 Bretton Hall, in West Bretton, was deemed suitable for such a purpose. (Friend n.d.: 5). The cross-fertilisation of practices in music, movement, arts and drama, how this could enrich children's learning as a signature of West Riding provision, and the creative home which embodied these principles was established at Bretton. The college worked across all platforms to spread the word, locally, nationally and internationally. John Friend was the first appointed Principal of Bretton Hall in March 1949, coming north from London County Council as a Staff Inspector for Secondary Education. It had been agreed with the Ministry of Education that 60 students would be recruited with four courses to establish the provision. A national teacher shortage accelerated the college's opening, resulting in a programme of ongoing renovations and building work to the site that continued into the early 1950s. Sir Alec's hand became visible in in recruiting staff, as also did the Chairman of the Education Authority, Walter Hyman, and the Principal, John Friend. The importance of selecting these first staff members was reflected on by Friend years later:

> The whole future of the college could well depend on the quality of this team. Much would be asked of each member. I was determined that the division so often found in training colleges between those tutors responsible for academic work and those for professional training must be avoided. All tutors therefore would be proven teachers, all highly qualified specialists but also willing to work as a team in both areas according to interests and experience. All candidates were made aware of the founding principles and were expected to be in sympathy with them. Finally we were seeking a team willing to take a full part in the community life of the college, to be resident or to live nearby.
>
> (Friend n.d.: 6–7)

Dissemination of the founding principles was fundamental to the framework of Bretton Hall and the experiences to be cultivated there. A clear understanding and kindred mindset of the teaching staff was identified and understood by Clegg and his fellow interviewers when recruiting staff. Attracting like-minded educators who aligned with the founding principles was further supported by access to staff within the Local Education Authority (LEA) whom Clegg knew well and often had recruited himself. Being able to recruit and identify staff who believed in a common direction shaping West Riding education, and Bretton Hall as part of that, cultivated an environment of aspiration and collegiality. The *new education experiment* had begun.

Philosophy of practice

'He who is not alight, cannot fire others.'

(Bretton Hall College motto)

> So by 3pm on Thursday, September 25th, 1949 a group of 56 men and women had gathered at the main door of the Mansion waiting to be admitted as the first students of Bretton Hall. They had been arriving since mid-morning but could not be admitted as preparations for their reception were not yet completed. They were a very mixed group with ages ranging from eighteen to forty, musicians and artists from many parts of the country. When it was finally possible to open, they found their way around the Mansion, sought out the pianos and soon the Hall was full of music. We seemed almost at once to have created an exciting community.
>
> (Friend n.d.: 7)

The creation of Bretton Hall College is palpable, in reflecting back from the present. At the time, too, the sense of a new landscape for education in the West Riding, and the potential that held, was felt by all, staff and students. The activity, the eagerness, the exploration.

Teacher training at Bretton Hall 125

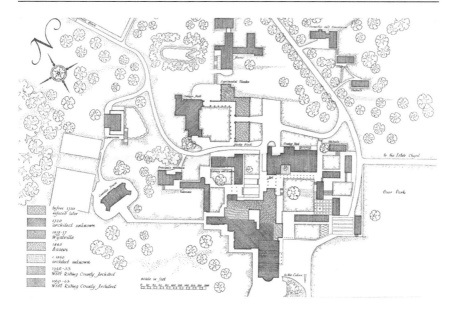

Figure 7.2 Plan of Bretton Hall and Park, 1963

Reproduced from the 1963 College Prospectus, it shows the development of buildings on the site between 1700 and 1963

WREC, *Bretton Hall Prospectus* 1963/1969, centre-page spread

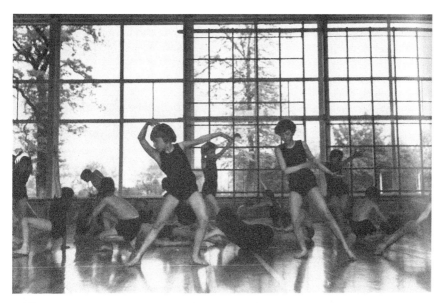

Figure 7.3 Bretton Hall Gymnasium in use
WREC, *Education 1954-64*, facing p.151

In August 1949, nearly two months before its official opening, Sir Alec attended a dinner with the newly appointed staff and posed 11 questions, not anticipating an answer 'for twenty years, and perhaps not then' (Friend n.d.: 11). Those questions show the depth and breadth of Clegg's knowledge, his aspirations for the college and for the children who would benefit from teacher education. The questions he posed were:

1. (a) What in order of importance are the purposes of teaching an art?
 Enjoyment of the art by the general public;
 Skill as amateurs in the art by the many;
 Skill as professionals by the few especially gifted.
 (b) Is it perhaps true to say that from enjoyment by the masses comes amateur skill by the many and professional skill by the few, as is true in the case of almost all games?
 (c) If this is true, is our approach to the teaching of the arts right and are our methods the right ones?
2. Is technical knowledge of an art necessary to a sensitive appreciation of it? Must one be able to sight read to enjoy music? Must one understand the technical mysteries of acting and the theatre to enjoy plays and film? Who is more sensitive to good wine, the connoisseur or the vintner? Or is it perhaps true to say that knowledge of technique increases understanding but not sensitivity, and, if so, which is the most basically important field of education?
3. Put this question another way, does technical proficiency in an art carry with it any guarantee of sensitive appreciation? Is it true, for instance, that our highly trained architects today, whose technical knowledge far exceeds that of Wren and Nash, Inigo Jones and Adams, are correspondingly greater artists? Do all our swing saxophonists harbour a love of Beethoven far more passionate than that of normal concert-goer?

 If it is true that sensitivity of imagination should have, so to speak, a higher priority than understanding in the world of arts, how much time should be spent on sight reading in music, stage-craft in drama, and figures of speech in the study of literature, and so on?
4. Is it true of the teaching of the arts that we over-emphasise what we can teach and neglect what we can't? We perhaps don't know how to inspire a love of music but to teach musical form is something we can grasp and carry out with measurable and considerable success.
5. To what extent in the teaching of arts should a child be directed? Children can be made to sing, to dance, and even to paint; if they are made to do these things what remains when they are no longer made to do them? At what age can a child safely be directed?
6. What is the essential difference between encouragement and applause as applied to children's work? When may children safely perform before each other and before adults?

7. Is it true that a child loses its sensitivity as it approaches adolescence, or is true to say that the average junior school syllabus kills it? How, in each of the arts, can sensitivity be fostered through those years when the acquisition of skills and the first absorption in factual knowledge tend to fill the mind of the young child?
8. Is the right way to teach the arts the way in which to teach games? Or is the right way to teach football to spend the first term kicking first with the right foot and then with the left, the second term with trapping and running with the ball, the third term with heading the ball, right through to a detailed study of various kinds of forward and defensive play, until in the sixth form real football could be started? Is it true to say that we often teach music in this way and consequently only the most incurably musical survive?
9. Would it be possible with adult students in a college like Bretton to try out a somewhat novel form of artistic appreciation based on a sensitive understanding of qualities? Would it be possible, for instance, without embarking on too artificial a scheme of co-operation, for the experts severally to determine what they meant by rhythm, form, lightness, strength and many other qualities in their respective media, and illustrate them so that the students become sensitive to similar qualities in several media?
10. How far is Herbert Read right in saying that movement is basic to all art? Is it a heresy to say that a child who is good at art may be made even better if his movement were made more sensitive?
11. Is it true that the arts, properly taught, offer a form of emotional release to children which is of extreme value both to their personal and intellectual development? Is so, should a balance be struck between this therapeutic function of art and the encouragement of a love of art?

Clegg's knowledge of teaching, his understanding of what is being measured in education and why, valuing the child and their spirit in their own journey through learning, and his reflective awareness of contemporary voices, all are evident in the questions which he posed. He wasn't simply posing rhetorical questions; he was posing a blueprint for learning through an arts education in the most holistic way. Beginning to address these questions, Friend, as first Principal of the college, also came with a set of beliefs he felt should be woven into this new experiment.

> I felt that my own experiences had led me to some fundamental principles which I considered would be helpful in our planning. In particular, I had become convinced of the value of purpose, meaning, and wholeness in the learning process and of creative experience in the development of the individual at all ages and was interested to discover how these principles could be applied to the training at Bretton.
>
> (Friend n.d.:13)

The triangulation of Clegg's drive and vision, of Friend's fundamental principles, and of the specialist staff engaged at Bretton Hall, culminated in seven agreements for shaping the initial courses that would be delivered at the college:

1. *Concentration*, that whole days would be spent studying, providing deep learning, and where development of the whole person could be achieved.
2. *Concurrent training* bringing together arts subject knowledge with the impact it could have on the child, and developing their practice as teachers.
3. *Resources* available would be a guiding principle in the provision delivered; it was agreed that music and art/crafts would therefore be the focus of initial provision and that secondary school would be the sector for attention.
4. That all students and ideally staff would be *residential*, which would in and of itself cultivate a community and where cross-fertilsation of practices could occur. The geographical nature of Bretton Hall and its surrounding park also ensured a remoteness that could provide an all-encompassing environment where arguably distractions would be limited.
5. There was a *unifying principle of personal development* which provided a clear bridge between the individual and their engagement with artistic practice, and subsequently that influence would be brought into their teaching practice.
6. It was also 'agreed unanimously' (Friend n.d.: 15), as with teacher training in colleges around the country, that courses in religious education and physical education would be included. However, physical education was framed and delivered through 'Movement', a key characteristic of the West Riding as a leading light nationally (see Chapter 6).
7. *Development through the arts generally* where students were encouraged and expected to engage with wider arts such as singing, and working with each other in extra-curricular activities and with times ring-fenced for this to take place. This approach also supported the residential community model which had been agreed to with the engagement of all staff and students at Bretton.

Finally, and not one of the unifying principles but possibly a radical stance, was that 'No formal rules would be set up until the students had arrived, and experience proved them to be necessary' (Friend n.d.: 15). Placing the onus on self-development, focus, cross-fertilisation, community, trust and true nature of experimentation, the design and practice of Bretton Hall took shape.

The value of arts

The arts, and their intrinsic value and influence on individual personal growth, underpinned the ethos and provision at Bretton Hall. The arts and their value were visibly conjoined in thinking and practice, and this positioning and belief

established an approach with unity between the visual and performing arts and the self-development and growth of the individual in their environment.

> It was never the intention at Bretton to impose qualities upon a person. Great care was taken in the selection of both staff and students to ensure that, as far as possible, all possessed qualities of warmth, sympathy, sensitivity and respect for persons or at least the potential for their development. We tried to provide an atmosphere, an environment in which such qualities, considered so essential in a teacher of the arts, could best grow.
>
> (Friend n.d.: 16)

It is the *potential* of the person that was always highlighted by Clegg, whether in selecting staff or when supporting a child or a learner, 'who they *could become*'

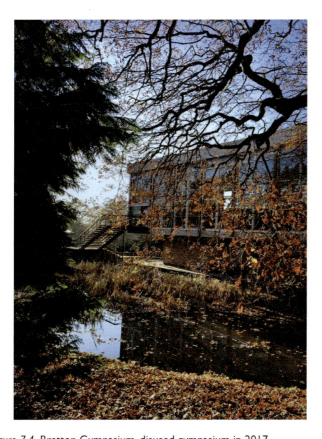

Figure 7.4 Bretton Gymnasium, disused gymnasium in 2017

Built in 1962, the gymnasium was used for dance, drama, gymnastics and theatre performances
Photo: Lottie Hoare

had value. The qualities of *warmth, sympathy, sensitivity and respect* in personality became a tangible foundation of the environment at Bretton Hall. The value of the arts was extended to the value of the potential. 'We were all sure that we must look for potential [when recruiting students] for development rather than immediate attainment' (Friend n.d.: 16). The co-creation of satellites, of the individual as an agent of change, was set in motion.

The founding principles were in place; the qualities needed in shaping teachers through the arts as the vision of Bretton Hall was established.

> We all agreed that among the main qualities of a teacher of the arts, warmth, sincerity and sensitivity were of the greatest importance. Though we mapped out, as it were, a pattern for our students, we realised that each would have a unique and individual personality which we would need to respect and allow to develop.
>
> (Friend n.d.: 17)

Again, the character of Clegg becomes visible at Bretton Hall, guiding principles and qualities in place yet always with room and respect for the individual to grow. The evening of 25 September 1949, the first evening on the opening day at Bretton Hall, suggests that the growing had already begun:

> The evening meal was taken in the beautiful dining room of the Mansion with its heavily decorated ceiling. Staff and students sat in tutorial groups. Quite deliberately, the student body was made up of an equal number of men and women, artists and musicians, one and two-year students. After the meal, over coffee, the necessary administrative arrangements for the next day and week were made. The rest of the evening was spent in talking and making a first exploration of the Mansion. Later a hot drink was served and, quite spontaneously, the students gathered on the fly-over, a bridge connecting the two parts of the Mansion under the dome of the central hall. There, they began to sing in parts, quietly and simply, the acoustics of the dome helping the quality of the singing. This was the beginning of a custom which became part of Bretton life and a foretaste of some of the joys to be experienced by living in such a community of artists.
>
> (Friend n.d.: 20)

The value of the arts at Bretton was multi-faceted and multi-layered. It was seen through the founding principles or seven agreements, the impetus for self-development; placed not in silos of separate arts, but rather all practices cross-fertilised in terms of music or art and craft, and through bringing curriculum and environment together:

> The Founders deliberately acquired Bretton Hall and its immediate environment with the conviction that the whole would assist our purposes and

help to develop the qualities of sensitivity and creativity in our students. I believe that the experience of our early years fully justified their confidence. In retrospect, I realise too how the structure of the Mansion itself with its various staircases and landings aided the growth of the community. The rooms of the students led off from the landings where small groups would regularly gather for discussion and social purposes, all linked to the whole community by common interests and purpose.

(Friend n.d.: 58)

Again, Clegg's hand is shown as a founder through the developing years of the college believing that 'the *whole* would assist'; Sir Alec always concerned with the whole child, the whole of the learning experience, the whole of the arts and not just any one aspect of it. The value of the *whole* of Bretton Hall was its unifying strength, not simply the value of arts as a subject, or artist as practitioner, but the value of arts as a whole.

'All overgrown by cunning moss' (Emily Dickinson)[3]

In 1978, the following was written, showing the enormity of change that education had undergone and is perpetually reflected in contemporary times:

A Rip Van Winkle who fell asleep in the England of 1944 would be astonished and bewildered by the multifarious changes in social life and affairs which he could not fail to notice on awakening today… The list would include such items as blues jeans, the Pill, high-rise flats, nylon tights, bingo halls, discos and supermarkets, parking meters and traffic wardens, flyovers and motorways, jet aircraft and package holidays, transistors, tape recorders, hi-fi and pocket calculators, decimal coinage and metrication, oil rigs, computers and lasers, hippies and long-haired youths, canned beer and bearded men… And if Rip happened to be an educationalist he would find the institutional landscape equally unfamiliar… he might well ask what happened to the Central Advisory Councils, the Technical High Schools and County Colleges, all of which promised to be growth-points at the time he fell asleep. Comprehensive and Middle Schools, Polytechnics and Colleges of Education, the Open University, Teachers' Centres and Resource Centres, the Schools Council, O- and A-Levels and CSE – these and a host of others had made their appearance during his slumbers.[4] Doubtless he would be impressed by some of the changes, appalled by others, and hard put to decide whether the last state was better or worse than the first.

(Richmond 1978: 8)

The landscape at the college's beginnings was a bygone age in 2001 when it closed. 52 years was its lifespan in West Bretton village: life with the Mansion

house, the Ezra Taylor Gymnasium, Stable Block, the Principal's Residence, Dining Hall, the Art Block, the Music Block, the Auditorium, the Camellia House and the 1964 Student Hostels. All sleeping. The vast grounds and woodland, the never-ending vistas. And yet, the satellites of the college, far beyond the educational institution, far beyond the geography, beyond memory and transcending time were the products of Bretton Hall. The students co-created a community of a new age, of education through the arts. Students who became teachers and spread the word, the values, founding principles, seven agreements, the voice and vision of Sir Alec Clegg. The legacy of Bretton is everywhere in education, maybe not explicit but surely there. The value of the individual, self-development of all, a need for self-expression, debates on measurement of knowledge in education, on how to build collegiately in classrooms, in schools, and in learning. Like Sleeping Beauty, it is time to reawaken the legacy of Clegg through his vision at Bretton Hall. The blueprint is in place, the narratives of the 21st century are of crisis in education, a vision is needed, and Sir Alec Clegg has provided the map.

Conclusion

Clegg had a deep understanding, appreciation and innate belief that underpinned the 11 questions he posed at dinner in 1949. The educational experiment that was Bretton Hall College began a deep reflective process of how to teach children, through the arts and with the arts. Enrichment goes far beyond the classroom and notions of measurements of success or attainment; questions address the whole child, the whole teacher, the whole system. The voices of Bretton always shaped its life and continue to do so, as student teachers embraced and lived its values and principles, influencing children, schools and families.

Notes

1 The fairy tale of *Sleeping Beauty* refers to a princess who falls asleep for one hundred years, remaining in a perfect state. As Bretton Hall College closed, the ideal could have closed with it. The memory of what had taken place there remained perfect and intact. By re-engaging with the voices of the West Riding Education Authority and of Bretton Hall College, once awakened, the story can continue.
2 W. Kenneth Richmond was a prolific educational commentator publishing widely throughout a long career spanning from the 1940s to the 1980s. Richmond's work provided a critical commentary on the wider educational landscape in which Sir Alec Clegg worked.
3 Title of a poem written by Emily Dickinson for Charlotte Bronte on the fourth anniversary of Bronte's death, representing a forgotten legacy, which is then revisited, but would not be seen again.
4 Richmond here lists a number of institutional innovations that entered the educational system during Clegg's period of office in the West Riding. Ordinary Level

and Advanced Level GCE (General Certificate of Education) were school-leaving exams for 15- and 18-year-olds initially introduced for Grammar School students in 1951 and Certificate of Secondary Education in 1965 for Secondary Modern School school-leavers.
5 Several copies can be found in NAEA, e.g. Bretton College collection: BHBCBK00292.

References

Clegg, A. (1980). *About Our Schools*. Oxford: Basil Blackwell.
Friend, J. (n.d.). *Community and Creativity in the Education and Training of Teachers: Bretton Hall 1949-1968* (with an introduction by Sir Alec Clegg). Sutton-under-Brailes: Privately printed [c.1968].[5]
Maclure, S. (2000) *The Inspector's Calling: HMI and the Shaping of Educational Policy, 1945-1992*. London: Hodder and Stoughton Educational.
Richmond, W. Kenneth. (1978) *Education in Britain since 1944: A Personal Retrospect*. London: Methuen.

Chapter 8

Global travel and exchange in promoting 'a change of heart towards children'

Catherine Burke

The extent and impact of travel and exchanges among networks of educationalists and others concerned with schooling has been an important strand of work among historians of education in recent years (Lawn and Grosvenor 1999; Fuchs 2007; Vick 2007). This chapter will account for and explore the many international visits and exchanges made by educationalists to and from the West Riding during Clegg's time in office and in his retirement. It will also account for some of the ways that Clegg addressed groups of teachers and administrators across the English-speaking world during his time in office. This period of time was also one when the notion of increasing the humanity of the classroom occupied the efforts of individuals committed to public service and caught up in the desire to redesign schooling in ways that would, they believed, regenerate democratic relations of living in the post-war world. This chapter takes the career of Alec Clegg as a starting point in exploring the reaches of related ideas of education through art and increasing the humanity of the classroom in efforts to reconstruct educational relationships in the post-war world.

'A change of heart towards children'

In addressing the global influence of Clegg's career, it is important to understand the nature and extent of the many exchanges that focused on the central role of the arts in the curriculum and the efforts to design democratic environments for the education of children in the immediate post-war decades. The axis upon which these exchanges occurred was the 'humane' and 'lively' education recognised to be flourishing in the English primary school. This was mainly but not exclusively occurring in newly built schools under the leadership of progressively inclined headteachers. Any progressive educator worth their salt during the 1960s and 1970s was planning a visit, or recovering from the experience of visiting, new schools in Hertfordshire, Oxfordshire, London, Bristol, Leicestershire as well as the West Riding. The English primary school was then considered to be the most advanced in the world in shaking off the shackles of the 19th-century mechanical model, and

developing an educational experience that might be enjoyed in an atmosphere of freedom, humanity and openness.

Global exchanges with educationalists: Europe, United States, Canada, Australia and New Zealand

Wherever Clegg travelled he spoke in very similar terms, using the same stories and metaphors to explain and encourage engagement with his view of teaching and learning. This was true also of the formal speeches he made to visitors from abroad who partook in workshops at Woolley Hall. It was his habit to end his speeches by inviting the audience to peruse a rich selection of children's writing, art, textiles and embroidery that he habitually carried about with him in an old leather suitcase. For him, children and young people had the same needs and dispositions wherever they were in the world. Teachers, too, were faced with the same challenges and similar restrictions. Clegg offered his audiences of teachers and administrators the very same philosophy of education wherever he was invited to speak and suggested that 'a change of heart towards childhood' was necessary everywhere.

Fundamental to this viewpoint was his contention that modern schooling had institutionalised relationships of teaching and learning across the modern world. It was therefore necessary to develop ways to increase the humanity of the classroom. This could be achieved through a change in relationships to support teaching and learning, redesigning the material conditions of schooling, and by bringing the arts, creativity and appreciation of beauty to the heart of pedagogy and the curriculum. None of this was to be at the expense of the development of basic skills such as reading, writing and mathematics. Rather, this increased humanity in relationships of teaching and learning, and knowledge would, he contended, enhance those skills.

Clegg had gained much of his knowledge of the extent to which children were capable of exceeding expectations through direct observation of a sympathetic teacher. Thus, during the 1940s, at the suggestion of Christian Schiller, the first HMI to be appointed Staff Inspector of Primary Education, he had witnessed the extraordinary achievements of education through the arts, brought about by headteacher Arthur Stone and his staff at Steward Street School in Birmingham (Burke and Grosvenor 2007; Burke 2011; Burke and Grosvenor 2013). Visitors to this school during the late 1940s included a great number of educationalists and advisors from the UK and Europe, and we know that it was here that Clegg experienced his epiphany.[1] Observation of good practice was fundamental to Clegg's understanding of how teachers learn, and in this he was in agreement with a generation of progressive directors of education and HMI. So it is no surprise that when visitors from abroad came to the West Riding to discover what was so special about the 'revolution' in infant and primary education that they had heard so much about, they were directed to certain schools and encouraged to closely observe certain teachers. Particular

schools were regularly on the list. When a group of teachers and administrators from Germany took part in an Anglo-German arts education course in April 1954, they were taken to schools chosen for their excellence in certain respects. At Wheldon Lane they saw 'some good physical education and movement'; South Kirkby 'where the whole school is illuminated by its art'; and Bolton-on-Dearne where they were 'more impressed by the dancing than by the art' (NAEA Sir Alec Clegg Collection 1954). Another school often on the visitors' itinerary was Three Lane Ends infant school at Whitwood Mere, Castleford, long associated with excellence in education for children of nursery age.[2] Not only was it an attractive building, designed by Oliver Hill, but the tradition of providing a humane education there reached back as far as the early 1940s.

United States

Clegg visited the United States on a number of occasions during his career and many Americans made the trip across the Atlantic to experience for themselves the changes in education taking place in some of the most progressive educational authorities in England. During the 1960s, the introduction of what were known as 'informal methods' and 'the integrated day' operated as something of a magnet, attracting interest from Europeans, north Americans, Australians and New Zealanders. While in America, Clegg was invited to visit schools across the country, many of them in 'spectacular' new buildings. But while he appreciated the high quality of the buildings and their equipment, he was 'only interested in them [the buildings] if they offered evidence of some new educational principle'.[3] As in other national contexts, Clegg took the opportunity of these travels to forge links with progressive educators in order to arrange for teacher exchanges to take place, towards sharing good practice.

During the early 1970s, Clegg established a lasting friendship and series of exchanges with Ed Yeomans Junior who was at that time principal of the independent progressive Shady Hill school in Massachusetts. In a letter written to Jessie Clegg shortly after Clegg's death, Yeomans recalled his first becoming aware of the achievements already secured in Clegg's schools:

> I was serving as member of the staff of the National Association of Independent Schools. We heard exciting reports of work being done in primary school classrooms in a number of authorities in English State schools, among them the West Riding of Yorkshire… Having been raised in the progressive education tradition in this country in which the arts are seen as quite central in the curriculum, I responded warmly to the reports and decided to see for myself. This visit turned out to be one of the most profoundly moving experiences which happen rarely in life if at all. Sir Alec met me cordially and wasted no time in arranging for me to visit a number of schools. He would talk to me later on, after I had seen teachers

and children at work. My odyssey extended over several days among the coal towns and villages of the district... what I was seeing of course was the vision of Sir Alec embodied in the work of the people whom he had trained.

(Yeomans 1986)

Yeomans subsequently arranged with Clegg that a group of West Riding teachers would travel to the United States the following summer to lead workshops. These workshops, which lasted six weeks at a time and were repeated over several years, created transnational communities of teacher-learners and were acknowledged by Yeomans as having been 'profound experiences for the teachers from public and independent schools alike'. Having experienced teachers' courses at Woolley Hall himself, while visiting the West Riding, Yeomans took the model of teacher development he was so impressed with back to the United States. 'We set up teachers centers and tried to draw some of the essence of Woolley Hall into our districts.' Some centres succeeded for a few years before being recommissioned for other purposes. Clegg made the return trip several times when, according to Yeomans' account, 'his influence was pervasive' as he brought 'glimpses of a new way in American education: at least among teachers whose eyes were not sealed shut'.[4]

Over the years, several visitors, like Yeomans, sought out the opportunity to meet and talk with Clegg. Charles Rathbone was one of a number of Americans who were drawn to visit England in the 1960s to see for themselves the 'revolution' in primary education that they had heard was developing there. In 1968, while preparing his book on open classrooms, Rathbone vividly recalls meeting Clegg for a prearranged interview in a London hotel along with fellow American Roland Barth. At the start of the hour-long interview, Clegg offered the Americans the key ingredients of his advice. 'Clegg began by telling us the story of Arthur Stone, and then proceeded to his theory of how to "grow" teachers. Find something to praise – anything at all – and next time there will inevitably be more of it.'[5]

The publication of the Plowden Report, *Children and Their Primary Schools* (Central Advisory Council for Education 1967) led to a far greater public awareness across the world that progressive approaches to education need not be confined to the independent sector but could be successfully applied in the densely populated classrooms of public schools. According to Joseph Featherstone, who first brought Plowden to the attention of an American readership, 'The Plowden Committee (was) in a sense the official voice of the primary school revolution' (Featherstone 1967: 7). In his review for readers of the *New York Times*, entitled 'An English Lesson for America', Featherstone remarked that 'visitors to scattered poor, slum and immigrant areas in England have found first-rate primary schools doing an exemplary job teaching the children of the poor'. Recognising a current vogue for seeing the schools in action, he noted, 'Thousands of Americans are flocking to the better English

educational authorities; indeed, the swarms of curious educational tourists are becoming a nuisance' (Featherstone 1970).

Shortly after Featherstone's articles were published in *The New Republic*, further influential accounts began to appear; the result of visits made by Americans intrigued by what they had heard, and now read about. The physicist and environmental educationalist David Hawkins spent a year (1968–1969) observing practice in the more progressive English schools (Hawkins 1969). On returning to the United States, inspired by what he had seen in Leicestershire, the West Riding of Yorkshire and Oxfordshire, he and his wife Frances opened the Mountain View Environmental Education Centre in Boulder, Colorado, funded by the Ford Foundation and managed by the University of Colorado.[6]

In his book, *The Informed Vision* (1974), Hawkins made connections between the aesthetic (the visually pleasing) environment and pupil engagement, arguing that 'classrooms that are aesthetically dreary places are ones where children are bored' (Featherstone and Featherstone 2002: 24). He contrasted these with:

> British infant classrooms in which children's murals, calligraphy and illustrated reports on scientific enquiries decorate walls… while found materials collected by children – shells, intriguing stones, moss and toadstools – line shelves and tables.
> (Featherstone and Featherstone 2002: 25)

In these senses, Hawkins' beliefs and values found their ideological home within the more progressive English regions among teachers, advisors and administrators such as Alec Clegg.

In April 1969, Clegg addressed the Department of Elementary School Principals at their annual convention in Las Vegas.[7] His address, 'The Revolution in the English Elementary Schools', was later published in the journal of the National Education Association (NEA). By this time, the term 'revolution' was being used without hesitation to describe the changes occurring in pioneering state schools in the English regions. In his lecture, Clegg explained the English system and invited the audience to look closely at the examples of children's art he had displayed, 'all produced by sons and daughters of coal miners', and alluded favourably to the presentation made by Dr William Glasser. Glasser was at this time a prominent American psychologist and well-known critic of the American school system, whose article 'The Effect of School Failure on the Life of a Child' was published by the NEA (Glasser 1971). Later, addressing teachers at a meeting for Department of Education Officers at West Yorkshire's Bramley Grange Conference Centre in June 1969, Clegg let it be known that he was in agreement with Glasser and had found in his lectures and publications what was to him a rare example of American regard for increasing the humanity of the classroom (NAEA Sir Alec Clegg Collection 1969). But in general terms, Clegg was disappointed with and highly critical of the accountability approach to education in the United States that was, he believed, leading

in the wrong direction. He was fearful, notwithstanding the interest shown by American educators in developments in the West Riding and other progressive English regions, that right-wing critiques of the methods he espoused would lead to increased emphasis on testing and measuring (NAEA Sir Alec Clegg Collection 1971).

During the early 1970s, towards the end of Clegg's career, American educationalists continued to make the trip across the Atlantic, such was the excitement generated by the various published accounts in text and in film of the British classroom 'revolution'. The American educationalist Vincent Rogers visited Oxfordshire and declared 'I have not been the same since' (Paull 2012: 157). Rogers produced *Teaching in the British Primary School* in 1970, a collection of essays by English teachers and advisers. There was also an impressive initiative to consolidate and document the practice that was so admired, through a Ford Foundation sponsored series of publications in conjunction with the British Schools Council for Curriculum and Examinations. Featherstone provided the introduction to the series. But on the American side, perhaps the best-known volume was Charles Silberman's *Crisis in the Classroom: The Remaking of American Education* (1970), which drew inspiration from the English innovations. Silberman not only was inspired by Featherstone's prose but was assisted by him in his efforts to see for himself what was transpiring in England. Silberman 'observed informal schools… in the depressed coal mining towns of Yorkshire, in middle class and lower class neighborhoods in Leicestershire county in the industrial midlands, and in pastoral but increasingly industrialized Oxfordshire' (Silberman 1971: 212).

Taking a cue from Featherstone's intimate descriptions of English education, in his book, Silberman invites the reader to step inside the informal classroom. To enter is at first 'disorienting'. The classroom 'does not look like a classroom'. He continues, 'somewhere in the room, or perhaps in the hall outside, there will be some large easels with jars of paints and large brushes' (Silberman 1971: 223). And to convey something of the variety of activities and constant movement in the scene, Silberman makes the following well-observed remark:

> To photograph a formal classroom in action, one needs only a still camera with a wide-angle lens; to photograph an informal classroom for infant and younger junior children, one needs a motion-picture camera with sound, for the initial impression is that the children are all in motion.
> (Silberman 1971: 223)

On his visit to Yorkshire, Silberman had met with Clegg and invited him to produce an account, for American audiences, of the British 'revolution' in the primary schools. The resulting pamphlet, written by Clegg, with a foreword by Silberman (1971), was richly illustrated with pupils' art and writing and showed classroom and outdoor scenes featuring children in a variety of

situations: painting at easels, working with plants, drawing, measuring and dancing. In this publication, Silberman quoted Clegg as saying:

> It is a matter of great interest to me to watch over a twenty year span, the development of the fundamentals of education as seen, not in intelligence tests or reading techniques or history syllabuses, but in the way children dance and paint and write and behave towards one another.
> (Silberman 1971: 4)

Canada

In 1965, the educational community in Canada was canvassed for nominations of overseas educators who would subsequently visit Canadian schools from coast to coast. Clegg was invited to give informal talks to teachers and to visit and observe what was happening in schools across the vast country. This was the start of a long-lasting connection between the West Riding and Canada, and Clegg visited the country frequently over the following fifteen years. The other two educators nominated were Sir Harold Wyndham, Chief Education Officer of New South Wales, Australia, and James Revell, Chief Education Officer for the London Borough of Croydon. Clegg was nominated by the Canadian Education Association through its esteemed secretary, Freeman Stewart.[8] The visitors were able to see a vast number of schools in practice, in an extensive programme offering them 'a birds-eye view of Canadian education in each of the ten provinces (NAEA Sir Alec Clegg Collection 1989). The following year, Clegg was once again in Canada, this time in Vancouver for the Canadian Education Association Convention. In his address entitled 'The Expansion of Knowledge and the Reform of the Curriculum', he warned about the temptation to regard 'national power' and 'progress' as a rationale for the design of the curriculum. Calling for a 'change of heart on what we are doing to these youngsters', he argued for an educational experience that enabled pupils

> to derive pleasure from those things designed to give pleasure, and these would include art, music and the crafts, and also physical activities which included not only gymnastic skills, games, hiking, camping and swimming, but also drama and the dance.
> (NAEA Sir Alec Clegg Collection 1989)

As in other parts of the world, Clegg forged a key relationship with one individual who subsequently collaborated in designing teacher development exchanges over many years. In this case it was William J. McCordic. Having commenced his career in education as an elementary school teacher, McCordic was the first Director of Education for the Metropolitan Toronto School Board. After retirement in the 1970s, he became the Executive Director for the Ontario Association of Education Administration Officials and was probably

responsible for inviting Clegg to address the organisation's annual conference held in Ottawa in November 1970.[9] In his keynote address to that gathering, Clegg, who was concerned about the distracting effect of affluence in Canadian society, stated firmly that 'the aim of education should be to do the best for and get the best out of every child – not what will produce the most for the Gross Domestic Product'. In 1971, a group of educationalists from Toronto finally made the trip to the West Riding, 'spending two days in Yorkshire, including an overnight stop at Woolley Hall… and a visit to Mrs Pyrah's classroom to witness and hear a "conversation class"' (NAEA Sir Alec Clegg Collection 1989).

Australia and New Zealand

Clegg made the lengthy journey to Australia and New Zealand on several occasions while in post and during retirement. One of his first visits was made in 1957 when the Australian branch of the New Education Fellowship invited him to take part in a lecture tour alongside other renowned educationalists.[10] On this occasion, Clegg's talks in Australia and Tasmania covered a range of subjects: further education; selection at 11; home school and family life; 'filling pots and lighting fires' (NAEA Sir Alec Clegg Collection 1957). On the evening of 22 August 1957, Clegg spoke on the subject of 'Problems for the British Educationalists' in an ABC radio broadcast. In that talk he praised the achievements in the State of Victoria relating to the selection of children for secondary-level education and made clear his reasoned opposition about the availability of private schooling (Ibid.). But apart from the formal responsibilities, Clegg took up opportunities to see for himself what was happening in Australian classrooms and, with an eye already to forging future teacher exchanges, initiated what was to become an extensive programme over the following years. During his stay in Sydney, Clegg was hosted by a newly qualified elementary school teacher, Fred Armstrong who recalled:

> At my one-teacher school I was able to give Mr Clegg a full run-down on my training, how the classroom functioned daily and showed him the range and quality of the work the students were producing. He was most impressed. The result was that, if I could get to England he would give me a job and anticipated that I would interact and share my Australian experiences with the schools and any teachers that I would meet. He felt that we had much to offer each other in our own way.

Armstrong and his wife spent a year, 1959, in the West Riding of Yorkshire, attached for six months to Redhill Primary School, Castleford where he 'participated, absorbed, gleaned and shared educational methodology, philosophy and basic routines'.[11]

By the early 1960s, two teachers each year were exchanged between the West Riding and Tasmania in a programme financed by the League of British

Commonwealth and Empire. Clegg made sure to arrange for the most experienced infant and primary school teachers to make the trip and to teach and advise for two to three months. In the main, these were women teachers, many already in headships, mostly unmarried. While the Tasmanians were keen to host male teachers, these were more difficult to recruit owing to family responsibilities. Arthur Stone was especially invited, but declined.[12] The journey, made by ship over several weeks, was quite a commitment and for many a significant adventure in their professional careers.

These exchanges soon prompted reflection and recording of changes taking place in Tasmanian schools as a result. Several articles were published during the early 1960s describing and evaluating the application of informal methods of teaching and learning.[13] Occasionally, West Riding visitors stayed and settled; in 1966, K. D. Thomas who had been a supervisor for art education from the Sheffield Education Authority became a lecturer in art education in the University of Tasmania at Hobart. Thomas promoted creativity in art education through his advocacy and publications (Thomas 1968).

The administration of the teacher exchange scheme was time-consuming but highly valued and in 1964, Clegg sent addresses of West Riding schools to Australian contacts 'so that there could be direct contact between schools in both countries' (Darvill 2000: 159). In 1970, a delegation of Australian teachers and administrators, including Phil Cullen, then serving as regional director of primary education for the North West of Queensland, travelled to England to visit schools. He recalled:

> In 1970 I paid a special visit to the West Riding of Yorkshire because I had heard that the Authority, under the leadership of Sir Alec Clegg had some special things going for it in regard to children's capacity to learn at the primary school level by increasing the humanity of the classroom. I was not disappointed. It was a real educational experience. You could 'feel' an atmosphere of real learning in the schools.[14]

This comment was typical of those made by visitors to the English regions who travelled from many different countries during these years. That humanity had deep roots and parallel branches in the Australian and New Zealand territories. Once again, a strong friendship was established and Cullen hosted Sir Alec and Lady Clegg when they visited Queensland during a trip in the mid-1980s.

Returning to Australia, after his year in the West Riding, Fred Armstrong was inspired to develop Clegg's philosophy in his practice as a teacher and subsequently as a principal. Woollahra Demonstration School, during the 1970s, under Armstrong's direction, became an internationally celebrated progressive centre receiving up to 500 visitors each year between 1973 and 1985. While Clegg returned to Australia, he did not visit Woollahra, but if he had, Armstrong reflects:

I would have liked to have taken Sir Alec Clegg to Woollahra Demonstration School in the late 1970s and showed him what he had achieved with one simple but generous gesture to a raw young teacher. To let him stroll through the school chatting to the boys and girls, observing the teachers and having his talent for 'listening and learning', working overtime would have been quite rewarding.[15]

After Clegg's death in 1986, Lady Clegg reached out to individuals whose lives and practices as educators had been particularly changed through their coming into contact or forming friendships with him. In Tasmania, Clegg had created a deep connection with the West Riding through his own visits and through the work of advisors such as Rae Milne who spent many months there over a period of years.

Conclusion

The pursuit of the global Clegg leads to identify parallel histories of individuals loosely associated with one another but committed, in spite of differences in geographical location, to an education uniting head, heart and hand. Within this prosopographical framing, Clegg's efforts to enhance the experience of schooling in the West Riding of Yorkshire, informing and inspiring national policy in general, can be seen to have had deep and extensive roots, and a wider global context. Exploring the networks of individuals engaged in efforts to promote modern education for the young child across several continents during this period has enabled the career of Alec Clegg, and the global extent of his influence as a progressive educational administrator, to be placed in context. That context consisted of a rich and vigorous enthusiasm for the central place of the arts and creativity in education, supported by international sponsoring bodies such as the New Education Fellowship and the Carnegie Foundation. Individuals from across the world were drawn, by the influence of Clegg, to see for themselves what the so-called 'revolution' in the English primary school consisted of, and this experience shaped their subsequent careers as well as the careers and experiences of the teachers and pupils they influenced in turn. It can be argued that the flowering of 'open education' as it became known across these nations during the 1970s was rooted in a deeper transnational conversation. That global context underpinned the strength of conviction held by individuals encountered in this chapter, that the arts, that aesthetics and design should be integral core elements in any curriculum that enhanced the humanity of the classroom.

The constellation of actors explored in connection with Clegg, in their specific ways, became actively engaged with an optimistic turn in the post-war world. This turn advocated a role for the arts in encouraging 'a change of heart towards children', meaning a fundamental change in the response of the adult world to childhood. It was vital to approach the experience of

childhood through an empathetic engagement with children's material and social worlds. The shift in perspective was enriched by travel and serious international exchange. Mutual interest was realised in shaping a humane educational plan. The commonly shared principle was that art and creativity were fundamental features of humanity. However, while their practice and expression were universally provided for by nature, social inequalities led to unequal access. A striving towards more equitable levels of social justice was essential to the widespread experiments and innovations, designs and interventions, achieved or struggled for in these years.

Notes

1 Clegg often talked about his visits to Steward Street School as a profound learning experience. He recruited the school's headteacher, Arthur Stone to the West Riding to work with him in the advisory service.
2 See 'I Give You – the Three Rs' by Miss M. M. Newton, headmistress, Whitwood Mere Infant School, Castleford, in Woodhead 1943.
3 He visited schools in Virginia, Massachusetts, and Philadelphia.
4 Letter from Ed Yeomans to Jessie Clegg, 30 November 1988. AC/PL/573. For an appraisal of the English post-war school, see Yeomans (1986).
5 Charles Rathbone, personal email correspondence with the author, 5 April 2018.
6 Hawkins published his book *The Informed Vision* in 1974, drawing from his work at the Mountain View Centre. The book was favoured by Loris Malaguzzi, pioneer of celebrated Reggio Emilia schools, who deemed *The Informed Vision* essential reading for all teachers.
7 The DESP was a professional body of the National Education Association of the United States.
8 Stewart was well travelled himself, representing the Canadian Education Association all over the world. See G. E. M. MacLeod and R. E. Blair, *The Canadian Education Association: The First 100 Years, 1891–1991*, CEA, p.50.
9 William J. McCordic (1919–2008). The friendship outlasted the official careers of both men. Indeed, the two families shared a vacation in France during the 1980s. McCordic's obituary is available online at legacy.com.
10 The others invited were Professor J. W. Tibble and Dr Mateur.
11 Fred Armstrong personal correspondence with the author, received 3 October 2017.
12 NAEA Letter from Stone to Clegg dated 18 April 1963 in a box of papers relation to Tasmania.
13 *The Tasmanian Teacher* published an article in 1961 entitled 'Revolution in the Primary School'.
14 Phil Cullen, personal correspondence with the author, 16 April 2015.
15 Fred Armstrong, personal correspondence with the author, 3 October 2017.

References

Burke, C. (2011). 'Creativity in school design', in *The Routledge International Handbook of Creative Learning*. ed. Sefton-Green, J., P. Thomson and K. Jones. London: Routledge, 417–427.

Burke, C. and I. Grosvenor. (2007). 'The progressive image in the history of education: Stories of two schools'. *Visual Studies* 22(2): 155–168.
Burke, C. and I. Grosvenor. (2013). 'The Steward Street School experiment: A critical case study of possibilities'. *British Educational Research Journal* 39(1): 148–165.
Central Advisory Council for Education. (1967). *The Plowden Report: 'Children and Their Primary Schools'*. London: HMSO.
Darvill, P. (2000). *Sir Alec Clegg: The Man, His Ideas and His Schools*. Knebworth: Able Publishing.
Featherstone, J. (1970). 'An English lesson for America'. *New York Times*, 20 September.
Featherstone, J. (1967). 'The primary school revolution in Britain'. *The New Republic*, 19 August.
Featherstone, H. and J. Featherstone. (2002). 'The word I would use is aesthetic: Reading David Hawkins'. *For the Learning of Mathematics* 22(2): 24–27.
Fuchs, E. (2007). 'Networks and the history of education'. *Paedagogica Historica* 43(2): 185–197.
Glasser, W. (1971). *The Effect of School Failure on the Life of a Child*. Washington, DC: National Education Association.
Hawkins, D. (1969). 'Square two, square three'. *Forum* 12(1): 4–9.
Hawkins, D. (1974) *The Informed Vision: Essays on Learning and Human Nature*. New York: Agathon Press.
Lawn, M. and I. Grosvenor. (1999). 'Imagining a project: Networks, discourses and spaces – towards a new archaeology of urban education'. *Paedagogica Historica* 35(2): 380–393.
NAEA Sir Alec Clegg Collection. (1954). Concluding address given by Clegg at the close of the Anglo-German arts course at Woolley Hall, April 1954. BHACPL00074.
NAEA Sir Alec Clegg Collection. (1957). Talks in Australia and Tasmania, including broadcast talk for ABC 'Problems for British Educationists', 22 August. BHACPL00118-123.
NAEA Sir Alec Clegg Collection. (1969 and 1970). *The National Elementary Principal* XLIX no 1. September 1969 BHACPL00270; 'What is Humanising Curriculum?' Copy of publication from *The National Elementary Principal* XLIX(4), Department of Elementary School Principals. BHACPL00575.
NAEA Sir Alec Clegg Collection. (1971). Criticism of USA system, in 'We Are Going That Way'. Notes for talk at Bootham School, York, 12 June 1971, AC/PL/293. BHACPL00293.
NAEA Sir Alec Clegg Collection. (1989). McCordic, W. J. Paper outlining the influence of Sir Alec Clegg on the development of Canadian education, 22 October 1989. BHACPL00429 [and copy in Clegg family archives].
Paull, J. (2012). *Through My Eyes: On Becoming a Teacher*. Bloomington, IN: Xlibris Corporation LLC, USA.
Rogers, V. (1970). *Teaching in the British Primary School*. London: Collier Macmillan.
Silberman, C. (1971) 'Foreword' in *Revolution in the British Primary Schools*. In <https://files.eric.ed.gov/fulltext/ED059535.pdf> (last consultation: 11 January 2018).
Silberman, C. (1970). *Crisis in the Classroom: The Remaking of American Education*. New York: Random House.
Thomas, K. (1968). 'Creative art education in the infant and primary schools'. *Tasmanian Journal of Education* 2(2).

Vick, M. (2007). 'Australian teacher education 1900–1950: Conspicuous and inconspicuous international networks'. *Paedagogica Historica* 43(2): 245–255.
Woodhead, E. ed.. (1943). *Education Handbook*. Norwich: Jarrold and Sons.
Yeomans, E. (1986). *When the Voice of the Teacher is Heard in the Land*. North Dakota Study Group Evaluation monograph, Centre for Teaching and Learning, University of North Dakota. www.ndsg.org/monographs/NDSG_1986_Yeomans_When_the_Voice.pdf

Chapter 9

Children in distress and their need for creativity

A psychotherapeutic perspective

Alison Roy

I first learned about Clegg when I was asked to speak at a seminar celebrating the work of Clegg, which took place at the Faculty of Education, University of Cambridge. The seminar addressed contemporary concerns in education and the well-being of children and young people. Clegg asserted that, 'every child, no matter how impoverished their circumstances can be creative if given the opportunity'. *Children in Distress*, by Alec Clegg and Barbara Megson (1968, 2nd edition 1973),[1] is a book which embraces the complexities of childhood and being human and what affects behaviour or causes distress. In writing this chapter, I have drawn from some of the ideas in this book but I have also reflected back over my own experiences in education and the schools I attended both in East Anglia and the midlands in the years following that book's publication.

Over the course of my childhood and adolescence, I had very varied experiences of being in different learning environments and realise now as an adult that so much depended on the focus and vision of the headteacher or leadership team within those environments. However, at the time, my experiences of those who taught me made all the difference between whether I enjoyed school and was willing to learn, or whether it was just a part of my life to be endured.

If I felt a teacher understood me and could bring out the best in me, their subject became one of 'my' subjects; if not, then I, more often than not, dropped it as soon as I had the opportunity to do so. I have heard similar stories from the great and the good – where an inspirational teacher (rather than the subject itself) captivated a child or young person and gave them the motivation they needed to excel. It is therefore my intention in this chapter to set out how I believe that it is these meaningful relationships, alongside being given the right knowledge and experience, that create the best learning environments, ones where children and young people can really develop and thrive.

My first school (in my opinion) was a terrifyingly bad infant school where I spent most of my time wondering how I would survive each day. I don't remember the names of any of the teachers except one who noticed that

I became more animated when using paints (which rarely ventured out of the art cupboard). On one occasion, he allowed me free rein of all the colours and placed a number of large sheets of paper on the easel. I rose to the occasion and painted a big red moon, with silhouetted trees and people as shadows. I remember painstakingly introducing the tiniest bit of yellow paint (light) which was trying to penetrate the darkness and chaos. I covered every inch of paper as if I knew that I had to make the most of this experience. Looking back, that painting probably resembled a gothic horror scene to the teacher who tried to make sense of it with me, but despite being only four years old, I suspect it was creative communication about what school felt like for me at that time. Up until this point my teacher had described me to my parents, who were also teachers, as a 'slow developer' and a 'dreamer'. I had the distinct impression that I was viewed as a disappointment to my teacher who knew my parents, and yet my painting bewildered him. He put it on the wall and gave it (and me) his close attention, calling my parents in to see it. I was surprised to hear him describe me as an artist, but my painting had enabled him to see me with new eyes and I had proved that I was worthy of at least his curiosity and an open mind.

The value of allowing space for the 'free' expression and creativity of children should not be underestimated, as it allows for other or 'new' aspects or versions of the child or young person to emerge, which may allow the adults around them to view them differently. It also creates an opportunity for different kinds of communication to become possible. A quiet or 'invisible' child may find a way to make themselves heard and understood through art or music for example – where verbal expression may not have been possible especially in a group situation, and a traumatised or distressed child who may have been explicitly told not to 'tell' can show us about their experiences through their play-making.

I remember little else of my time at infant school but to my relief and surprise, after my family moved further north, I attended a junior school where play or being playful was positively encouraged. Building meaningful and safe relationships between teachers and pupils was supported by the head and appeared to be central to the school ethos and vision. What mattered to me was that I felt for the first time since the age of four that school was a place where I could enjoy my learning and could begin to be curious again! I woke up every morning eager and happy to go to school and would collect things en route to add to my various creations, such as a chaffinch made of clay and feathers. This chaffinch became 'alive' in my hands but also in my mind and I tended to it during break and lunch times, adding colour to its clay body and sticking feathers to its plumage. I was also permitted to research finches in the library and this research became a part of my classroom learning. I would also have been perfectly happy to concentrate on less appealing subjects like maths if the main focus for that learning had been my chaffinch. Capturing children's interest and engaging their imagination therefore can provide the

motivation needed for good self-led learning in any educational environment. It was while I was at this junior school that I also expanded my precious fossil collection; my child-focused interest in rocks and ancient discoveries 'underground' nurtured the seeds for my adult preoccupation with the emotional archaeology or geology of a person – their ancestry, history and valences and all that makes them who they are.

In the 1960s, Sybil Marshall wrote about the need for creativity in schools and how learning through the arts was beneficial for primary school aged children and their development. Her book, *An Experiment in Education* (1963), explored contemporary ideas about how teachers should be encouraged or supported to allow children the freedom to be playful and to learn how to be 'in the moment'. She wrote:

> The sight of the familiar green and white drawing books was too much for me, and without even asking permission I removed the lot, tore them up, and handed back to my astonished pupils the separate sheets of paper. Whatever else happened while they were in my charge, the children should not be presented, week after week, with their smudgy, finger-marked and tear-stained failures of the past.
>
> (Marshall 1963: 10)

The idea that a child could begin with a fresh page and that previous 'errors' and 'failures' would not be held against them was and is still refreshingly new. Experiences of getting it 'wrong' wouldn't be forgotten as such but they could be viewed as part of learning and positive risk taking – a sign of growth and development. In my years of working with children and young people in a number of settings, I have come to realise that a child who can embrace chaos and learn from their mistakes is much more likely to develop confidence in their ability to recover and to be resilient. In contrast, the child who feels that perfection and the acceptance and approval of others is vital will always be striving to 'make the grade'. They are unlikely to achieve any lasting satisfaction no matter how hard they try, and are more inclined to be critical of themselves and others.

I wonder if this is what Marshall was getting at in encouraging learning through rejecting the 'tear-stained' pages of 'failures' from the past and embracing a version of themselves where there could be possibilities, having had achievements acknowledged. Self-awareness and acceptance of so-called 'mistakes' as a normal part of development can therefore enrich the child's learning in that they are more able to absorb meaning and learn to manage frustration for themselves.

If each child was permitted the freedom to link the pages of their learning together in their own way, then it is possible their discoveries would have far greater worth to them than any version designed for them by their educators. That does not mean that there is no value in planning, or in visiting the past,

but there is a difference between planning in order to facilitate safe curious learning for children, on one hand, and producing rigid plans which can actually be traumatising for a child, in order to achieve target grades on the other. These ideas are ones which support Clegg's perspectives on encouraging or enabling children to express themselves creatively. He emphasises that a good or 'sensitive' school will show 'real concern for its pupils' and pay less attention to achievements but will make 'strenuous efforts to discover ways in which the weak can excel and to help them over their weakness' (Clegg and Megson 1968: 89). I recognise that I am advocating a freedom to be in the moment, when as a psychotherapist I am interested in how our histories shape us and influence our life decisions in the here and now. However, I do believe that it is the freedom to be in the moment and to be oneself that enables the past to surface in a way that is more manageable and meaningful and also allows the bigger picture to take shape.

Society may have different views today about what constitutes 'weakness', and the term 'vulnerability' is frequently used to describe children and their families who struggle to engage with education, but I also want to reflect on what 'success' might look or feel like. I don't believe that any self-respecting or self-reflecting adult would disagree that it is the grown-up's responsibility to create an environment where the child can feel safe and achieve success. However, I have encountered too many children who become rather confused about the meaning of 'success' in relation to their experience in school. A number of them have spent long periods in isolation booths or exclusion zones, and are unfortunately under an illusion that they have failed to modify their behaviour and have therefore let the school down and made it an unsafe environment for other pupils or students. That their behaviour has consequences, they can agree with, but their understanding of these consequences as having a negative impact on the success or rating of the school, rather than as impeding their own betterment or development, makes little sense and sets up a complicated power dynamic.

This is where there appear to be massive contradictions between what we know or instinctively feel to be true – a common-sense approach to educating children – and how the child appears to be understood politically. Perhaps if there was more scope for creative and reflective thinking in schools, especially around how to manage and support the more challenging and conduct-disordered children and young people, we might avoid further distress, humiliation and ultimately exclusion from an environment that should provide a safety net for them through opportunities for socialisation.

We know that children do not exist in isolation – they are part of a wider social picture and their relationships are central to their development. When we leave out or muddle up any part of this picture, we develop an incomplete or inaccurate version of the child's personality, because we lose sight of 'significant others' who are deeply connected to the child. This is certainly true when it comes to children in distress. The pages are being 'joined' together

in the wrong order, or the wrong way round, with little regard for the child's story as a whole.

I often find in the workplace that it is the least experienced or most vulnerable members of staff who highlight or communicate the core difficulties within the organisation. In this respect, children, especially those who have experienced adverse life experiences, can serve as a kind of emotional barometer for society as a whole. Clegg would support this view, reminding us that children can teach us about ourselves but also about society. He and Megson quoted Richard Hauser in their book *Children in Distress*, about the need for learning through observation. Hauser explains that it is through social interactions and being part of a community that a child can learn how to interact with others but also develop the skills to overcome difficult situations.

In my work in child mental health services and a specialist adoption service, I will rarely see a child in isolation. This is because for every child referred to me, there are a number of adults who also need to be taken into account and worked with. This includes working with the professional network around

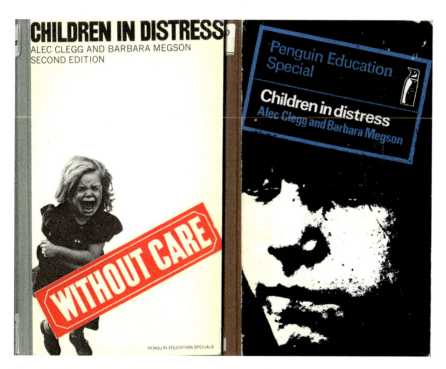

Figure 9.1 The covers of *Children in Distress* by Alec Clegg and Barbara Megson (Penguin Books 1968, 1973)

Copyright © Penguin Books 1968, 1973

the child, which needs to happen before the difficulty can adequately be addressed. I see very young children through to young adults and parents, and I am frequently hearing terms used by children and young people that 20 years ago rarely featured. Young children will tell me they feel stressed, anxious or confused and adolescents use the word anxiety as frequently as if they were talking about a common cold. However, when I spend time with the adults who care for or support these children and young people, it is clear to me that many of them are also feeling distressed and anxious.

Donald Winnicott (1945, 1960, 1971), a psychoanalyst, psychiatrist and paediatrician, was fascinated by how much the parent/infant relationship can teach us about adults and how they interact with each other. He recognised the importance of viewing the child within a contextual framework of relationships, and the huge significance of these relationships on development of the personality in the baby and child. He also observed how extreme a baby's feelings could be in response to any change in the adult's availability and state of mind, particularly if the adult or caretaker showed signs of distress. 'There is no such thing as an infant… without maternal care one would find no infant' (Winnicott 1960: 586).

I would like to expand this quote from Winnicott and suggest that there is no such thing as a child in distress, without an adult who is also in distress. If the adults the child comes into contact with are in a distressed or highly anxious state, the distress will be transferred and even magnified. This isn't important only when thinking about parents and carers, but for other adults such as teachers who have a significant impact on the developing child and their personality. How often have we seen young children mimic adults, repeating phrases or facial expressions, and taking a fragment of the sentiment such as with a telling-off where a child will amplify the threat and discipline with such aplomb that it can be both hilarious but also shocking.

A child's internal version of their parents or teachers may require some modification over the years, but they will use their playful interpretations of the adults who are close to them in order to understand them and learn for themselves how to interact with others and manage certain situations and feelings. If adults around the child are overly and consistently anxious, feeling under threat or lacking in creative resources, there is little balance or opportunity for resilience in the child, who may come to view the world and others as persecutory and overwhelming. Wilfred Bion (1962a, 1962b), an influential British psychoanalyst, wrote about trauma and how it affects one's capacity to think. He himself experienced first hand the catastrophic shock and distress caused by fighting in World War I. He was also one of the first psychoanalysts to treat patients with serious mental illnesses and highlighted the distinction between *having* an experience and *learning from it* (Bion 1962b).

Although Clegg and Megson (1968) didn't actively write about psychoanalysis or psychotherapy, Clegg often referred to Piaget, Laban and Cižek and repeatedly stressed the importance of relationships for the child, specifically between

the pupil and his or her teacher but also between the school's headteacher and the staff team.

> Good schools… all tend to share the same characteristics. They are first and foremost courteous places. Their tone and level of concern are set by the head, whose attitude to children is one of natural and unaffected friendliness… He will be available and accessible to his staff and his advice will be readily sought by them.
>
> (Clegg and Megson 1968: 89)

In my own experience of working within child and adolescent mental health services for over 20 years, I continue to notice how environments like schools, the best of which would once have played a key role in consistently supporting the emotional well-being of children without identifying it as such, appear to be adversely adding to their distress, despite claims that ensuring the emotional well-being of its pupils is a top priority. It would appear that opportunities for spontaneous child-focused learning are being restricted or removed from the school programme of learning, and although art is structured into the curriculum, there is little opportunity for the likes of chaffinch-making and fossil-collecting but rather a greater emphasis on testing and targets. However good the intentions, this comes across as being a somewhat reductionist view of the child (particularly a distressed child) and pays little attention to what he or she needs in order to settle and learn.

When children are little, they often take great delight in looking at themselves in the mirror. Very young children usually take longer to work out that the child in the mirror is actually him or herself, but when they do work this out, they are usually delighted and curious. Older children and adults use the mirror to help them gain a better understanding of who they are, their appearance or their physical self, but also how the mirror can be used as a tool for noticing what needs attention. Winnicott describes the caretaker's role in this respect, validating or reflecting the child's sense of him or herself.

> The mother gazes at the baby in her arms, and the baby gazes at his mother's face and finds himself therein… provided that the mother is really looking at the unique, small, helpless being and not projecting her own expectations, fears, and plans for the child. In that case, the child would find not himself in his mother's face, but rather the mother's own projections. This child would remain without a mirror, and for the rest of his life would be seeking this mirror in vain.
>
> (Winnicott 2005: 149)

If children are modelling themselves on the adults they spend the most time with, it is worth asking what kind of a reflection we offer them? I suggest that in many cases, professionals who would have taken the time to notice the

children in their care have less space or encouragement to do so. A number of reasons for this include changes in the modern world through technology, but I wonder if we as parents and professionals are more likely to reflect an inaccurate version of the child, not only because we haven't time to understand and know them fully, but also because we don't have enough time to understand and view ourselves properly.

Should we expect children to accept our rushed version of who they are and what they are capable of? I would argue that if we focus mostly on academic achievement, then our impression is likely to resemble a sketch at best. A sketch done by an artist like Picasso will be 'drawn' from years of observation, and an understanding of the intricate detail of the human form and mysterious emotional landscape within. Whereas if a parent asked a stranger to sketch their child, they would probably be unable to create a fair or true likeness of them visually, it is even less likely that their character and personality would be captured with any accuracy.

More concerning is that children often blame themselves for their discomfort when they are misunderstood or not recognised for who they are and who they could become. They can instead begin to believe the version of themself offered to them or preferred by 'trusted' adults. Margot Waddell, psychoanalyst and consultant child and adolescent psychotherapist, writes in her book *Inside Lives* (1998) about the centrality of relationships for personality development and how our early relationships prepare us for later-life disappointments and frustrations. 'The capacity to develop is very much dependent… on the different degrees to which it is possible to tolerate frustration and absence' (Waddell 1998: 197).

Around the time that Sybil Marshall was writing *An Experiment in Education* (1963), the then Minister of Education, Sir Edward Boyle, commissioned the Central Advisory Council for Education (England) 'to consider primary education in all its aspects and the transition to secondary education' chaired by Bridget Plowden (Plowden 1967). Others cover this report in more depth in their chapters, but interesting to me is the report's psychological basis, taking ideas from developmental psychologist Piaget, and its stress on the centrality of the child in developing a broad and creative curriculum. It also highlights the advantages and strengths of services such as health and social care, working together to support the child in an integrated way, like a professional community around a child. What's more, it draws attention to the fact that not all that is valuable in education can be measured.

> The qualities needed in a modern economy extend far beyond skills such as accurate spelling and arithmetic. They include greater curiosity and adaptability, a high level of aspiration, and others which are difficult to measure.
> (Plowden 1967: para 1175, p.433)

Under the present-day testing regime, it is very difficult for children and adults alike to see themselves as free to discover themselves and acquire their

own version of what success means to them. They will therefore find it very difficult to acknowledge 'mistakes' and to manage what can be a very uncomfortable transitional space between being a complete novice and becoming an expert.

The role of the Office for Standards in Education (Ofsted) is key here and is commented on in Anne Longfield's Report as Children's Commissioner for England (2017). At that point it was described as having a significant (negative) effect on the promotion of well-being and affecting the morale of teachers. Since then, Ofsted has proactively been encouraging schools to generate 'Cultural Capital', which it defines as '…the essential knowledge that pupils need to be educated citizens… helping to engender an appreciation of human creativity and achievement' (BAECE 2019). Unfortunately, Ofsted can so easily fulfil the role of a punitive parent who is perceived as constantly critical and never quite satisfied with the achievements of the child or able to manage or accept a different version of success.

I remember as a child myself feeling proud, because on an adventure holiday with other children and parents, I had finally learned to dive to the bottom of the pool to retrieve a diving brick, only then to have a much heavier rock thrown in which I couldn't possibly manage. In attempting this retrieval, I cut off the top of my finger, but looking back, I think what hurt more was losing the success of the first dive. I did not feel able to reflect on any learning objectives relating to how I had not successfully lifted a load too heavy for me. I knew that I was being given an unmanageable load, and felt the unfairness of the task being changed from achievable to unrealistic – perhaps impossible. However, I was encouraged to ignore this reality and replace it with a drive (or dive) for even greater success and an unobtainable perfection.

Teachers, without intending to, can therefore project onto children the parental presence or 'message' of the state, which may in reality be less punitive than the version that is handed down. This means that Ofsted so often becomes viewed as the critical parent constantly looking for opportunities to point out failures, rather than celebrating the successes. This approach to education will not empower or motivate adults let alone children. If the load is too heavy, adults will start to behave as distressed or over-compensating children. They will close down emotionally, get sick, leave or go to omnipotent lengths in order to survive – but at great personal cost to the self.

There is some interest, still, in what Plowden had to say and a willingness in some quarters to recognise the importance of creativity for children's healthy development, but at the time of writing this chapter, it's difficult to see where real integrated change will come from. It would appear that society has developed an obsession for knowing through quantifying, and performance data is driving policy in a way that feels new and at times delusional. I say this as an NHS clinician who would rather see my patients than spend hours in front of a computer screen defining their level of risk and developing their treatment plans while having less time to administer that treatment or to minimise the

risk. In order to make a meaningful change in education currently, we could do worse than to take hold of some of Clegg's ideas about allowing children (and their teachers) to continue to learn about themselves while learning about the world, and therefore have a better chance to find their own way of surviving and thriving in the world with all its current challenges.

In the world of mental health, there is now much emphasis on short-term interventions, testing, diagnosis, clear pathways and treatments like cognitive behavioural therapy (CBT) and other acronymed, manualised approaches to treating the 'known' aspect of mental ill-health, and these are on the rise. These clearly have their value, but many practitioners are concerned that they have become more prominent because they are easier to measure. In contrast, approaches that grapple with complexity and rely more heavily on the therapeutic relationship appear to be fast diminishing. I see many good, well-trained and experienced people leaving the profession, at a time when they are needed more than ever.

Much of my work is about bridging gaps – gaps between professionals working in different services, but also gaps between what the child or young person feels they need and what adults around them think they need. I find the gaps getting bigger and it is becoming more challenging than ever to facilitate professionals working together, as highlighted in the Plowden Report, to understand and manage the distress of a child. There is little capacity to bear it, moderate and therefore reduce it.

According to Children's Commissioner Anne Longfield (2017), millions of children in England are growing up in vulnerable or high-risk environments; she warns that an 'unacceptably high' number face having their future chances of happiness blighted, and that it was impossible to know the true figure as the numbers uncovered in her report were 'only the tip of an iceberg'. Her team of experts calculated that among the children in jeopardy were 580,000 receiving some form of care or support from the state, 670,000 whose families were seen as vulnerable, an estimated 46,000 or more gang members aged between 10 and 18, and almost 55,000 children reported as 'missing' from the education system. Nearly 160,000 in addition were excluded from school. I supervise and consult to a number of professional teams and networks, and I see patterns of psychological distress manifested in these professionals that I would normally equate with deprived, traumatised and vulnerable families. One social care professional confided in me: 'I have lost the will to fight. I have become tired of challenging. It's like no one cares whether I stay or go and that I am easily dispensable.'

What must it be like for a child to be in the presence of an adult who is lacking in affect and liveliness, and preoccupied with their own distress and difficulties? It is becoming clear that not only vulnerable parents are in that predicament, but professionals such as teachers and social workers too. A child needs the presence of an adult who will fight to protect them and model appropriate challenge – without this, he or she will lack agency to notice their

feelings and give appropriate responses to others, making them more vulnerable to exploitation and abuse. Clegg and Megson made a distinction between the details of learning and the experience of becoming a well-rounded and inspirational human.

> …the ability to add up, to spell and to learn the facts of history or science or the Bible, is one thing; honesty, compassion, eagerness and inspiration… are another, and the latter do not necessarily flow from the former.
> (Clegg and Megson 1968: 172)

In Philip Pullman's *His Dark Materials* trilogy (1995–2000), Lyra struggles to find her sense of identity and to work out where she belongs. In the world she inhabits, all humans have animal souls or *daemons*. These *daemons* take the form of creatures, and are a different gender to the human they belong to/with. In children, these so-called daemons are shape-shifters and frequently transform in order to communicate something about the personality, emotions and state of mind of their human. They also have a name and provide companionship as well as offering the capacity to reflect. In this respect, each child can learn about his or her true self, as defined by Winnicott (1960), through interacting with his or her daemon. Once the child has matured into a young adult, the shape 'settles' and the core self becomes known. As coming-of-age books, Pullman's trilogy examines the journey from childhood to adolescence, identifying what children take from their parents and their environment but also what young adults will need in order to 'settle' and find their unique and separate selves. In the first book, *The Northern Lights* (1995), there are so-called 'scientific experiments' carried out on children to see what happens when the daemon is severed from the rest of the personality. It becomes painfully apparent that cutting away the core and playful parts of the personality, including their experiences (good and bad), only leaves them feeling incomplete and bereft. The child then begins to psychologically 'waste away'.

Michael Rosen, another children's author and advocate for being 'idle' (Rosen 2019), writes about the importance of play and encourages adults to be playful with their children. Play has perhaps been misunderstood but there is growing evidence to support the need for being playfully 'idle' in that the brain is most active when we are not being driven by tasks or 'doing' anything in particular. Loren Frank, professor at the Centre for Integrative Neuroscience at the University of California, explains how, 'To learn something well, you need to study it for a while and then take a break' (Frank in Heid 2019). He also insists that we all need 'free time to process new information and turn it into something more permanent'. Adults who are 'full up' and stressed or distressed with little space for idleness and reflection may as well display the 'no entry' sign to children, who will quickly pick up on how distracted and unavailable they are. As busy and beleaguered professionals, we can become so concerned with our own capacity to manage that we fail to take in or appreciate the impact

on children. This is where there needs to be change and soon. For if we are to improve learning environments (and outcomes) for children, then we are going to need to improve those environments for the adults who work in them, so that they can begin to model resilience and liveliness.

We have much to learn from children about the capacity to recover from adverse life experiences. I have encountered numerous children and young people who have had very troubling and traumatic starts to their lives but who continue to be creative, resourceful and genuinely hopeful. It is interesting that each of them can provide an account of having experienced at least one 'good' relationship at key points in their lives where they received encouragement and nurture. In this respect, we have come full circle and are back to looking at the strength and value of relationships. These are the harder-to-measure, almost 'magical' but potentially playful aspects of learning which we know instinctively to be true. I recall a child who brought a bean shoot that he had planted to his therapy session. It appeared to be healthy and was growing well despite being in a plastic cup and having only a small amount of soil. I had the impression that he was pleased that he had played a part in bringing something to life, but he was also confused. He wanted me to explain to him what had made the bean grow, asking: '…how come this [the shoot] is bigger than the bean?'

I tried to explain that the bean shoot had a root which was taking its food from the soil and that the shoot also took nurture from the sunlight. These, together with what was already inside the bean, made it grow. He looked at the little bit of soil with some dismay and then declared that he thought that there must also be 'a little bit of magic' helping the bean to 'grow out'. There was something very reassuring for him about the certainty of a thing which is alive, and with some good soil and a bit of 'magic' can continue to grow.

I would like to end with a quote from George Monbiot who has had much to say about what he believes has gone 'wrong' with today's society. However, here he gives us a hopeful message and one which confirms many of Clegg's ideas, about education and teaching what we should aspire to in order to find meaning for ourselves and for the children in our care.

> To seek enlightenment, intellectual or spiritual; to do good; to love and be loved; to create and to teach: these are the highest purposes of humankind. If there is meaning in life, it lies here.
>
> (Monbiot 2016)

Note

1 Its publication as a 'Penguin Education Special', followed by yearly reprints and a second edition within five years are indications of the wide attention generated by this book.

References

BAECE (British Association for Early Childhood Education). (2019). 'Cultural capital'. www.early-education.org.uk/cultural-capital.

Bion, W. (1962a). 'A theory of thinking'. *International Journal of Psycho-Analysis* 43: 306–310; reprinted in *Second Thoughts: Selected Papers on Psycho-Analysis*. London: Heinemann (1967).

Bion, W. (1962b). *Learning from Experience*. London: Heinemann Medical Books; Reprinted Karnac 1984.

Central Advisory Council for Education (England). (1967). *Children and their Primary Schools* (Plowden Report). London: HMSO.

Clegg, A. and M. Megson. (1968). *Children in Distress*. Harmondsworth: Penguin Books Ltd. (2nd edition 1973).

Gillard, D. (2002). 'The Plowden Report', in *Online Encyclopaedia of Informal Education*. http://infed.org/mobi/the-plowden-report/.

Heid, L. (2019). 'Our obsession with productivity is making it harder to solve simple problems' (February 22, 2019). https://qz.com/work/1554702/why-your-brain-needs-idle-time/

Longfield, A. (2017). *The Children's Commissioner's Report on Measuring the Number of Vulnerable Children in England*. www.childrenscommissioner.gov.uk/wp-content/uploads/2017/07/CCO-On-vulnerability-Overveiw-2.pdf (and online update 2019).

Marshall, S. (1963). *An Experiment in Education*. Cambridge: Cambridge University Press.

Monbiot, G. (2016). *How Did We Get into This Mess?: Politics, Equality, Nature*. London: Verso. Quotation also online in Monbiot, G. (2015) 'How a corporate culture captures and destroys our best graduates'. *Guardian* newspaper, 3 June. www.theguardian.com/commentisfree/2015/jun/03/city-corporates-destroy-best-minds

Pullman, P. (1995–2000). *His Dark Materials*. Trilogy. London: Scholastic.

Rosen, M. (2019). *Michael Rosen's Book of Play*. London: Wellcome Collection.

Waddell, M. (1998). *Inside Lives: Psychoanalysis and the Growth of the Personality*. London: Duckworth & Co. Ltd.

Winnicott, D. (1945). *Getting To Know Your Baby*. London: Heinemann.

Winnicott, D. (1960). 'The theory of the parent-infant relationship'. *International Journal of Psycho-Analysis* 41: 585–595.

Winnicott, D. (1971). *Playing and Reality*. London: Tavistock.

Winnicott, D. W. (2005). *Playing and Reality* (Routledge Classics). 2nd ed. Oxon.: Routledge.

Chapter 10

The timeliness of Alec Clegg

Ken Jones

'How long do works last?' wrote Bertolt Brecht, and answered, 'they last till they are finished' – until, that is, the audience they seek to reach no longer wants to think in the way they propose and answer to the demands they make (Brecht 1927/2019). So long as audiences are motivated by their own situations to make the effort of comprehension, the works 'do not decay'. In this chapter, I aim to make a case for the timeliness of Alec Clegg, and of the traditions of thinking and practice that sustained his work. I do this not so much through discussion of particular policies with which he was associated, as by reconstructing some of the ways in which he thought about education, culture and society. I ask how analysis of Clegg's thinking may help elucidate the manifold crises of schooling in 21st-century England and provide a resource for more productive approaches. This is not a question that can be answered in a straightforward way. Over 30 years after the 1988 Education Reform Act, the relevance of Clegg's work to our time is something to be argued for, rather than assumed. Its uncertain status is less a consequence of a lack of coherence or substance – on the contrary, its strength of focus and intellectual seriousness are still striking – than an effect of wrenching historical changes that have transformed the context in which it is read and responded to. In the aftermath of these changes, any encounter with Clegg's work needs to have in mind Brecht's distinction between works which are 'finished', and thus of diminishing relevance, and those which are still able to provoke their audiences into thinking about their own conditions and problems. I think Clegg's work belongs in the second category.

Clegg was an intellectual of a type recognisable throughout the long period of social reform that dated from the late 19th century to the advent of the new public management one hundred years later. His work combined critical reflection on the failings and restrictions of reform with a confident involvement in projects for its transfiguration into something more inclusive, more generous, open to a wider conception of human need. He was thus both outsider and consummate insider, adept in the tactics of influence. His objectives were both classically administrative – more schools, better teachers – and socially ambitious. He saw the role of administrators like himself as to create institutions and

professional capacities adequate to the tasks involved in continuing a century-long, but notably uncompleted, programme of reform – and at the same time to ensure that there existed a public sphere sensitised to the importance of an educational agenda at once social and cultural. The attainment of these objectives required a teaching force capable in its methods and appreciative of its mission. For Clegg, the work of teachers involved a continuous encounter with the cultures and experiences of children damaged by social conditions, but redeemable through educational practices which valued their personalities and had faith in their capacities for learning and self-expression.

The institutions and networks that sustained Clegg's projects – local authorities and teacher professionalism – exist now only in much reduced form. His central concerns, for an education of the 'whole child' and for alleviating the 'misery of unimportance' which blighted the lives of many children, have no secure place in policy. And if the intellectual traditions in which he located himself are alive and the debates to which he aimed to contribute continue to be pursued, it is at the margin of practice and not its centre. A few days before completing this chapter, I talked with teachers who work in an academy chain in Yorkshire, once home to Clegg's projects of reform. They described practices so far removed from those that Clegg's work had fostered as to suggest some epochal reversal had occurred. In Clegg's own period, visionaries of the political right had imagined an education system denuded of progressive influence; now here it was, powerfully present in Yorkshire schools, definitively shaping the processes and meaning of education. From the point of view of this new world, where teachers are the deliverers of lessons planned centrally and students are tested regularly, attuned to the demands of examinations that are in some cases years away, Clegg's vocation, purposes and achievement seem to lie on the far side of an unbridgeable gulf between 'now' and 'then'. In what follows, I want both to take the measure of this distance by suggesting the extent of change, and to reach back across it to recover something of the unfamiliar discourse of an earlier period.

Pasts

From one perspective, these intentions will themselves seem anachronistic. For several decades, the mode in which education policy-makers have thought about problems and programmes has been anti-historicist. Educational history is seen neither as providing a standard of value, against which contemporary experience might be judged, nor as a path that in some way influences present events. One might say that before 1988, policy-makers saw themselves as building on a previous history of educational reform but that thereafter the emphasis fell not on continuation but on rupture. The New Right of the 1970s and 1980s did much to present schooling's post-war history as a catalogue of policy errors and self-inflicted cultural damage. The Labour governments of the 1990s and 2000s accepted much of this polemical historiography (Jones

2015). As Faucher-King and Le Galès noted of the Blair government, 'the New Labour élites' were 'profoundly marked by history' (2012: 5), but this mark was negative. History was something to be escaped. Labour would be a modernising force, adapting Britain to a new 'historical phase... marked by globalization' (Ibid.) and this ambition entailed telling what was for Labour a different story about the educational past. The high period of educational reform (1944–1988) was no longer presented as a golden age; it was rather a time when the Labour governments of Clement Attlee (1945–1951) and Harold Wilson (1964–1970, 1974–1976) – like their Tory counterparts – had presided over an undynamic economy which had produced a school system in its own image. In what was alleged to be the static society of the post-war decades, there was a 'general acceptance that only a minority would reach the age of 16 with formal skills and qualifications' (DfES 2002: 4). By setting 'social' rather than 'economic' goals, comprehensive secondary school reform had contributed to stasis if not decline. Overreacting to the failings of the 11+ selection exam and dominated by the 'ideology of unstreamed teaching' (Blair 1996: 175), it had failed to differentiate among students and to 'link different provision to individual attitudes and abilities' (DfES 2002: 5). One of the results was mass illiteracy; another, relatively slow rates of economic growth. Teachers had contributed to the problems. Despite a huge investment in their recruitment and training, teachers were not a source of change but a barrier to it, a policy problem – in Tony Blair's words, 'forces of conservatism' (Smithers 1999), who combined low expectations of students with a belief that schools could make little difference to social inequalities. Whereas for Clegg the development of teachers' capacity for educational change was to be achieved through dialogue and what a subsequent generation would have called empowerment, from Blair's perspective the task looked different: teachers' work needed to be reshaped through a process that involved constant, target-induced pressure and occasional coercion.

When the Conservative Party – in coalition with the Liberal Democrats – entered office in 2010, it was able to build on a widely accepted narrative, and to use it to justify further change, both institutional and cultural. The Education Secretary, Michael Gove, concluded that, more than 20 years after the 1988 Education Reform Act, there was still much to be done to break the influence of progressive educational ideas and the organisations that harboured them: the majority of secondary schools, and many primaries, were removed by encouragement or coercion from local authority control; teacher education was removed from university departments of education; national frameworks for teachers' pay and conditions were broken up; professional influence over curriculum and assessment further reduced, as the Department for Education took direct control of policy development. Gove justified these measures through an account of educational history which was written largely in terms of failure:

> For generations... working-class communities... have been tragically ill served by council-run schools which consistently failed to secure a decent

clutch of GCSEs or their equivalent for the overwhelming majority of their pupils. It was assumed that the children could scarcely be expected to do better, given their backgrounds. And parents were denied any meaningful information about how their children's schools performed relative to others so they had no real idea how badly they were being betrayed by those who took their votes, council rents and rates for granted.

(Gove 2011)

To the betrayals of local councils were added those of educationalists, of whom Gove wrote:

School reformers in the past often complained about what was called 'The Blob' – the network of educational gurus in and around our universities who praised each other's research, sat on committees that drafted politically correct curricula, drew gifted young teachers away from their vocation and instead directed them towards ideologically driven theory. This Government is taking it on.

(Gove 2013)

What kind of new?

These repudiations of the past – on the part of both Labour and Conservative governments – were much more than ideological exercises. As Gove made clear, critique was accompanied by institutional change which removed the space for progressive practice, and nourished other kinds of educational perspective. Gove's policies accelerated the replacement of a system based on local authorities with one based on the management of schools by private interests. Since 2010, the number of 'academies' and 'free schools' has risen sharply, so that in January 2019 they educated over 70 per cent of secondary students and nearly 30 per cent of primary pupils. In the process, supported by government, academies and free schools have become centres of educational initiative, and have played a leading part in implementing new policies for school-based teacher education and for curriculum change. Academy chains – groups of schools under one board of management – have promoted influential new models of curriculum and pedagogy (e.g. Wallace 2017).

The development of a certain sort of school autonomy has been accompanied by policies designed to ensure that practice in autonomous institutions is strongly regulated. Regulation particularly affects the work of teachers, which is strongly shaped by the demands of external tests and examinations, often mediated by school managements for whom the penalty for underperformance of students and teachers can be the loss of their jobs. The effects on educational quality of the emphasis on high test scores has frequently been commented on. In Alice Bradbury's 2019 research on headteachers' experience of Key Stage 2 SATs – tests for 11-year-olds – 90% of those who responded

agreed that the effect of SATs was to narrow down the curriculum to focus on those subjects which were tested. In this, headteachers echoed the comments made by teachers in earlier surveys conducted by the National Union of Teachers: 'Since Christmas, I have only taught literacy and numeracy,' wrote one teacher. Another wrote, 'When asked their favourite subject [my pupils] say English or Maths because they don't know anything else' (Jones 2017). In the Fabian Society's 2019 survey of arts provision in primary schools, two-thirds of teachers said that it had decreased in quantity since 2010; almost half said that its quality had worsened (Cooper 2019).

Teachers are overworked to the point where innovation and reflective practice become difficult. The Education Policy Institute (Sellen 2016), analysing the OECD's Teaching and Learning International Survey, found that teachers in England are working, on average, longer hours (48.2) than in most other countries. A fifth of teachers worked 60 hours or more. The National Education Union's surveys starkly demonstrate the consequences of these demands for teachers. 84% said that workload was manageable only 'sometimes' or 'never':

> 'I spend every evening and weekend working. If I don't, I feel guilty for not working and I am made to feel guilty as well. I am now planning to leave the profession – the workload is making me ill and I want my life back.'
>
> 'I'm not able to have a life. I hate this job. Nothing is ever good enough. It's not about the children, it's about data.'
>
> 'It's unmanageable and I need a new career. I'm unhappy most of the time and am unwell with stress and anxiety.'
>
> (NEU 2018)

In this situation, both the supply of further professional development and the demand for it are restricted. Of the 36 jurisdictions in the TALIS dataset, England ranked 30th in terms of the average number of days spent in a year on professional development (Sellen 2018). Substituting for this provision is an approach to the development of curriculum and pedagogy which is organised by management specification of process, rather than teacher judgement. Figure 10.1, an all-purpose lesson template to which teachers are expected to adhere, graphically indicates the processes that are required by managements, as well as the conceptions of teaching and learning which they entail.

Poverty

If Clegg's advocacy of teacher initiative finds no secure place in the new world, what of those aspects of his work which insisted that part of the intellectual climate of the school should be an understanding of poverty and its multiple effects? Clegg was not a believer in the economic maxim that a rising tide of GDP floats every boat. Like other critics of post-war social policy (Loach 1966, 1969; Coates and Silburn 1970), he was aware of the insecurities and poverty

The timeliness of Alec Clegg 165

Figure 10.1 Lesson planning template, c. 2019

that persisted on council estates and in inner cities. This was a condition, he suggested, which was a structural feature of a society where some kinds of labour were no longer economically productive. It provided all the more reason why schools should be supported in taking poverty as a central fact around which their work would be organised: those excluded by a hostile social and economic environment might find themselves, affectively, in the school.

In the second decade of the 21st century, schools are certainly aware of poverty. 4 million children are affected by poverty in Britain, with the number set to rise to 5 million in 2020. In Clegg's West Yorkshire, there are constituencies where more than half of children are growing up in poverty (End Child Poverty 2019). But the means by which schools are meant to address the effects of poverty are very different from those advocated by Clegg. Much current policy rhetoric maintains a calculated silence around poverty while exhorting schools to close the 'disadvantage gap' between working-class children and their peers. The gap is measured by test results – such as attainment in English and Maths at the age of 11 – and as we have seen, primary schools devote significant resources to preparing children for the test, so that test preparation becomes a central feature of school life. But despite the orientation of the primary school towards test preparation, the gap in educational achievement between children of different social classes remains wide, and the failure rate of working-class children high. In 2018, 54 per cent of children eligible for free school meals (FSM) – an accepted proxy for poverty – were failed in at least one of the tests in Reading, Writing and Maths. In other words, more than half of FSM-eligible pupils left primary school with a label saying they were 'not secondary ready'. Affectively, a significant number of working-class children are positioned as 'losers' in a hyper-competitive educational environment. As Diane Reay puts it:

> Getting low grades in your SATs, low marks in a test, being placed in a bottom set, or simply receiving little attention, and in particular, little praise, all conspire to make the working class experience of education one in which success is, at best, tenuous and failure often feels inevitable.
>
> (Reay 2017: 180)

Long-lasting work

So great is the contrast between Clegg's way of understanding education and that which dominates contemporary thinking that there is a temptation to see his work as something completed – an achievement whose loss should be mourned, or an example of what went wrong with 20th-century education, or a benchmark from which the acceleration of education policy in new directions can be measured. From these perspectives, enquiry into its contemporary resonance would not be necessary. I take a different view. As the epigraph to this chapter implies, I take Clegg's work to be *unfinished*. By this I mean that the problems it addresses are extant (however much policy maintains they are not),

that it is productive to reflect on the practice which it reports and champions, that perhaps above all it is useful to identify its absences and weaknesses, because to do so may help us understand what needs to be done now. To paraphrase Brecht again, those who intend their work to be continued or completed by others will 'show gaps', which introduce a precariousness in their writing, a kind of infirmity that their readers will seek to correct. In this sense, Brecht writes, 'the long-lasting are forever on the brink of falling in' (Brecht 1927/ 2019).

Clegg and tradition

The *Oxford English Dictionary* defines tradition as 'the action of transmitting or handing down or the fact of being handed down, from one to another, or from generation to generation; transmission of statements, beliefs, rules, customs or the like'. It is an idea that has often been claimed by the right – a set of time-honoured ideas and practices that underpins a social order and provides for those who inhabit it the very grounds of their thinking and feeling (Quinton 1978). But 'tradition' can equally be associated with other tendencies which similarly seek to strengthen their legitimacy and establish a common stock of emotional and intellectual reference points. One of the features of 20th-century writing about educational history was the deliberate construction of such a tradition, as a form of trans-generational collective memory, intended to become integral to the identity of those who worked in education. Looking back at decades of change and embracing child-centred education and institutional and social reform, tradition was presented as something alive and cumulative, unfolding towards a moment of realisation, where the principles and values of reformers would be accepted as the norms of the system.

To some extent, Clegg shared in this story-making. For him, educational discourse was in an important sense historical discourse. The speeches he made towards the end of his career were organised around the same blend of chronology and decisive incident as the work of a celebrant of educational progress like G.A.N. Lowndes (1937) and he was likely as any other narrator to mine the past for exemplary quotations and nuggets of inspiration. His conception of his own career was permeated by a sense of thinking and working in a tradition that included the ancestral voices of family experience, the intellectual influences of 18th and 19th-century thinkers and the institutional achievements of the mid-20th century. When he spoke at Central Hall Westminster to commemorate the centenary of the 1870 Education Act (Clegg 1970a), or to teachers at Bingley College in 1972, his speech was rich in family memories, and saturated by collective memory. On these occasions, Clegg made no claim to originality; his role was rather one of public remembrancer. Even the quotations he cited were filtered through the writings of others: his appreciation of Edmund Burke's praise for 'the method of teaching which approaches most nearly to the methods of investigation' rests on a

quotation not excavated from Burke's own writing, but borrowed from one of Clegg's own fellow-spirits, the scientist Harry Armstrong, writing in 1898 (Armstrong 1898, quoted in Clegg 1972).

Likewise, Clegg's repeated insistence that education should serve the 'spirit' as well as the 'mind' (Clegg 1972) echoed Pestalozzi's distinction between 'heart' and 'hand', while what he had to say about the social mission of education was supported not by extensive argument, but by the authority of quotation – from Edward Thring (1821–1887), headmaster of Uppingham, and Henry Moseley (1801–1872), mathematician and HMI. 'Education is not a privilege to be graduated according to men's social condition', Moseley had written, 'but the right of all, in as much as it is necessary to the growth of every man's understanding and into whatever state of life it may please God to call him as an element in his moral well-being.'

As remembrancer then, Clegg's purpose was to identify a tradition, to make other educationalists aware of its preoccupations, values and aims, and to encourage them to elaborate it – to create a community of practice. Any tradition is selective: taciturn in some places, over-emphatic in others; always over-determined by the contexts in which it is assembled. Clegg's is no exception. But this did not make it an exercise in conformist thinking. His reconstruction of tradition was not a dogmatic or unreflective exercise. The movement of his thought between past and present was more subtle and open-ended than most; reference to educational tradition was an occasion for reflexiveness and self-criticism, of an awareness of policies botched and difficulties glossed over. Central to these negative readings of tradition was a sense of the ways in which, for all its gradual progress in matters of increasing access and curriculum breadth, the school had been a cold place for many children, keeping the doors of perception closed and denying them the 'impalpable essences' of 'love, faith and devotion' which teachers should have extended to them (Clegg and Megson 1968: 164). Clegg does not look back on these experiences with a sense that they belong firmly in the past. Certainly, 'it would be difficult to imagine a greater difference than the one which exists between the influences which our grandfathers brought to bear upon our fathers and those which we are bringing to bear on our children' (Ibid.: 174). But education still worked to consolidate social divisions and, in transmuted form, its deep failings remained active. A system based on meritocracy and sorting by ability could do worse damage than one in which educational opportunity was rationed by wealth and status:

> When Robert Lowe, a founder of our public education system, said that the lower classes should be, 'educated that they might appreciate and defer to a higher cultivation when they meet it', the hurt that such an attitude could cause was softened by the fact that high and low and rich and poor were at that time held to be the natural order of things and to some extent outside human control. But the newly despised – those whose minds work

slowly – as they are deprived of the work which machines do, leaving them without any work which they can do, will know that they are rejected by society because of an inferiority which they cannot help.

(Ibid.: 176)

Clegg employed his historical sense as a means of sensitising his audiences to these continuities. If he 'said a word or two about odd education practices in the past', it was not in a spirit of condescension but in the interests of relativising the present and suggesting the unfinishedness of the work of reform:

> Our grandchildren will surely be amazed that for the last fifty years we have held the Intelligence Quotient as sacred. They might think it odd that we so often conceive of teaching as imparting large slabs of knowledge to be memorised, rather than as providing material for the mind to work on. They will be astonished that we have not yet realised the full power of expectation. They will criticise us for concentrating on what can be marked and undervaluing what cannot... They will be astonished, I think, that we don't yet understand how to develop discrimination and judgement and the enjoyment of things designed by civilised man to be enjoyed – painting, music, art and so on – all of which are just as much part of our education as history and geography, but we tend to undervalue them because we cannot mark them or have them externally examined.

(Clegg 1972)

Unlike the new English right, Clegg does not claim that the policy direction for which he argues will accomplish a wiping-clean of the slate, and an erasure of historical failings. The problems of English education are embedded in its history; they are multi-faceted and enduring. But equally, the means of addressing them possess a historical basis. To an important extent, this basis lies in the work of teachers, to which Clegg pays detailed attention.

Professional agency

When he looks back at educational history, Clegg tends to highlight the great deeds of individuals, summarised as 'the wisdom of our distinguished forebears'. When he thinks about the present, however, he sees a larger group of agents, whose energies are essential to educational change. It is these people, teachers and administrators, in whom he seeks to develop a sense of educational tradition, of the place they have within it, and the obligations they have inherited from it. In the audiotape of his 1970 speech in Central Hall Westminster, to a large professional audience, the reception of these attempts to create a consensus for change is vividly present: in the first part of the speech, a warm response to Clegg's humour, as he evokes past absurdities; in the second, an attentive stillness as his criticisms become sharper and more frequent.

Clegg's assumption throughout this speech, and others, is that his audiences constitute the main forces of educational change. He depicts change as a work of institutional, intellectual and spiritual reform. It involves conflicts, certainly, but these will be played out within a community which he assumes will share normative expectations about the ways in which change will occur: educational reform is above all a professional matter. At no point does he employ tactics which would polarise debate. He names no individuals and makes no friend/enemy distinction between supporters and opponents of reform. Instead, he offers a kind of collective narrative – a narrative which is also an autocritique, in the name of a 'we' whose referent seems to encompass both the professional community of educators, the political community, and the nation as a whole. 'We've paused several times,' he says, 'to ask what we are doing and why we are doing it and what we ought to be doing that is even better.' The government reports of the 1950s and 1960s, Crowther, Newsom, Robbins and Plowden, have provided some of the answers. But there remain problems on a vast scale: 'for as long as we have provided secondary education, we have been ruthlessly selective. We select at 11, 16 and 18. And every time we select, we discard or underestimate those left behind' (Clegg 1970a).

The contrast between Clegg's rhetorical inclusiveness and Gove's counterposition of a 'blob' of school reformers, and a government which was taking them on, is clear. Just as stark is the contrast between Gove's model of centrally driven change in curriculum and pedagogy and Clegg's idea that change in these areas would depend upon the engagement of teachers, through whose everyday practice a kind of molecular transformation would occur. This engagement did not entail so much a political commitment, as an acceptance of 'newer ways of teaching' (Clegg 1970b), which 'forced the teacher's attention on the individual'. 'The relationship between teacher and taught has changed', Clegg told the audience at a lecture in Peterborough (Ibid.):

> There is very little of the sterile memorising which used to pass and still passes for education. Most of what the child does is done on his own initiative rather than on the teacher's instruction and because of this it is more readily assimilated by him and seems to add more to his stature… the teacher has at last become a real professional. He sees each child as an individual, diagnoses his needs and with great subtlety ensures that they are met, and that no area of activity is neglected. It is a very different job from that of doling out a prescribed quantum of information to be taken by the child regardless of the state of his digestive powers.

Thus, the development of a body of 'real professionals', who had come to understand the intricacy of a teacher's work, would begin to address the long-standing neglect of large sections of the student population.

Showing gaps

There are many ways in which Clegg's work remains unfinished, in Brecht's sense – and therefore many ways in which it is alive. It addresses the role of the school in consolidating inequalities. It holds on to the idea of school as an institution where affect matters: schools are always affective places, where the architecture of a system spreads out into the experience of those who work and learn within it. It never lets go of the maxim that the educators themselves must be educated, and insists that this is a matter of the shaping of dispositions as much as the inculcation of techniques.

But the work endures, also, because of its gaps and failings – qualities which are not the flaws of an individual but rather signs of the intellectual and political difficulties faced by a wider collection of actors. These difficulties persist, and partly explain the impasse of progressive education. Recognising their extent and their causes is one means of getting beyond our present problems. The success of the educational politics of the right means that those who do not welcome its triumph need to be reflective about the shortcomings of the tradition which they themselves have inhabited, so we need to read Clegg *self*-critically. *De nobis fabula narratur* (Their story is our story).

The alleged theoretical and pedagogical errors of post-war progressive reform have been much discussed (e.g. Peters 1969; Walkerdine 1993). What can broadly be termed its political weaknesses have been less fully explored (CCCS 1979; Jones 1983) though these contributed to its eclipse in several ways. It overestimated the stability of post-war reform – the extent to which it provided a solid platform on the basis of which further gains could be achieved. It was too comfortable in its belief that there was an enduring political consensus around reform's procedures and general objectives; political differences around educational choices were thought of as enduring arguments oscillating around a common core of agreement about the importance of expanding education, under professional influence. There tended to be an assumption of public trust in professional work: the wisdom of educators should provide the warranty for educational practice. Confident for too long in these assumptions, progressive thinking was not sensitive to the shifting grounds of educational politics: the erosion of post-war consensus and the emergence of a New Right were not treated as matters of central importance (CCCS 1979).

Of course, now we have been made to know better. History turned out not be coterminous with progress; modernisation did not follow a path of democratisation. Thus, our reading of Clegg's work is shadowed by a realisation of how its project foundered. To resume that work, to create with patient optimism a comparable complex of ideas, practices, networks, alliances, agency and institutions, is both difficult and necessary.

References

Armstrong, H. (1898). *Special Report on Educational Subjects*. Cmnd 8943. London: HMSO.

Blair, T. (1996). *New Britain: My Vision of a Young Country*. London: Fourth Estate.

Bradbury, A. (2019). *Pressure, Anxiety and Collateral Damage: The Headteachers' Verdict on SATs*. London: More than a Score. www.morethanascore.org.uk/wp-content/uploads/2019/09/SATs-research.pdf

Brecht, B. (1927/2019). Uncollected poems, in *The Collected Poems of Bertolt Brecht*, transl. and ed. Kuhn, T. and D. Constantine. New York: Liveright Publishing Corporation, 2019.

Centre for Contemporary Cultural Studies (CCCS). (1979). *Unpopular Education: Schooling and Social Democracy in England since 1944*. London: Hutchinson.

Clegg, A. (1970a). *The Centenary of Public Education*. Speech at Central Hall Westminster on the occasion of the centenary of the 1870 Education Act. London: HMSO. (Audiolink available at Derek Gillard, Education in England. www.educationengland.org.uk/documents/speeches/1970clegg.m4a.)

Clegg, A. (1970b). *Education in Society: The Arthur Mellows Memorial Lecture*. Peterborough, 1970. (Text available at Derek Gillard, Education in England. www.educationengland.org.uk/documents/speeches/1970clegg.html.)

Clegg, A. (1972). *Making the Whole World Wonder*. Speech at Bingley College of Education, August 1972. (Text available at Derek Gillard, Education in England. www.educationengland.org.uk/documents/speeches/1972clegg.html.)

Clegg, A. and B. Megson. (1968, 2nd edition 1973). *Children in Distress*. Harmondsworth: Penguin.

Coates, K. and R. Silburn. (1970). *Forgotten Englishmen*. Harmondsworth: Penguin.

Cooper, B. (2019). *Primary Colours: The Decline of Arts Education in Primary Schools and How It Can Be Reversed*. London: Fabian Society.

Department for Education and Skills (DfES). (2002). *Success for All*. London: Department for Education and Skills.

End Child Poverty. (2019). www.endchildpoverty.org.uk/key-facts/

Faucher-King, F. and P. Le Galès. (2012). *The New Labour Experiment: Change and Reform under Blair and Brown*. Stanford, CA: Stanford University Press.

Gove, M. (2011). Speech at the Durand Academy, London, 1 September. www.politics.co.uk/comment-analysis/2011/09/01/gove-speech-on-the-underclass-in-full

Gove, M. (2013). 'I refuse to surrender to the Marxist teachers hell-bent on destroying our schools: Education Secretary berates "the new enemies of promise" for opposing his plans'. *Daily Mail*, 23 March.

Jones, K. (1983). *Beyond Progressive Education*. Basingstoke: Macmillan.

Jones, K. (2015). *Education in Britain*. Cambridge: Polity.

Jones, K. (2017). '"Since Christmas, I have only taught Literacy and Numeracy": What the 2016 SATs taught us', in *The Mismeasurement of Learning. Reclaiming Schools*. ed. T. Wrigley. London: NUT. https://reclaimingschools.files.wordpress.com/2016/11/mismeasurement.pdf

Loach, K. (1966). 'Cathy Come Home'. BBC TV Play for Today.

Loach, K. (1969) 'Kes'. Feature film based on the novel by Barry Hines *A Kestrel for a Knave* (1968)

Lowndes, G. A. N. (1937). *The Silent Social Revolution: An Account of the Expansion of Public Education in England and Wales, 1895–1935*. Oxford: Oxford University Press.

National Education Union (NEU). (2018). 'Teacher's workload'. https://neu.org.uk/policy/teachers-workload

Peters, R.S. (ed.) (1969). *Perspectives on Plowden*. London: Routledge Kegan Paul.

Quinton, A. (1978). *The Politics of Imperfection: The Religious and Secular Traditions of Conservative Thought in England from Hooker to Oakeshott*. London: Faber and Faber.

Reay, D. (2017). *Miseducation: Inequality, Education and the Working Classes*. Bristol: Policy Press.

Sellen, P. (2016). *Teacher Workload and Professional Development in England's Secondary Schools: Insights from TALIS*. London: Education Policy Institute. https://epi.org.uk/wp-content/uploads/2018/01/TeacherWorkload_EPI.pdf

Smithers, R. (1999). 'Unions angered by Blair attack on teachers'. *Guardian*, 22 October: 7.

Walkerdine, V. (1993). 'Beyond developmentalism'. *Theory and Psychology* 3(4): 451–469.

Wallace, N. (2017). 'Case study, Innovation in English teaching at Key Stage 3'. Westminster Education Forum, Keynote Seminar.

Conclusion

The legacy of Alec Clegg

Catherine Burke, Peter Cunningham and Lottie Hoare

Revisiting Clegg as history

History deals with time: time passing and change. It speaks to the origin of things, ideas and phenomena. It draws attention to situation, context, place and contingency. But it can also illuminate consistencies in spite of inevitable changes in context.

One of the purposes of the series which hosts this book is to explore and explain how ideas and practices associated with the broad spectrum of progressive education, however subjected to repression, emerge and re-emerge over time. Much of what gives confidence to those engaged in their own time in pursuing the values, principles and practices associated with progressive education is attention to past pursuits. Thus, in our case, Alec Clegg drew very consciously in his public speeches from prior theorists and practitioners whose life pursuits had enabled him to recognise and connect with the more adventurous teachers he encountered in public or state schools.

Simply put, certain principles that address the responsibility of any community to educate its young in order to survive and thrive collectively, regardless of political or economic circumstances, return and will continue to return. This is because they touch on our common humanity, which education strives to enhance for the good of all.

As contributors to this volume have demonstrated, Clegg was an acute observer of children as pupils and adults as teachers. He was a keen listener and paid attention to *their* observations. He regarded free access to the arts, and the support and encouragement of creative expression, as a vital human need that modern schooling might possibly be designed to meet. In the main, in spite of his efforts and achievements, the mechanistic drivers of education, which prioritised the measurable extrinsic over less readily calculable intrinsic motivations of children, steadily devalued these aspects of the curriculum. However, Clegg would have not been surprised to hear the consistent voices of school pupils who over time have repeatedly called for more attention to be given to beauty in the school environment and humanity in the school curriculum. Pupils offered the opportunity to reflect on their experiences of education and

envisage its possible features have called time and again for changes in the direction of priorities like those promoted in the West Riding under Clegg.[1] This speaks to the significance of attending to the past in enriching the possibilities of the future as such awareness of consistent re-emerging priorities will continue to haunt our sense of communal responsibility to the young.

Our research aimed to revisit Alec Clegg, to document and understand his vision through modern eyes, but also to explore and interpret the relevance of his legacy for teachers, schools and education systems today. That aim has been implicit throughout, but Roy (Chapter 9) and Jones (Chapter 10) have been explicit in focusing on children's and teachers' well-being in the present. Consistent over time is the importance of their personal fulfilment and social engagement. The morale of the teaching profession, their dedication and effectiveness were of vital consideration in the past as well as under present and future conditions. With regard to this, our concluding remarks return especially to the role of the arts which, as we have demonstrated, were central to Clegg's aims for young people and communities in the West Riding. Creativity is increasingly recognised in this century across the world as a key to individual and community development as well as to economic prosperity; yet in England creativity is seriously neglected and undervalued in formal schooling. In Wales (and Scotland) by contrast, Clegg's concerns have been significantly reflected in recent educational policy statements, encouraging arts and culture in the school curriculum along with physical activity and sport, and a 'Well-Being of Future Generations Act' (2015) includes amongst its aims to foster cohesive communities and a vibrant culture. Recently this has inspired privately sponsored draft legislation in the British Parliament requiring public bodies to act for the social and cultural well-being of the United Kingdom in accordance with a 'Future Generations' principle.

In revisiting Clegg, as historians and educationists we recognise that circumstances also had their part in enabling his achievements. Peter Newsam warned against 'painting some idealised portrait of an admired individual' (Newsam 1990: 12–13).[2] Clegg, he points out, happened to be right person, but 'at the right time in the right place'. We should note that for decades before Clegg's arrival, the West Riding had forged good practice that anticipated his efforts and eased his path. Former Education Officer J.H. Hallam (1918–1935) worked at constructing a secondary school system; in 1922, Hallam visited schools in the United States, making a detailed report to the WREC. His successor, A.L. Binns (1935–1945), was a leading figure in educational administration nationally, as Honorary Secretary of the Association of Directors of Education from 1937 and throughout the Second World War, respected and consulted by national government in drafting the 1944 Education Act; it was he who inducted Clegg as his successor before moving on to lead education in another huge authority, Lancashire.

The scale of the West Riding and its resources provided opportunities of which Clegg took full advantage, and the exceptional context of national

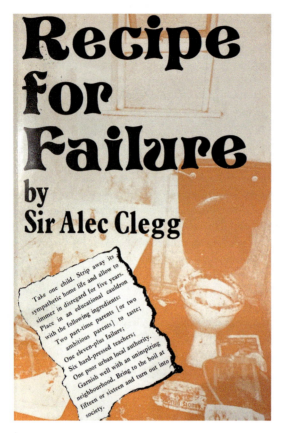

Figure 11.1 Recipe for Failure by Alec Clegg, published text of National Children's Home Convocation Lecture in 1972. NCH originated in 1869, now the national charity 'Action for Children'.

Reproduced by kind permission of Action for Children

post-war reconstruction and educational expansion was one that clearly facilitated fulfilment of his ambitions. The West Riding was indeed lucky to have him, but he was also lucky to have, in Newsam's words, 'the broad canvas, the rich human material with which to work, and the resources to put at their disposal'.[3] Newsam reminds us, as historians, to constantly readjust our focus between foreground and background, and the preceding chapters have aimed in various ways to do this. Such a large Local Education Authority generated resources and attracted professional educationists with vision. But its broad canvas included a wide spectrum of disadvantage.

We are aware that Clegg would not want his legacy to be idealised, as to do so would underplay the real struggles he faced in helping communities in

the West Riding. *Children in Distress* in 1968 emphasised the need for teachers to do all they can to alleviate pressures felt by children disadvantaged in their home circumstances. In *Recipe for Failure* four years later, he focused sharply on the relentless, undermining impact of poverty and unemployment.[4] Planned changes in local government would mean diminished public resources in areas already suffering from low employment, poor housing and widespread ill-health, and these authorities would be unable to compete with the wealthier areas in providing for their young people:

> We do not know what is going to happen to unemployment but there is no doubt about the mark which [such] social ills can make on education. The child who is poor is more conspicuous by his poverty than he used to be, it will hurt him much more than when the majority knew poverty or something like it. Unemployment can have a vicious effect on education. The sensitive child will be mentally disturbed by the fact his father has no job, but far worse is the effect on him when after ten years of schooling in which he has in all probability lacked the recognition that many of his fellows have enjoyed, he is further rejected when he seeks a job.
> (Clegg 1972: 39)

Clegg's realistic understanding of local education services, and his deep empathy with disadvantaged youth, conjured a pessimistic mood on his retirement from office.

Clegg's legacy

How is Sir Alec Clegg remembered publicly today? A Blue Plaque to commemorate his career in the West Riding was erected two decades after his death in 2005. Its inevitably brief text is limited to 'comprehensive education', recording Clegg's contribution to secondary school reorganisation and middle schools, and referring to his 'national' influence in that regard. Lawn in Chapter 2 highlighted secondary school selection and comprehensive reorganisation as a focus of his concern for social justice, while other chapters have attended to other important achievements, in infant and primary education, the arts, school architecture and environment, teacher training and development, mental health and well-being. And there remain yet other aspects of his work that require further revisiting in the future, such as community and adult education, physical and outdoor education, and special education in which significant improvements were achieved under his leadership in the West Riding.

As well as the national, there are both local and international dimensions to Clegg's legacy that call for recognition. Burke has discussed in Chapter 8 the currents of international influence that flowed between the West Riding and the English-speaking world beyond Britain's shores. Locally, the Blue Plaque adorns the Education Office (1962) in the prestigious civic quarter of Wakefield,

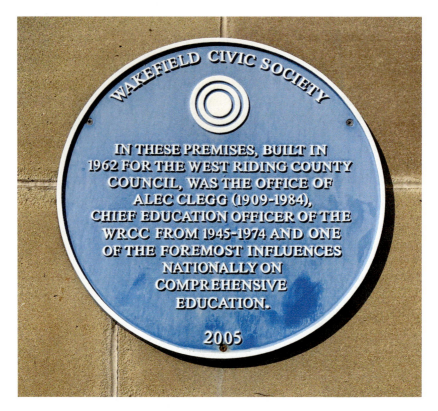

Figure 11.2 Blue Plaque in memory of Alec Clegg, installed on the Education Offices in Bond Street, Wakefield, in 2005 (date of death incorrectly stated as 1984 – he died in 1986)

Photo: Peter Cunningham

political and administrative centre of the (extensive and diverse) West Riding County Council from the late 19th century to its disbandment in 1974. This distinctive modernist building came to symbolise the education service for the local community. It sits on high ground, fronting the tree-planted lawn of Coronation Gardens in a square bounded on its west side by an imposing 'palazzo', the original County Hall (1898).

This historic square accommodates a Cenotaph in remembrance of Wakefield's citizens who fought in world wars and later conflicts, and a statue of Queen Victoria, a tribute from the people of Wakefield in 1904. Just visible from his office window was a Victorian Mechanics' Institution that housed a 'music-saloon, library, newsroom, bank, baths and public dispensary',[5] a monument to education and well-being that must surely have appealed to Clegg's heart.

The legacy of Alec Clegg 179

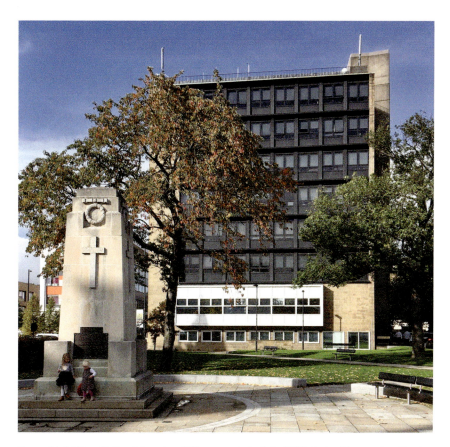

Figure 11.3 West Riding Education Offices, newly built in 1962, facing Coronation Gardens in the civic heart of Wakefield, with historic monuments such as Queen Victoria's statue, and the Cenotaph

Photo: Peter Cunningham

Were he able to see the future from his office, Clegg would have been gratified by a living legacy of his example in the modern campus of Wakefield College immediately north of his office, providing further and higher education. Stretching downhill to the main rail station is 'Wakefield One' opened in 2012 and housing the offices of Wakefield Council, a public library and museum; modern public art in this quarter includes a garden that celebrates Yorkshire's art and landscape; in the summer of 2019, a large figurative sculpture by Huma Babha stood in Coronation Gardens as part of the Yorkshire Sculpture International Festival, where formerly Barbara Hepworth's monumental 'Family of Man' stood for many year by the Cenotaph. A major new

building for Performing Arts at Wakefield College is expected to open in 2021 which further enhances the townscape of this educational and cultural quarter. Clegg's project of the mid-20th century appears to continue and flourish in the 21st century.

His regional, national and indeed international legacy for the arts is impressively embodied in the Yorkshire Sculpture Park. Bretton Hall as a pioneering college for training teachers of the arts, described by Mills in Chapter 7, led to the establishment of a sculpture park in the grounds three years after Clegg's retirement. An initiative of one of Bretton's staff, Peter Murray, supported by the then Principal Alyn Davies, the Yorkshire Sculpture Park (YSP) grew from small beginnings in 1977. It may be seen as pursuing and realising on a grand scale principles that Clegg had in mind for an education service, welcoming children and families, working with local schools including studio space, and in more than 40 years' existence attracting local, national and international communities. Subsequently, the Henry Moore Institute opened in Leeds in 1993 and The Hepworth Wakefield in 2011. 2019 witnessed the first Yorkshire Sculpture International with many activities for pupils and students, and where artist Phyllida Barlow, invited as 'festival provocateur', pronounced sculpture as 'the most anthropological of the art forms'.[6] Exhibiting sculptors are drawn from around the globe. International reach in respect of education was recently illustrated by Ruth Ewan's installation of Muriel Pyrah's classroom (Chapter 5), exhibited in Bergen, Norway as well as at the YSP. The National Arts Education Archive, described earlier in this book, is an integral feature of the YSP that also attracts international interest.

Clegg represented a new generation of Chief Education Officers, active in the post-war era when the role of the arts in peacetime recovery and restoration of democracy acquired a national profile. When he came to lead West Riding education, two Yorkshire artists had become established with international reputations. Barbara Hepworth had grown up in Wakefield, and Henry Moore in nearby Castleford, son of a mining family. Both remained deeply attached to their native county; both, a few years older than Clegg, had established their reputations as he launched on his career. A third Yorkshire figure of great significance for the arts and for education was the philosopher and art historian Herbert Read, whose widely-read classic *Education through Art* was published in 1943, followed by *Culture and Education in a World Order* in 1948. Read became President of the Society for Education through Art in 1946, a post he occupied for 20 years until his death and which gave him an international platform through UNESCO. Yorkshire can also boast poets Ted Hughes, Ian McMillan, and current Poet Laureate (from 2019) Simon Armitage, all schooled in the West Riding and all reaching an international audience.

Clegg's legacy is to be understood against the background of these subsequent developments, which also reflect continuing cultural change since his death. But finally, we return to the character himself. Art in the inter-war years and in post-war Britain revealed a significant cultural trend that he aimed to

promote. He clearly enjoyed learning from others, wished to share his learning and appreciation of art for the benefit of all, identifying and grasping the opportunities afforded by his role. He applied his commitment, energy and organisational ability in supporting the efforts of teachers and advisers, sharing these ideas but always open to argument and debate. It would be a distortion of history to attribute 'forward vision' – he was pragmatic and engaged with 'the present' as he found it, yet, as this volume has demonstrated, there's a case to make for revisiting his work in the light of later and ongoing developments.

Notes

1 Evidence of this has been strikingly presented over the past half-century by Blishen, E. (1969). *The School That I'd Like*. London: Penguin., and by Burke, C. and I. Grosvenor (2003; 2015). *The School I'd Like. Children's and Young People's Reflections on Education for the 21st Century*. London: Routledge.
2 This caution is especially valuable from one who served Clegg as Deputy Director before pursuing a prominent and varied career himself, in educational leadership and public administration: Newsam, P. (1990). '"What price hyacinths?" An appreciation of the work of Sir Alec Clegg' in *Bramley Occasional Papers* 4, 1990 (NAEA).
3 Newsam's 'appreciation' noted above, was echoed eighteen years later in an academic article with the same title but modified content: Newsam, P. (2008) 'What price hyacinths? An appreciation of the work of Sir Alec Clegg'. *Education 3-13* 36 (2): 112.
4 He did so in a National Convocation lecture to the long-established and leading children's charity (founded 1869), now renamed 'Action for Children'. Clegg, A. (1972). *Recipe for Failure*. London: National Children's Home. His pessimism on retirement was also sharply expressed in WREC (West Riding Education Committee). (1974). *The Final Ten Years 1964-1974*. Wakefield: West Riding County Council: 104–107, and in Clegg, A. (1974). 'Much to worry us', *Times Educational Supplement*, 11 October, 24–25.
5 The Mechanics' Institution remains as a listed building dedicated to educational purposes. A description of its original functions cited here is taken from the blue plaque on its frontage.
6 Barlow, P. (2019) 'On sculpture', in *Yorkshire Sculpture International Festival Guide*. Wakefield: Yorkshire Sculpture Triangle.

Index

Note: AC = Alec Clegg; specific works by Alec Clegg appear under his name entry; page references in *italics* refer to figures and information in captions; 'n' indicates chapter notes.

academies 163
accountability 51, 138–139
adult education 7, 11, 16, 74, 177
advisory service, teachers' 77–78
Airedale School 83–96; children's artworks *100, 102, 103*
Armstrong, Fred 141, 142
Armstrong, Harry 168
art education 1–5, *3*, 66, *68*, 78–80, 84, 88–92, 109–112, 124–132, 134, 143–144, 164, 174, 175, 180–181; children's artwork collection *99–104*; movement and dance 8, *65*, 86, 105–119, *125*, 127, 128; music 11, 13, 33, 59, *65*, 66, *68*, 80, 110, 123, 126, 127, 128; *see also* creativity; play
Artists International Association 79
Australia 111, 140, 141–143

Balby Street Primary School 27–28, 91, *99*, 117, *118*
Barth, Roland 137
Bedales School 79
Bell, Bob 91, 93
Bernstein, Basil 84
Bewerley Park Camp School 33
Biggins, Michael *104*
Binns, A.L. 175
Bion, Wilfred 152
Bolton-on-Dearne School 136
Bowman, Anna 1
Boyle, Sir Edward 12, 18, 25n2, 51
Bradbury, Alice 163–164
Braster, S. 71
Brecht, Bertolt 160, 167

Bretton Hall College 1, 16, *17*, 33, 59–62, *61*, 90, 121–133, *122, 125, 129*, 180
Brookfield Infant School 90
Broughton, C.T. 52
Browne, Leonard 16, 74
Buckden House 33
Burke, Edmund 167–168
Burt, Cyril 7, 74

Canada 111–112, 140–141
Carlinghow School 75
Carlisle, Nora 112
child-centredness 9, 74
children: 'a change of heart towards children' concept 109, 119, 134–135, 143–144; child development 5, 88, 105, 109–111, 129, 130, 132, 149, 154, 175; potential 129–130; whole child education 107, 111, 128, 131, 161; *see also* distress, children in; relationships
Chorlton, Alan 74
class, social 28, 29, 31, 34, 38; *see also* working-class communities
Clegg, Lady Jessie 108, *108, 109*, 136, 143
Clegg, Sir Alec: 'a change of heart towards children' concept 109, 119, 134–135, 143–144; data and research 38, 40–43, *42, 44, 45*; educational leadership of 1–6, 11–26, 25n3, 46, 68–69; experience 29–34; legacy of 174–181, *178*; timeliness of 160–171; writings and addresses *2*, 6–7, 18–19, 25n5, 28, 34–40, 76, 106, 112, 167; *About Our Schools* 6–7, 18, 19, 121; 'Attitudes' 29, 34–36; 'The Centenary of Public Education' 169–170;

The Changing Primary School 86, 93; and Barbara Megson, *Children in Distress* 9, 18, 88, 147, *151*, 151–153, 157, 177; 'Dangers Ahead' 29, 36–39; 'Education in Society' 29, 39–40, 170; *The Excitement of Writing* 26n11, 78; 'The Expansion of Knowledge and the Reform of the Curriculum' 140; 'Fable of Fred' 18, 21–24, 25n5; *Making the Whole World Wonder* 168–169; *Recipe for Failure* 86, 87, 89, *176*, 177; 'The Revolution in the English Elementary Schools' 138; *Times Education Supplement* articles 6, 18, 47; 'We Are Going That Way' 139–140; *see also* West Riding Education Committee reports
Coe, John 16, 19, 25n8
Conservative governments 47, 52, 162–163
Cooperrider, D.L. 25n3
corporal punishment 36, 94
Counts, George 36
creativity 30–31, 43–47, 147–158, 175
Cullen, Phil 142
curriculum 5, 6, 56, 62, 66, 72n2, 80, 105–119, 130–131, 134, 135, 140, 143, 153–154, 163–164, *165*, 170, 174, 175; national 117–118; *see also* pedagogy

dance *see* movement and dance
Dartington Hall, Devon 110, 112
Darvill, Peter 7–8, 9
democracy 28, 36, 73, 75, 134–135
deprivation *see* poverty
development, child 5, 88, 105, 109–111, 129, 130, 132, 149, 154, 175
Dewey, John 78
distress, children in 5, 147, 150–158; A. Clegg and B. Megson, *Children in Distress* 9, 18, 88, 147, *151*, 151–153, 157, 177
Dover Wilson, John 7, 74
Dudley Girls' High School *3*
Dussel, I. 71

Education Act (1944) 16, 175
Education Act (1964) 88
Educational Priority Areas (EPAs) 18, *32*, 87, 88
Education Reform Act (1988) 162
emotions 105, 110, 114–115
environment *see* school buildings and environment
EPAs *see* Educational Priority Areas

equality 28, 29, 34, 35–36, 39, 73, 95, 144, 162, 171; *see also* social justice; poverty
Eveline Lowe Primary School, London 116
Ewan, Ruth 91–92, 94

failure discourse 36, 81, *104*, 106, 155, 162
failures, learning from 149, 155, 158
Farrar, Maggie 19
Faucher-King, F. 162
Featherstone, Joseph 137–138, 139
Foster, Ruth 114
Frank, Loren 157
freedom 109, 135, 149–150
free schools 163
Friend, John 123–124, 127, 130–131
Fullan, Michael 17–20
funding 38, 40, 47, 51, 78, 79–80

gender 15, 25n5, 94, 105–106, 142; *see also* male teachers
George, Nora 7, 8, 9
Germany 112, 136
Girnhill Infant School 112–113
Glasser, Dr William 138
Gove, Michael 162–163, 170
Grosvenor, Ian 71

Hallam, J.H. 175
Halsey, A.H. 18
Hauser, Richard 151
Hawkins, David 138, 144n6
head teachers *see* leadership
Hepworth, Barbara 180
Her Majesty's Inspectors (of schools in UK) (HMI) 15, 29, 30–31, 75, 110, 135
Hogan, Jim 16, 74
Hoole, Charles 89
Hornbury Bridge CE Primary School *113*, *114*
humanity 5, 108, 134–135, 136, 138, 142, 143–144, 174
Hyde, Gary 91
Hyman, Walter 52, 54, 75, 88–89, 92, 123

identity 110, 118, 119
imagination 28–29, 36, 86, 89–90, 107, 126, 148–149
independent schools 38, 136–137, 141
individuality 106, 114
inequality *see* equality; social justice

184 Index

infant schools 105–119, 135–136, 142, 147–148; *see also* West Riding Education Authority
informal education methods 36, 76, 136, 139, 142, 143
international exchanges 5, 108, 134–144

Jooss, Kurt 110
Jordan, Diana 15, 77, 85, 107, 110, 113, 115–116, 118
judgement (criticism) 114, 119
judgement, professional 27, 29, 41, 46, 77, 164
junior schools *see* primary schools

Laban, Rudolf von 105, 108, 110, 112
Labour governments 46, 52, 62, 121, 161, 162
language skills *see* literacy; oracy
leadership 5, 11–12, 17, 19–20, 33, 34, 46, 73–74, 134, 147, 148, 153; of AC 1–6, 11–26, 25n3, 46, 68–69
LEAs *see* Local Education Authorities (LEAs)
Le Galès, P. 162
life-long learning 87, 95
literacy 93, 135, 162, 164, 166
Local Education Authorities (LEAs) 5, 7, 9, 11–12, 18–20, 28, 30–34, 41, 43, 46, 47, 52, 62, 71, 77, 81, 86, 87, 93, 124, 161–163, 176–177; *see also* West Riding Education Authority
London County Council, 'Patronage of the Arts' 79
London Day Training College 7, 74
Longfield, Anne 155, 156

Mackie, Sheila 113
male teachers 8, 105–106, 112, 142
Marsh, Leonard 115
Marshall, Sybil 149
Martin, Jane 6
Mason, Stewart 74, 80
McCordic, William J. 140–141, 144n9
McKittrick, D. 115
McLuhan, Marshall *3*
measurement 88, 106, 112, 114, 139, 150, 153, 154, 156; *see also* testing
Megson, Barbara 9, 93; and Alec Clegg, *Children in Distress* 9, 18, 88, 147, *151*, 151–153, 157, 177
mental health 5, 6, 95, 118, 151, 153, 156
middle schools 19–20, 25n9, 83, 88

Mills, C. Wright 6
Milne, Rae 15, 143
Ministry of Education (1945–64, later DES) 33, 51, 53, 123; *Building Bulletins* 117; *Moving and Growing in the Primary School* 111, *111*; *Story of a School* (Stone, 1949) 13, *14*, 33, 53, 107, 116
Ministry of Information, War Artists Advisory Committee 79
MOE *see* Ministry of Education (1945–64, later DES)
Monbiot, George 158
Moore, Henry 79, 180
Moorhouse, Edith 15–16
morale, teacher 36, 155, 175
Morgan, Joyce 86
Morris, Henry 79, 109–110, 116
Moseley, Henry 168
Mountain View Environmental Education Centre, Colorado 138
movement and dance 8, *65*, 86, 105–119, *125*, 127, 128
music 11, 13, 33, 59, *65*, 66, *68*, 80, 110, 123, 126, 127, 128

National Arts Education Archive (NAEA) 1–4, *2*, *3*
national curriculum 117–118
nature 84, 89–90, *99*
New Right 161, 171
Newsam, Peter 7, 16, 17, 19, 25n5, 76, 175, 176, 181n2–3
Newsom, John 12, 73, 170
New Zealand 141–143
Niblett, W. 52
numeracy 135, 164, 166
Nunn, Percy 7, 74

observation: learning through 84, 86, 89–90, 91, *99*, 151; of teaching 6, 13, 25n3, 107, 112, 135–136, 140, 174
Office for Standards in Education (Ofsted) 155
open education 137, 143
oracy and 'asking out' method 83–96

parents and carers 151–154, 156; *see also* relationships
Park Camp School 33
pedagogy 56, 62, 72n2, 76–78, 83–96, 107, 135, 164, *165*, 170; oracy and 'asking out' method 83–96; *see also* curriculum

Pedley, Robin 37
physical education 8, 53, 59, 62, *65*, 66, 105–106, 111, 117; *see also* movement and dance
planning 149–150
play 148–149, 153, 157
Plowden Report, *Children and Their Primary Schools* (1967) 5–6, 9, 62, 71, 77, 81, 137, 154, 155, 156
policy, educational 20; new 163–166, *165*, 175; *see also* reform, educational
potential, child 129–130
poverty 5, 18, 25n8, 31, 35, 74, 79, 95, 137, 139, 147, 164–166, 177
primary schools 12–13, 40, 76, 83–96, 105–119, 134–137, 139, 142–143, 148–149, 162, 163, 166; *see also* Plowden Report, *Children and Their Primary Schools* (1967); West Riding Education Authority
'Prints for Schools' 79
private schools *see* independent schools
privilege 38–39
professionalism, teacher 26n8, 28, 37, 43–46, 169–170
progressive education 5, 15–16, 53, 54, 70–81, 86, 107–108, 134, 136–139, 142, 143, 161, 163, 171, 174
Pullman, Philip 157
Pyrah, Muriel 83–96, *85*

Rathbone, Charles 137
Read, Herbert 79, 80, 180
Reay, Diane 166
Redhill Primary School 141
Red House, Denaby 33
Rée, Harry 74
reform, educational 37–39, 74, 160–162, 167, 170, 171; *see also* policy, educational
relationships xv, 18–19, 147, 148, 150, 152–154, 158
resilience 149, 152, 158
Revell, James 140
Richardson, Marion *3*, 79
Richmond, W. Kenneth 131, 132n1, 132n4
Robertson, Seonaid 90
Rocke, Basil 79
Rogers, Vincent 139
Rosen, Michael 157

Schiller, Christian 15–16, 30–32, 110, 112, 113, 135

school buildings and environment 5, 19, 30–31, 34, 74, 75, 79–80, 115–117, 128–131, 134, 136, 138, 147, 149, 150, 153, 158; caretakers 19, *60*, 66, 68–70, *69*; West Riding Education Committee reports on 53–70, *55*, *57*, *58*, *60*, *61*, *64*, *65*, *67*, *69*, 72n2
schools *see* free schools; independent schools; infant schools; middle schools; primary schools; secondary schools; West Riding Education Authority
Scrivener, Ruth 79
secondary schools: reform 162, 163, 170; selection 35–38, 75, 88, 141; *see also* West Riding Education Authority
Shady Hill School, Massachusetts 136
Shaw, George Bernard 21
Silberman, Charles 139–140
Simon, Brian 37
Simpsons Lane First School 90
Smith, Lester 51
social critique 28–29, 31, 34–40, 43
socialisation 150–151
social justice 28, 52, 73, 75, 144, 177; *see also* equality
South Kirkby School 136
spending *see* funding
sports *see* physical education
Srivastva, S. 25n3
Steward Street School, Birmingham 13, 30, 107, 110, 116, 135, 144n1
Stewart, Freeman 140, 144n8
Stone, Arthur 13, *14*, 30, 33, 53, 77, 107, 109, 116, 119n1, 135, 137, 142
success 106, 132, 150, 155

Tanner, Robin 15–16, 30
teachers: male 8, 105–106, 112, 142; morale 36, 155, 175; observation of 6, 13, 25n3, 107, 112, 135–136, 140, 174; professionalism 26n8, 27, 28, 29, 37, 41, 43–46, 77, 164, 169–170; workloads 164; *see also* relationships
teacher training and professional development 5, 8, 15, 16, 36, 59–62, *62*, 66, 75, 77–78, 80, 105, 110, 112–114, 127, 128, 135, 137, 162, 164, 171; *see also* Bretton Hall College; London Day Training College; Wentworth Woodhouse; Woolley Hall
technologies 6, 39–40, 154

testing 88, 139, 153, 154–155, 163–164, 166; *see also* measurement
Thomas, K. D. 142
Three Lane Ends Infant School 136
Thring, Edward 18, 19
tradition 167–169

United States of America 136–140

Vaizey, John 37
Vertinsky, Patricia 105

Waddell, Margot 154
Wakefield College 179–180
Wakefield Education Offices *64*, 177–178, *178*, *179*, 181n5
Walker, Mary 113
Warnock Report, 'Handicapped Children and Young People' (1978) 9
Webb, Sidney 46
well-being 5, 6, 9, 73, 78, 95, 105, 106, 153, 155
Well-Being of Future Generations Act (2015) 175
Wentworth Woodhouse 16, 59–62, *61*
West Riding Education Authority 5, 6, 9n1, 11–12, 31–33, *32*, 38, 51, 52, 66, 73–81, 86–88, 121, 175–179, *179*; 'Thorne Scheme' 37, 87–88; *see also* Airedale School; Balby Street Primary School; Bedales School; Bewerley Park Camp School; Bolton-on-Dearne School; Brookfield Infant School; Carlinghow School; Dudley Girls' High School; Girnhill Infant School; Hornbury Bridge CE Primary School; Park Camp School; Redhill Primary School; Simpsons Lane First School; Three Lane Ends Infant School; Wheldon Lane School; Whitwood Mere Infants School
West Riding Education Committee (WREC) 34, 41, 50–72; *West Riding Education: Ten Years of Change* (1954) 41, 44, *45*, 51, 52, 54–62, *55*, *57*, *58*, *60*, *61*, 72n2; *Education 1954-64* (1964) 41–43, *42*, 44, *45*, 51–52, 62–66, *63*, *64*, *65*, 71, 72n2; *The Final Ten Years* (1974) 43, 44, *45*, 52, 66–70, *67*, *68*, 72n2, 106
Wheldon Lane School 136
Whitwood Mere Infants School 90, *101*, 113
whole child education 107, 111, 131, 161
Wilkinson, Andrew 83
Winnicott, Donald 152, 153, 157
Woollahra Demonstration School, Sydney 142–143
Woolley Hall 8, 15, 16, 33, 59–62, 70, 75, 77, 85, 112–113, 135, 137, 141
working-class communities 43, 81, 83, 87, 88, 92, 95, 162–163, 166
workloads: central administration 43; teachers' 164
WRCC *see* County Council of the West Riding of Yorkshire
WREC *see* West Riding Education Committee
Wyndham, Sir Harold 140

Yeomans, Ed, Jnr 136–137
Yorkshire Sculpture Park 180; 'Asking Out' exhibition 91–92, 94; National Arts Education Archive (NAEA) 1–4, *2*, *3*; *see also* Bretton Hall College
Young, Michael 39
YSP *see* Yorkshire Sculpture Park